PENGUIN BOOKS

PROSPECT

Anne Truitt is the author of two other memoirs, *Day-book: The Journey of an Artist* and *Turn*. Her paintings and sculptures are in the collections of the Whitney Museum of American Art, the Metropolitan Museum of Art, the Museum of Modern Art, the National Gallery of Art, and many other museums and galleries.

PROSPECT

THE JOURNEY OF AN ARTIST

ANNE
TRUITT

PENGUIN BOOKS

PENGUIN BOOKS

Published by the Penguin Group
Penguin Putnam Inc., 375 Hudson Street,
New York, New York 10014, U.S.A.
Penguin Books Ltd, 27 Wrights Lane, London W8 5TZ, England
Penguin Books Australia Ltd, Ringwood, Victoria, Australia
Penguin Books Canada Ltd, 10 Alcorn Avenue,
Toronto, Ontario, Canada M4V 3B2
Penguin Books (N.Z.) Ltd, 182–190 Wairau Road,
Auckland 10, New Zealand

Penguin Books Ltd, Registered Offices:
Harmondsworth, Middlesex, England

First published in the United States of America by Scribner,
an imprint of Simon & Schuster Inc. 1996
Published in Penguin Books 1997

10 9 8 7 6 5 4 3 2

The publisher thanks Janice Greenberg for permission to quote from
Clement Greenberg's letter to the author and thanks Misha Ringland
for permission to quote from his letter to the author.

THE LIBRARY OF CONGRESS HAS CATALOGUED THE HARDCOVER AS FOLLOWS:
Truitt, Anne.
Prospect: the journal of an artist / Anne Truitt.
p. cm.
Includes bibliographical references.
ISBN 0-684-81835-3 (hc.)
ISBN 0 14 02.6768 9 (pbk.)
1. Truitt, Anne—Diaries. 2. Artists—United States—Diaries. I. Title.
N6537.T73A2 1996
709´.2—dc20 95-26194
[B]

Printed in the United States of America
Set in Garamond Book
Designed by Song Hee Kim

Acknowledgments

It is a pleasure to acknowledge my gratitude to the many friends who have contributed to this book. To single out only two examples, it was Cicely Angleton, a medievalist, who gave me illuminating information about Dame Julian of Norwich, and it was Daniel Jones who, one night at dinner, introduced me to Jakob Bernoulli.

Yaddo once again provided me with unique support, as did Bryn Mawr College, particularly in the person of Leo Dolenski, Manuscripts Librarian. Service on the board of the Academy of the Arts in Easton, Maryland, reminded me that my life remains rooted in my childhood there.

Margot Backas has over and over again given me the benefit of her counsel, her discernment. Jane Rosenman read the manuscript and made comments as probing as they were generous.

Nan Graham, my editor, has been, as always, intuitive and discriminating. Her confidence in my intent has been invaluable.

I am grateful to André Emmerich and to Ramón Osuna for their loyalty and their sagacity.

John Dolan's adventurous companionship during our trip across Canada was as delightful as it was reliable. I treasure Harold Kalke's trustworthiness and his wisdom.

Misha Ringland's ready generosity, his acumen and his energetic turn of mind have been sustaining on many different levels.

Above all, I am grateful to my family, to Alexandra, Mary and Samuel, whose comments on the manuscript were especially penetrating and useful. Their fidelity, as imaginative as it is affectionate, graces my life. Their children carry with them its continuity.

PROSPECT

Preface

One black night in the South Atlantic Ocean, while steering a jury-rigged lifeboat from Elephant Island to South Georgia Island in gale winds and cross-seas, the Antarctic explorer Ernest Shackleton saw a white line so high against the southern horizon that he took it to be a clearing sky. It marked instead the foam cresting a wave huge beyond any that he had ever met in his long years at sea. Meet it he did, headed his tiny craft into the wind and rode it out.

When I began writing the journal that has evolved into this book, I too hoped that the sky was clearing and I too found myself instead lifted by a wave daunting beyond any in my lifetime.

Unimpeded by land, the deep-sea swells in the southern latitudes encircle the earth, race toward their birthplace, where "reenforcing themselves [they] sweep forward in fierce and

haughty majesty. . . .At times, rolling over their allotted ocean bed, in places four miles deep, they meet a shallow of thirty to a hundred fathoms. . . . Their bases retarded by the bank, their crests sweep up . . . until their front forms an almost perpendicular wall of green, rushing water. . . . The madly leaping crests falling over and onward, probably attain a momentary speed of fifty miles or more. . . .The crest passing leaves the boat apparently stationary, gravity now holding her back. . . ."[1]

Shackleton outrode such a crest, a climactic meeting between the earth's adamant configuration and the waters moving on its surface. The wave that lifted me had no such grand sweep but was alike in that it swelled out of an interaction between my character and forces playing over it.

As 1989 descended toward the winter solstice, I found myself unable to maintain the judicious balance by way of which I had for years been able to support my work within the context of other responsibilities. Sales, long infrequent, stopped. I felt as if I were being strangled.

Appalled, I looked to my resources. I looked back on my life in art, and the bulk and weight of all that I had made bore down upon me. My practice is to face forward, work following work, each stored carefully. I had not taken into account their force as a whole. The work demanded to be answered to. The part of myself that I had trained to be a guardian began to transmogrify into a warrior. I thought to take arms and fight, to confront my work even as it confronted me and to join battle on its behalf. So in January 1990, I took a train from Washington, D.C., where I live, to New York and talked the matter over with André Emmerich, who had been showing my work in his gallery since 1963. He agreed that my career was at a crisis, and offered to give me a retrospective exhibition, a substantial exhibition with a catalog. Unlike

Shackleton, I initiated my own wave, as this exhibition lifted me into a visibility that resulted in four succeeding retrospectives of my work during the ensuing months.

André planned to show thirty years of sculpture, 1961–1991, and as I prepared for this review in the spring of 1991, I began to feel increasingly hopeful and increasingly anxious—reluctant to leave the refuge of my house, my garden and my studio for the glare of exposure. I started a journal two weeks before the exhibition opened on May 15. I stopped writing in June 1992, shortly after the close of the fiftieth reunion of my class at Bryn Mawr College, where a small collection of my work had been installed in the Mariam Coffin Canaday Library.

The journal did indeed, as I had hoped it would, keep me company, but writing became in the course of the year a relentless exposure of myself to myself. The crosswinds of events stripped me naked. I felt my own banality as I struggled with unearthed fears common to every life: dread of inevitable death, of painful illness, failure, of decreasing financial resources, anxiety for beloved children and grandchildren and friends. Acknowledgment of love unrequited, of loneliness unassuaged, of the bare face of fact.

By the time I went to visit my daughter Alexandra the month after I stopped writing, the very ground of my being had been scourged. While weeding in her garden, I was bitten by a deer tick, and spent the next year recovering from the resulting Lyme disease. But it was more than illness that paralyzed me. "The crest passing leaves the boat apparently stationary, gravity now holding her back." I felt that: held.

When I finally returned to the notebooks in which I had recorded my journal, I found that I had so changed that I could only write this book honestly if I collated the journal into a more cursive account of the year that it covered. I also decided to in-

13

clude parts of a notebook that I had written during a trip across Canada in the summer of 1989. I have folded the past into the present.

So although *Prospect* is a narrative account of one year, from spring 1991 through spring 1992, it constitutes as well a consideration of my whole experience as an artist, a mother, a grandmother, a teacher. Above all, as a person who is preparing to reach the end of a long life.

Washington, D.C., 1995

SPRING

\mathcal{S}pring is in glorious bloom this first day of May. I look to it for encouragement, as in two weeks "Anne Truitt Sculpture 1961-1991" opens at the André Emmerich Gallery in New York.

A list lies under my hand. I brought it in from the studio last evening as twilight slanted over my garden, graying the tulips swaying there as it grayed the sculptures I left behind me. Sixteen of them, ranging from *First*, wooden boards I had glued together and painted white in 1961, to *Sorcerer's Summer*, a tall dark column finished only a few months ago. Joined by a sculpture in Baltimore and two in New York recently shipped from Los Angeles, they constitute the retrospective exhibition that I both desire and apprehend.

My list is chronological and I have crossed off each sculpture as I have made it ready. The only way that I can address a work made years ago is by reliving the emotional complex out of which it originated, so I have had repeatedly to return to myself

as I was at the points they mark, the experiences they embody, in thirty years of my life—each piercing. Yet the source of each remains mysterious, as undetectable as the scent of a single blossom in a perfume compounded of many and various flowers. The first school paper I ever wrote, at the age of eleven or so, was an account of how perfume was made in France. A crude picture of immense wooden farm wagons heaped high with bright, multicolored blossoms had attracted me to the subject. I discovered that these mounds could finally be distilled into little drops of essence. Just so, each work is a distillation of vivid, emotionally charged impressions.

Recall has reawakened an innocence that is poignant to me now. When I began to make these sculptures thirty years ago, I had been taken by surprise, carried off by an impetus that bore me into a world new-made, fresh, sweet-smelling. I breathed a native air. I was enchanted.

I still look back on what happened to me with wonder.

I had been working in art since 1949. I studied first at the Institute of Contemporary Art here in Washington (to which I moved from Boston when I married in 1947 and where I have lived off and on ever since), and then continued in apprenticeship to myself from 1950 to 1961. During these years, I explored the possibilities of a variety of materials and methods: clay, cast plaster, cast cement, soldered wire, welded steel, carved wood and stone. This work was—I destroyed virtually all of it in 1962—expressionistic, declamatory, rhetorical. Life-size figures in colored cement; wire constructions derived partly from Cubism, partly from the colors and demarkations of stained glass; finally, toward the end of the 1950s, a stream of rapidly brushed abstractions in brown and black ink on large sheets of newsprint, and coarsely textured, dark-umber clay sculptures, roughly 18 inches x 18 inches x 5

inches, based on the proportions of the pre-Columbian archaeological ruins I had seen in Mexico.

So I had come on my own to an expressionistic geometric abstraction when, in November 1961, one year almost to the day after the birth of my third and last child, I took a train from Washington to New York. I went to look at what artists had been doing since 1957, while I had been living in San Francisco.

Three works at the Guggenheim Museum caught, and held, my attention. The first was a small painted wooden construction (I do not know the name of its maker) hanging on a wall. I liked its forthright look, which evoked in me the pleasure with which I had watched carpenters at their work when I was a child in Easton, Maryland, the small town on the peninsular Eastern Shore in which I grew up. I remembered how much I had liked wood, its resinous smell, and the long springy planed curls that the friendly carpenters used to let me hang on my all-too-straight yellow hair. I remembered the open-eyed way I had looked at things in my childhood. A little further down the ramp of the museum, I saw a strange painting which I took at first to be all black until my companion pointed out in it a blue-black cross, symmetrically vertical-horizontal; the artist, she said, was Ad Reinhardt. The words "Exactly like meaning in life" streaked across my mind—"at total risk of imperceptibility." And, finally, where the ramp widened into a semicircle, I came into the immense, grand field of a painting by Barnett Newman. I felt myself running free in that field, pelting. Exhilarated, I saw in Newman's great area of blue a space I had not conceived to be accessible save in imagination.

Combined, these three works exploded to reverse my whole way of thinking about how to make art. Until that afternoon, I had thought, had initially been trained to think, and had continued dumbly to think, that art was somehow intrinsic to material, im-

19

manent in it. That if I applied certain techniques to material with due respect for its nature, art would emerge out of it rather inevitably, as Michelangelo's slaves surge out of stone. I saw that the three artists who had so impressed me had not waited on, served, material, but instead had made it serve them. Had used it highhandedly to render their own ideas visible. I had to some degree also been doing that, but under the influence of a yearning to express myself. I had been on the one hand submitting to material and on the other forcing it to express emotions that overpowered me. I had not effectively brought to bear on them the order of a context outside myself.

I was so excited that night in New York that I scarcely slept. I sat on the middle of my bed like a frog on a lily pad, and as the hours went by all my patient plodding work during the past twelve years somehow locked into place, yielding a conviction of strength. I saw that I too had the freedom to make whatever I chose. And, suddenly, the whole landscape of my childhood flooded into my inner eye: plain white clapboard fences and houses, barns, solitary trees in flat fields, all set in the wide winding tidewaters around Easton. At one stroke, the yearning to express myself transformed into a yearning to express what this landscape meant to me, not for my own emotional release but for the release of a radiance illuminating it behind and beyond appearance. I saw that I could trust that radiance, could rely on its presence, even in the humblest object. Before I went to sleep, finally, spent, I decided to start by making a white picket fence.

It was by way of making this fence that I came upon the methods that I still use. The morning after my return to Washington, I got up early, bought a roll of shelf paper and drew on it the dimensions of three differently spiked pickets, a board on which to set them upright and two crosspieces to hold them at the back. I went

down the hill from our house in Georgetown to a lumber store and ordered these boards. I carried them back up the hill to my studio, a small room on the top floor of a house across the street from ours, glued them together and painted the resulting construction pure white. I named it *First*, and it is one of the sculptures I have been getting ready for the Emmerich exhibition.

I learned from *First* that I could do it: if I put my energy and experience into actualizing what I saw in my head, I could make it exist as a fact in real life.

I learned too that if a concept is sufficiently clear and strong, it magnetizes events. I had not known that intent was in itself so powerful. I was amazed by how my way was made smooth. When I went to the lumber store with a second set of drawings, I was told that this structure could be fabricated in the company's mill, right across the street. The mill manager took a look at the literal dimensions on my awkward roll of shelf paper and remarked mildly that I might do better to make scale drawings. I drove straight downtown and bought a scale ruler. So a system was put into my hands: scale drawings and mill fabrication. I was no longer limited to what I could put together myself, free to make large sculptures.

Kenneth Noland and I had been students together at the Institute of Contemporary Art in 1949. Luckily, he moved from Washington to New York early in 1962 and I took over his studio, a dilapidated carriage house in Twinings Court, an alley within easy driving distance of home. So I had two studios: a small one across the street from our house, for drawings and works on paper, and a big one for sculptures. There the bare wooden fabrications could be hoisted by hay-lift into the immense hayloft of the carriage house, and then painted. I had inherited some money, so I was able to open a special account into which I deposited sums to defray my

expenses; I used capital funds, invested in myself. This flow of events was rapid. Three months after my visit to New York, the whole system was in place. I had, in effect, set up a factory.

In this factory I made the sculptures which followed *First*. They simply presented themselves somewhere in an airy space high up over my head, as if already whole, real. I was astonished by their autonomy. I seemed to have little to do with the way they became larger and larger, more and more formidable; forthright, they stood as flat as I myself stood on my feet, challenged me, gave me no quarter.

In the beginning, they were literal. *First* was followed by other "fences." I painted them white, or the dark green of the trellises in the gardens of my childhood. Fences rapidly gave way to more three-dimensional structures that were as large as I was. These in turn gave way to those broader and taller than I: mass and weight and surface. I soon found housepaint limiting and began to use artist-quality acrylic paint. I telephoned to the manufacturer of this product in Ohio, and with his advice worked out a sound method of application. This involved successive layering in consistencies from that of water to that of thin cream. Acrylic dries in twenty or so minutes, so I could work fast. When I swept wide brushes over large areas, I felt profoundly attuned to both structure and paint, as if I were doing what I had been born to do. I found that I had a light hand—as some people have a light hand in pastry. Already identified with structure, I became more and more empathetic with paint. I put it on in coats that alternated vertically and horizontally, with and against the grain of the wood. The paint "married" the wood, sank into it, saturated it. Yet, paradoxically, I felt that alternating light brush strokes made a kind of shallow space within which the paint was set free to breathe on its own.

As my confidence and excitement increased, I began to mix my own color. From then on I was home free. The sculptures had become what I have been making ever since: proportions of structural form counterpointed by proportions of metaphorical color—essentially paintings in three dimensions.

I knew that this work looked odd, that I was in an exalted state of mind, possessed, but the authenticity of my impulse was so strong that it carried all before it. I remember thinking that no matter what the things I was making looked like, I would make them *anyway*. By 1964, when my husband was appointed bureau chief of *Newsweek* in Japan and I was uprooted in my tracks, I had made over fifty sculptures as well as many works on paper. The early delicate fences had evolved into massive works ranging up to 9 feet tall and 9 feet wide.

In some modest part of myself, I was appalled by my temerity. I was an unremarkable person to whom something remarkable had happened—so it seemed to me then and so it seems to me now. I didn't even think it remarkable until other people told me that it was. Kenneth Noland, always generous, told his friend David Smith about the work, David and he told Clement Greenberg, they all told André Emmerich. In October 1962, André came down to Washington for Morris Louis's funeral. He looked silently at the sculptures standing on the splintery floor of my studio, took out a little black book, consulted his schedule, and offered me a "one-shot show" for the following February, 1963. I accepted. After the opening of this exhibition, he shook my hand and said, "I hope this is the first of many shows."

The retrospective catalog has arrived and with it in hand and the sculptures ready in the studio, I can turn gratefully into the lee of domesticity. To my house, which I always like to leave in particu-

lar order when I depart for a venture into the world, and to the garden in which it stands, offset by the gray-shingled studio I built there in 1971. Four stout-stemmed tomato plants are growing vigorously in their supporting cages beside the luxurious spread of a fig tree thick with glistening leaves and fat little buds. The tulips that a friend sent me last autumn are ravishing, fulfilling the promise they held out through a winter when much else in my life was in question. Primroses make sturdy patches of butter-yellow and crimson. A mist of sky-blue forget-me-nots covers the stump of the Japanese cherry tree that died of old age last summer, measure of the twenty-two years that I have lived in my house, as a cousin gave it to me to celebrate our moving in.

I am content here in this establishment, which has matured as naturally as my children. It holds safe the history of our lives, has recorded in its earth and trees and wooden buildings the echoes of our voices, lilting threads of sound that keep me company now that I live here alone.

We, my three children and I, moved here in 1969, shortly after I separated from James Truitt, to whom I had been married for twenty-two years. Alexandra was thirteen, Mary eleven, Samuel eight. We began to make a life for ourselves as a unit of four instead of five. We drew closer together, our irretrievable loss of James's presence a tacit grief in common. Every evening we gathered around the table for dinner in candlelight and in years of conversation managed to weave a web of communication tensile enough to hold us together, flexible enough to allow us the natural diversity of our ways. We have sustained two deaths: James committed suicide in 1981 and Alexandra's second husband, Adam, died in 1989. We have been enlivened by four births. Three grandsons and one granddaughter will be joined by the baby that Mary and her second husband, John, expect in July.

However commonplace, it is an odd feeling to have borne babies who have grown up and had babies themselves. Logically it should be no surprise but I sometimes feel myself in some way taken aback, subtly startled. How things just keep on going amazes me, yet each new event seems inevitable once it has happened, has been assimilated into the family structure. As soon as a new baby is born, we wonder how we ever lived without that particular person. Nothing is forgotten, everything is factored in, the pattern grows ever more complex, richer by both bad and good fortune.

One year after Adam's death, Alexandra and her two sons moved from New York to South Salem in Westchester County, into a house Adam had bought as a weekend place. Sam and Alastair are twelve and ten; they flourish in the country but they have retained the alertness of a city point of view: they are resilient and self-reliant. Just before they moved, Alexandra and I were walking down Central Park West from their apartment when we saw in the distance a little boy strolling toward us. He had a bookbag on his back, a jacket slung over his shoulder, and was eating something, gazing around him with perfect ease: Sam returning from school, lord of all he surveyed. He has a way with all matters electronic; his room in South Salem is bumpy with coils of cable underfoot. Alastair is a person of enthusiasms; his fish tank contains a community in which natural selection is always taking place: the fish glide about and eat one another in an elaborate landscape. I notice in the boys a family pattern: when things go wrong, they draw together, form a unit. Alexandra has established herself as a freelance picture researcher. She runs her business out of their house, frequently commuting to New York. They have all bravely lived through and beyond Adam's death, led by Alexandra's high heart.

Mary's son by her first marriage, Charles, is eleven. He was born before her graduation from Sarah Lawrence College—a photograph taken at the ceremony shows him hanging cheerfully off his mother's arm. Mary went on to take an MFA degree in writing at Columbia University. She and Charlie moved from New York to Washington while she was still studying, and as soon as she was trained, she began to teach, at American University and George Washington University. Mary's wonderful stories, many of which have been published, were my first revelation of the secret life that children reveal to their parents when they reach a certain age: I recognize landmarks but from an angle oblique to my own and focused by a different lens.

Mary married John in 1987. He is the son of an old friend who, pregnant with him, telephoned me one winter afternoon in 1953 to ask if I would be willing to edit a translation from French to English that she had undertaken under the pressure of a deadline. As matters turned out, we translated *Marcel Proust and Deliverance from Time* together. So John has come into our family in a corkscrew of fate, the past wound into the present. He is studying law at the College of William and Mary in Williamsburg, Virginia. Roseanna was born in 1988.

Like Charlie, Rosie is a cheerful child though entirely different in temperament; fey, she dances on eager toes around and about her sober brother. Charlie is an indefatigable reader. Even as a baby, he used to enjoy his own company in his playpen. He seems to have been born with the ability to say whatever he chooses: he "tells," and that makes him entertaining, infinitely companionable.

When Alexandra and Mary were born, I had immediately the feeling of understanding them by instinct. When Samuel was born, I had the opposite feeling: I knew immediately that I did not understand him. I remember holding his dear shape in my

cradling arms, sniffing in his hair the lovely smell of birth, and thinking, "This baby is right off the steppes of Russia." He brought his own air with him, the air of a strange and faraway place. I could almost hear the wild wind. He seemed *packed* too, as if energy were tamped in him.

It must be this native force out of which his poetry is spun. Out of that and a life of thought: he is a thinking creature. An instinctively solitary one too, for all the variety of his experience. Writing, writing, he went from St. Albans School to Beloit College to Kenyon College, and then on to some years of graduate work, first in the United States and then in Ireland, where he studied Old English at Trinity College in Dublin. He has traveled across the American continent by hitchhiking, across Europe, north to the Baltic, south to Greece, where he spent a night on the Acropolis. Now he lives in San Francisco and works as a private investigator. He has published one book of poetry.

The family structure that we have evolved over the years is not pyramidal. On our *Animal Farm*, unlike George Orwell's, the animals are "all equal." Roiled as we occasionally have been, and are, by clashes, conflicts and confusions, we have so far managed to maintain loyalty along with idiosyncrasy. We change places a lot, lead and follow, pool our different characters and experiences as intelligently and generously as we can. What we cannot fix, we sustain.

It is commonly said that life is short. It is, of course, from a millennial point of view, but I am far more impressed by how long it is. Lived minute by minute, hour by hour, day by day, its linearity is remorseless. Everything counts. The poet Borges once wrote that "We can only lose what we have never had." We have our lives, make them as we go along, cannot lose them, and must answer to them. Nowhere is this inexorability more notable than in the life of a family. Interactions are as unpredictable as their results—as

27

parents discover when their children grow old enough to tell them what they experienced in childhood.

I noticed that when my children reached the age of about twelve, the balance of power shifted from me to them. I have sometimes felt myself in the quandary of a chicken who has hatched duck eggs: my children took to the water, I remained on the riverbank. But I cherish my own independence too much to begrudge them theirs. I do better on the bank cheering them on. If I keep a respectful distance, they welcome me into their lives almost as wholeheartedly as I welcomed them into mine when they were born. "Almost" because even the most affectionate adult children maintain with their parents a healthy reservation that marks the boundary of their autonomy.

I am more impressed by what my children have taught me than by what I may have taught them. The physical purpose of reproduction is, obviously, the continuation and renewal of genetic continuity, human survival. Its psychological purpose seems to me to be a particularly poignant kind of mutual learning and, matters being equal, ineffable comfort.

One of my sisters, Louise, has been visiting her daughter in San Francisco. She and Samuel have been discussing our childhood, hers and her twin, Harriet's, and mine. Louise and Harriet are eighteen months younger than I. This gap in time combines with dissimilarities in temperament to make their views of our childhood different from mine. Heisenberg's uncertainty principle— the principle that "uncertainties at the instant of measurement ... prevent complete certainty about the future course of a system under observation"[2]—governs families as well as observable quantities in general. Each child grows up in a singular psychological world.

I enlarged mine when I was very young. Easton was a safe town inhabited by provincial people who kept an eye on one another. My parents must have decided that I was a sensible child, as I cannot remember ever not having the feeling that, within reason, I was free to explore.

On my eleventh birthday in 1932, my father gave me a red-and-white bicycle; with it a scarlet rubber rain cape, ruffled and hooded. I had hungered for the bicycle but had taught myself not to hope for it because my parents, entirely dependent on inherited money, were stricken by the Great Depression. I felt as if we were being pulled down by a relentless undertow into a fathomless sea. My mother sickened under the strain; after a spell in a Baltimore hospital she took to her bed; the shades on the four tall windows in her elegant high-ceilinged bedroom were drawn down almost to the sills. My father tried to stay cheerful but he gave way now and then to attacks of depression (tears ran down his numb cheeks) and of alcoholism; a starched nurse became an occasional necessity. My sisters fell silent and wistful. The air in the house quivered with stifled fear.

I myself was filled with energy. I yearned to *leave*. The bicycle, bought, I understood, at the cost of real sacrifice in my father's economy, set me free. But I felt that the color was wrong for me. I felt miscast on red-and-white wheels, conspicuous in the scarlet cape. My intense gratitude was offset by an uneasy recognition that my father's image of me—a flying child in yellow pigtails, highlighted in red—was out of my character and in his. Cast as a dramatic symbol, I was to have the range of behavior that he had failed to make for himself. I wore the cape when I left for school, but when out of sight took it off and hid it in my bookbag.

One of the byways that I explored on my bicycle in ever-enlarging concentric circles around home was an alley that ran

along the back of an immense tangled garden. There, in a ragged round rose bed, a short cement pedestal held aloft an ornamental ball of mirror. I used to ride over and look at that reflection: my own barely recognizable stretched face if I stood close, and if I stood apart, a fascinating miniaturized picture of towering trees converging over a sumptuous pattern of surging plants. Once I had grasped how this worked, I used to maneuver my distance so that I could study this strange device by way of which the world was at once reduced, distorted and made magical.

Secting and bisecting the town of Easton, I formed of it a mental map like those I years later saw in the drawings that the seventeenth-century French engineer Sébastien de Vauban made of cities encircled by fortification. I came to understand the town as a whole, how stores abutted, how houses off-faced one another on square and rectangular plots of ground, how streets and alleys and footpaths wove in and out. I substituted for deprivation in the human realm the pursuit of this objective one, and imbued it with the love for which I otherwise found no rewarding place.

When my father put wheels under me, he offered me a healthy route from the smothering subjectivity of family to the invigorating objectivity of the world at large. His influence persists to this day.

The variety of scale illustrated in the ball of mirror initiated a lifelong habit of looking at what I see from many different points of view, each potentially fascinating. I took in the fact that the world was not fixed, that its meaning changed as its appearance changed and that these changes had something lawful about them so I could hope to learn how it all worked if I paid attention. I noticed too that by moving around something, moving toward it or moving away from it, I had some control over its meaning to me. I began to be interested in how things fitted to-

gether. It was so that I gradually came to grasp the topology of Easton, its reference to the compass points of east-west-north-south, a reference that informs the structure of my sculpture.

But it was more than structure that obsessed me. I somehow picked up the idea that each building in the town was a kind of fort, and that their geometric order as a whole constituted protection. This comforted me. My own particular building, my home, did not fortify me, did not give me a feeling of safety. In an instinctive attempt to provide for myself, I evolved the idea that I was myself a fortification, that in my own person I was in effect my only security. So I began to cultivate competence. To do this, I needed freedom. And when I took off my father's scarlet cape I took to going my own way even if I had to be deceptive to do so.

I was only a child. I write as a woman in her seventies looking back and trying to understand the pattern of her life. I did not think then as logically as I do now, but I remember how even then there was desperation in my efforts to make sense of things. I remember a life-or-death feeling that security lay only in independence. And I remember grief, grief that the cost of independence was an unspeakable loneliness.

When I write about my parents, when I speak about them to my children as my sister Louise spoke to my son, Samuel, I feel a profound loyalty to them because I felt in them the same unspeakable loneliness. I guard my tongue that I may honor their privacy, grant them respect. I sieve the good—their gentle ways, their traditional virtues, the quiet fidelity to moral principle that my mother embodied, the wry, merry slant my father brought to bear on life—so that they may pass on to their descendants, and mine, a legacy that will strengthen them as they in their turn strive toward good.

As a child, I yearned over my parents deeply, silently, as silently

31

as they bore their troubles. I came with infinite sadness to know that I could provide them no substantive relief. I felt for them the heartbreak I feel now as I watch my children encounter the inevitable struggles of adulthood. The wheel has come full circle. But I know now how love encompasses, absorbs and transforms all human travail, is in itself one of the shapes of wisdom.

The curiosity that impelled me out on concentric circles into the environs of Easton moved me to read as widely. My mother introduced me to this everlasting pleasure. She used to read to my sisters and me every possible evening. After our baths and suppers, we would gather around her where she sat on the graceful little rosewood sofa now in my living room. One on either side, the third on an ottoman in front of her, we listened to her musical voice and traveled in our imaginations to distant lands where we had adventures. As soon as I was old enough, I got my own library card and from then on supplemented my mother's classical books with anything that took my fancy. I learned about machines from Tom Swift, about boys from the Rover Boys. No one supervised my selections. My parents trusted my judgment and their trust made me trustworthy. I developed the habit of discrimination, of scanning as I read, retaining and discarding as I saw fit.

At some point in my eclectic reading as I matured, I came across Hermes Trismegistus. His phrase "As above, so below" caught my attention and I have been turning this idea over in my mind ever since. What I take it to mean is that a person honestly seeking to learn what life is about has to look in two directions: "above" for spiritual knowledge, "below" for practical knowledge. And that if wisdom is to result, development must proceed to an equal degree in both directions more or less simultaneously.

When I studied Latin, I picked up Terence: *"Homo sum; hu-*

mani mil a me alienum puto."—I am human; nothing human is alien to me. I was fired by this concept: the entire range of human experience is available to every single human being.

What these two ideas added up to for me was a decision to try to experience as much as I could with as open a mind as I could, in the hope that if I did so my desire to "know God," to understand "the meaning of life," might perhaps come to some result. At the least, I would undertake to lead a life as properly aligned as I could make it. This common aspiration has led me to a common limitation: from the baseline of my natural individuality, I only narrowly experience what is "above" and "below" it. I am unlikely to know spiritual ecstasy. Equally, I am unlikely to know certain human depths—for example, how in World War II the woman called "The Beast of Belsen" could have been so cruel to women in that German concentration camp as to tie their legs together in childbirth.

In 1975 I was approached by the Art Department at the University of Maryland and began teaching there as a part-time lecturer. I fell in love with teaching, undertook to work full-time, and in 1980 was promoted from lecturer to tenured full professor. The university has been a stable factor in my life, providing me with the steady income I have never earned from the sale of my work, as well as the inestimable satisfaction of sharing my experience with students.

I enjoyed this security until one day last November when the chairman of the Art Department mentioned casually in a faculty meeting that tenured university professors are subject by federal law to mandatory retirement at the age of seventy. I was due to reach that age the following March. Innocently, he annihilated my financial substructure. Comically too because so curtly: one sec-

33

ond I was duly attentive within the familiar stronghold of tenure, the next sentenced to exile. I continued to sit straight in my cushioned chair and instantly guarded my face, even equably contributed to discussion of matters at hand. A surge of adrenaline carried me out to my car but I was trembling by the time I got home.

Since then a lot of my energy has been absorbed by the effort to adjust to new circumstances. It was incredible, dumbfounding, that I should be ejected from the university in the full vigor of teaching, particularly as that year I had been honored as a "distinguished scholar-teacher." It was as if I had been struck by lightning off a mountain, become a loose rock tumbling in space. And I was embarrassed, dismayed that I could have neglected to realize so critical a fact; on the contrary, I had been confident in my belief that federal law held all mandatory retirement illegal.

I immediately investigated my status. I found out that when I was retired I could continue to earn a certain percentage of my pension without forfeiting it. I made appointments with the chairman of the Art Department, the dean of arts and humanities and the provost of the university, and made it clear to each of them that I wanted to keep on teaching. They enthusiastically agreed, and I now wait to see whether I can continue.

As time has gone on, I have begun to feel the replenishment of curiosity, of promise, for I have noticed that I have never lost anything that has not been replaced by something eventually more rewarding. I continue to feel startled that simply because I have become seventy, all other factors unchanged, I am worth so much less on the market. But it makes sense for an older person to make way for a younger in the pride of life and much more responsible for another generation.

Of course I had known that I was growing older but I never ac-

tually took in the fact that I could be defined as "old" until I lost my tenure. I am used to thinking of my body as a vehicle in which I ride rather lightly, paying it no more attention than needed to keep it in working order. I had had to give way to some physical limitations but had been fortunate that these limitations had developed only slowly, so I had been able to adjust the economy of my energy privately. I felt as if I had now lost that privacy as well as financial security. I cannot remember any other event in my life that so abruptly made me feel tentative about myself. Matters in general seem to me now to have become more precarious. It is partly this new vulnerability that is making me anxious about the coming New York exhibition.

I find to my surprise that I feel a little *ashamed* of being considered old. And not a little frightened that the competence with which I have underwritten independence may, inevitably must, decrease as I grow older. I am so used to defining myself for myself that I have failed to take into account the fact that age makes an objective statement. What people see in me is not what I am experiencing as myself. I feel at once stripped, and invisible.

I recently reread Flannery O'Connor's story "A Good Man Is Hard to Find." The protagonist is an old woman who leads her son, his wife, their three children and finally herself to death. In a mischievous attempt to entertain herself during a dull family outing, she imposes her will on her vapid, good-natured son and fashions a circumstantial tragedy. She is slyly seeking to perpetuate the power she had naturally possessed when she was a woman in the prime of her faculties.

I detect in myself a similar urge to continue to be in charge of what is going on around me. Under it burns a dumb resentment that age is automatically, without my consent, discounting me. Making mischief may be an available form of creativity no matter

how old you are, and mischief can indeed sometimes lead to evil. Perhaps it is wanton outrage that fuels the occasional unattractive vehemence of old people, deprived by age of the vigorous and effective self-expression which they have been accustomed to take for granted.

O'Connor's Grandmother is not only feckless but also has cognitive problems. She mixes memories and directions. She cannot take in what is happening. She behaves as if she enjoys immunity from the results of her actions. Even finally sprawled in a dry ditch, she desperately tries to coax into goodness the brutal man who has already killed her family so that she can claim that he should spare her because she too is a kindly person. In the last seconds of her life she tries to make herself count in his, a final spasm of egoism.

Today, May 12, the sculptures leave my studio for the Emmerich gallery. I go to New York tomorrow. We install the exhibition the following day and it opens on the 15th. I feel the chill that marks a transition from imagination to actuality. A pang comparable to the first unmistakable streak of childbirth up the backbone announcing clearly that the huge baby you are carrying is going to have to pass out of your body by way of a very narrow canal.

Transportation of my sculptures is a particular matter because they combine bulk and heft with delicate layers of paint. The packers, who are well-trained, patient and painstaking, will pack the work here in my studio and unpack it in the gallery. All that generous care can do will be done. But care cannot control fate. From the moment that my studio doors close behind them until June 28, when the exhibition is scheduled to end, the sculptures will together constitute an entity with a life of its own.

An entity like that of a ship which, although equipped with ad-

justable sails and steered by an experienced sailor on a calculated course, is continuously at the mercy of variable winds. And of the sea as well: a ship can be seized by invisible currents like the gyre of the Gulf Stream. On Ponce de León's voyage to the coast of Florida in the sixteenth century, sailors found "a current which, although they had a good wind they could not stem. It seemed that they advanced well, but they soon recognized that they on the contrary were driven back, and that the current was more powerful than the wind ... [one ship] was carried away by the current, and they lost sight of her, though it was a calm and clear day."[3]

The gyre that could carry away my own little ship is emotional. Whole parts of myself never heard of art: they "live" my domestic life, stick to cleaning and washing and ironing and cooking and gardening, and resist change—they are devoted to their habits. They also prefer to present a low profile to destiny, to crouch as close to the ground as possible: they have learned that visibility attracts lightning. Sometimes they are simply lazy; they like to read about other people acting while they lie prone on a sofa. The stern artist in me can also be troublesome: she ardently believes that I should make my work as perfectly as I can and let the world go hang. She is adamant, I respect her, I can count on her unfailing support in the studio.

And I owe to her romantic idealism my fascination with early Antarctic exploration, owe to her my acquaintance with two men who have taught me a great deal.

Roald Amundsen, a Norwegian, and Robert Falcon Scott, an Englishman, reached the South Pole on December 14, 1911, and January 16, 1912, respectively. Thirty-three days, as well as marked differences in character and temperament, apart.

Absent the advantage of electronic communication, a success-

ful polar expedition entirely depended in the early twentieth century on three major factors: the choice of men and equipment, adequate transportation, and meticulous navigation along a well-supplied, well-marked trail while isolated in a featureless, inimical terrain. Scott's carelessness is cruelly illuminated by Amundsen's scrupulous respect for fact.

More poetic than pragmatic by temperament, Scott seems to have swallowed whole the concept that a person who is privileged—he was a British naval officer—is entitled to some exemption from the operation of natural law. He chose his men and equipment more or less by whim, even sentimentally. Arrogantly discounting the evidence that Eskimo dogs were absolutely essential to polar travel, he took only a small number. He depended for transportation on tractors which were not only relatively untested but also, of course, too heavy—in fact they either broke down in one way or another, or sank. And on ponies. Anyone with any common sense could have foreseen that animals shaped like large barrels on four sticks would flounder in deep snow; nor could ponies withstand cold. They all suffered and they all died. So the expedition was finally reduced to hauling the sledges of equipment themselves—a terrible labor, but one that Scott apparently took to with some gusto, welcoming what he was convinced would be proof that Englishmen could surmount any and all odds. He scorned skis, which he seems to have considered a form of cheating, using them only reluctantly and ineptly. He allowed his men to suffer from cold feet and hands, and, unforgivably in view of British naval history, from scurvy. His navigation was exemplary, but it was undercut by slipshod marking of his critical points of reference, the depots at which he deposited supplies along his line of march.

Amundsen's depots, in sharp contrast, were each marked by

ten black identification flags at one-mile intervals stretching five miles east and five miles west across his southerly route; within a ten-mile band any one flag accurately indicated a depot's location. Before leaving Norway, he acquired a large number of the particular breed of Eskimo dog that had proved most enduring in the Arctic. Every single man in his expedition was specifically selected with an eye to skill and temperament, and the four whom he chose to accompany him to the Pole were experienced Arctic explorers and dog-handlers as well as seasoned skiers. Their sledges carried such ample provender that Amundsen was able to note on his way back from the Pole to his Antarctic base: "We have far too many biscuits, and can do no better than give them to the dogs."[4] The men were so warm in their Norwegian winter outfits that they only rarely used the special Eskimo fur suits that Amundsen had had copied.

Aside from affectionately naming an Antarctic mountain after his housekeeper, Betty, Amundsen is not as appealing as Scott; he won my heart by way of sheer admiration for his intelligent courage. Scott's courage, undeniable and touching too when considered in conjunction with his nervous excitability, was more the grit of a schoolboy than the mature determination of a man. His wayward decisions make me grind my teeth. His journal is, however, a marvelous hodgepodge of fresh, even intimate, observation and chatty comment, shaded by a romantic temperament alternately discouraged and resilient.

"Great God!" he writes at the South Pole on January 17, "this is an awful place . . . and terrible enough for us to have laboured to it without the reward of priority. Well, it is something to have got here, and the wind may be our friend tomorrow." There is no "friend." Instead nature's inexorable march toward winter: blizzards that nailed five men into a tent designed for four—Scott

had impulsively added his friend Birdie Bowers to the Pole party at the last minute—on rations calculated for four and further reduced by what Scott calls "bad luck." Edgar Evans succumbs to injury, frostbite and scurvy on January 17. Titus Oates, after mortal suffering gallantly endured, crawls out of the tent on March 16. "I am just going outside and may be some time," he says as he goes; he is never seen again. Birdie Bowers—who had survived what Apsley Cherry-Gerrard called "the most terrible journey in the world," a long trip that Scott had sanctioned in the dark of winter to find and retrieve emperor penguin eggs—dies as modestly as he lived. Apparently followed by Edward Wilson, on whose dead shoulder Scott finally lays his dying head.

March 29: "Since the 21st we have had a continuous gale from W.S.W. and S.W. We had fuel to make two cups of tea apiece and barely food for two days on the 20th. Every day we have been ready to start . . . but outside the door of the tent it remains a scene of whirling drift. I do not think that we can hope for better things now. We shall stick it out to the end, but we are getting weaker, of course, and the end cannot be far.

"It seems a pity, but I do not think I can write any more. R. Scott."[5] It was indeed a pity, but it was more than that: it was a shame.

In counting on a high heart and discounting actuality, Scott failed to understand that pride poorly serves aspiration, that courage influences events but does not control them and is only effective when combined with prudent forethought and clearsighted respect for facts. His flaw was hubris, the arrogance of a man who casts himself as hero of his own myth. But the Greek heroes bring only themselves to tragedy. Scott led four men to their deaths. I think of what he must have felt as in the end he lowered his head on his friend's shoulder, and I feel for him less

the pity he felt for himself and his failure than the kind of compassion that leads to self-examination. For my temperament is more akin to Scott's than to Amundsen's. I have a healthy distrust of my romantic nature.

I review my preparations for New York, where the forces and counterforces of the art world seem as complex as those of Antarctica. I honestly feel that I am as well prepared as I can reasonably be. My sculptures are sound structures, splined, mitered, weighted and sturdy; barring accident, they should arrive in New York in good shape. Navigation in an "inimical terrain" remains a concern: I will have to rely on my instincts, informed by many years of exhibiting. But no matter how well prepared, I know that I will be wounded. Although experience has shown me that critical reaction to my work runs parallel to its course, illuminates it only obliquely and does not deflect it, I have never weathered an exhibition without hurt. Any comment on the work feels to me as if it were a comment on me, personally. The part of myself that is identified with my work is as alive as a nerve, as quick as the nerve of a tooth. There is no honest way to protect myself from this reaction. First because it is automatic, but as cogently because I feel sure that in some subtle way vulnerability guards integrity.

I am not without my defenses, however—my private castles. The concept of a castle is that of a keep, a strongly fortified tower, surrounded by concentric walls which are more or less pregnable but can be defended at need. Whole areas of myself lie fair to my rear as I advance into New York: family, house, studio, garden, friends, students, books—all my everyday life. Then too, this notebook that I am writing is a castle that I can take with me.

*　　　　*　　　　*

I am in New York, staying at the Cosmopolitan Club, which I joined some years ago in order to have a home base here. Safely transported and unpacked, the sculptures stand ready in the gallery. We install the exhibition tomorrow. This afternoon I walked up and down Manhattan with all the delight of renewed congeniality. I visited the Frick Museum, my favorite, and tonight I will have dinner with my daughter Alexandra and William O'Reilly, an art dealer. I look forward to their lively conversation. The transition from imagination to actuality may be daunting in prospect but I usually find that I am animated by the change. The air is fresher.

I first set foot in New York, now so familiar to me, in 1944 at the age of twenty-three. I came as a psychologist, to attend a psychiatric convention at the Waldorf-Astoria Hotel. During my senior year at Bryn Mawr College I applied to Yale with the thought that I would proceed forthwith to a Ph.D. in my major field, psychology. After my graduation I returned to my father's house in Asheville, North Carolina, and during the summer became a volunteer Red Cross Nurse's Aide, following in my mother's footsteps—she was a Red Cross nurse in France during World War I. To my surprise, that training, which included work in a hospital, changed my perspective on what I wanted to do. Asheville is in mountain country; most of the patients on the wards to which I was assigned while being instructed were mountain people formidable in their inarticulate fortitude and truly patient; brave in pain too, and flavorsome in their idiosyncrasy—I liked their cranky ways. I felt with them an identification that opened up in me a well of tenderness. And in using my hands, I found a satisfaction I had never known before: a direct route from emotion to touch. As the summer wore on, academic work came in contrast to seem narrow, dry, uninvigorating; even self-centered. In the first

major decision of my life, I refused Yale's offer of a place in graduate school and moved to Boston, where my mother had grown up and where my sisters lived. There I was fortunate enough to be hired almost immediately by Massachusetts General Hospital, where I worked in the psychiatric lab as a psychologist by day and in the wards as a nurse's aide by night until the end of World War II.

That first visit to New York was a revelation of how exciting the world could be. My work in the hospital had steeped me in all sorts and conditions of human torment; it had not forcefully occurred to me that human achievement might be as universal. The sheer artificiality of the city itself, its verticalities tall beyond dream, narrowly bounded by rivers on either side and strictly laid out east-west-north-south, made me see Easton as homegrown; even Boston had that character, the higgledy-piggledy of a pioneer town still discernible in its twisting streets. New York seemed to have been invented whole, structure incarnate. I was astounded, overjoyed, that something so immense could have been brought into being, and had in turn brought forth so much vital variety. I listened to its sound with awe, an unceasing melodious wild roar that gave the city an epic voice.

I was writing poetry but I had no idea at all that I would become an artist. It was in one of those deflections that sometimes subtly predict the course of a life that I sought out, just for pleasure, the Museum of Modern Art.

On entering, I turned left and up the stairs straight into Picasso's *Les Demoiselles d'Avignon*. Shocked, my eyes clamped on it. I focused on the three towering women gazing out at me with the eyes of basilisks—their breath would be fatal—and then took in the remote shadowed faces of their companions. Suddenly I understood that I knew very little of what it is to be female. Even

less of art. I had not felt its naked power before, its power to shatter the appearance of things so as to reveal behind them another order. When in 1949 I began to study art, I more or less consciously looked for what I had found in *Les Demoiselles*: shock, an understanding deeper than my own of what it is to be human, and a mysterious revelation of a radiant order.

I woke up this morning in my pretty room at the Cosmopolitan Club. I had slept only fitfully, and lay disheartened and inert under my warm blankets, prey to a wayward impulse to flee. I envisioned the scenario: I would pack, taxi to the station, and bear south for home. Then the habit of a period of quiet on awakening, and a pot of hot strong coffee, restored me to my senses. As I dressed, putting on my cheerful butter-yellow sweater, fortitude straightened my backbone. I walked down Park Avenue to the gallery on 57th Street and every step confirmed in me the intention to make the exhibition, this particular transaction between my inner world and the outer world, as perfect as possible.

André Emmerich, with whom I have had six solo shows, claims that if its installation goes smoothly, an exhibition will be a success. Ours did.

Last night at dinner, Jane Livingston, who wrote the exhibition catalog essay, remarked that the sculptures which she had generously helped us to install are Celtic. She could not have said anything that would have pleased me more.

The Celtic meandering line, formally winding back in stately order to renew itself and move forward, has always seemed to me the quintessential metaphor for the birth-death-rebirth that lawfully governs all transformation from potentiality to actuality. The Celts took gold, the most beautiful element in the earth, and in

their intricate works of art made it show forth another human order of beauty. An order at once spare and elaborate. Jane's words evoked the dragon's jeweled hoard in the saga of *Beowulf*, and Beowulf himself, finally drawn by his fate into mortal combat with that dragon to become with him immortal. A host of images rose in my mind to put my moment in art into broad perspective. A happy perspective because Samuel had inhabited the quasi-mythical realm of the Celts while he was studying in Ireland. I had a warm feeling that he stood tall and straight beside me.

I feel invigorated as I face into the opening of the exhibition this evening. Our installation is perfectly lucid—a straight shot of thirty years of work. Led by two long, low sculptures—*Grant*, a stretch of mauves and tans, directly to the right of the entrance, *Remembered Sea*, reverberating Mediterranean blues, against the wall at a distance directly opposite it—the viewer's eye skims into the spacious gallery and then is brought to a standstill. We put the work of the early 1960s in a room of its own; these sculptures are plain, white and dark green fence-structures. A forest of brilliantly colored columns stands in a room to the right, offset, in an alcove, by *Gloucester*, a massive dark-towered rectangle. In a space stretching horizontally at the end of the gallery, *Valley Forge*, a large rectangle of two bright reds, flanks *Remembered Sea* to the left, opposite three tall slim towers in delicate colors to the right. *Nicea* looms alone against a wall of its own: glowing deep pink vertical bands—slashed by a brushed line of scarlet.

I walk around these sculptures in my mind and consider their existence. They look so objective. Yet each one sprang from the very core of my subjectivity. I see in them no trace of the hours and hours of intense labor by way of which they were made. People sometimes ask me if I feel as if my sculptures were my children. I do *not*. The love I feel for my children is unique in my

experience. Nothing is comparable. But it occurs to me this morning that they too are transformations of secret, silent resources similar to those out of which these sculptures emerged.

I am remembering my children with particular affection this morning because I feel the need to hold on to the security of my personal life as I face the exposure of this exhibition. Alexandra will come in from South Salem this afternoon for the opening. Mary cannot come; her baby is due in a few weeks. Samuel is in San Francisco.

In her memoir of her father, the painter Philip Guston, Musa Mayer speaks of the anguish that Guston felt when exhibitions of his work opened. "My father's openings were excruciating to him ... preceded as they always were by days and weeks of paralyzing indecision and anxiety. . . . Strings of sleepless nights. . . . His anxieties didn't seem particularly strange . . . they were inevitable, natural phenomena, to be endured like bad weather. . . . On the way to the opening, I would keep stealing looks at my father in the taxi. He seemed so miserable. . . . Philip would unfold himself with difficulty from the taxi, then stop on the sidewalk outside the gallery, rooted as if he couldn't move. . . . The whole thing was a mistake, a terrible mistake, he'd cry. . . . Finally, he calmed down and entered the building grimly, a criminal resigned to his punishment. . . . Lost in the crush of people, I couldn't even see him anymore, but now and then I heard his voice, holding forth, easy and booming now, that infectious laugh of his. . . ."[6]

I do not expect to be in a "crush of people." Walter Hopps, who curated the retrospectives of my work at the Whitney Museum of American Art and the Corcoran Gallery of Art in 1974–75, once pointed out to me that I had "turned a back on success" when I decided to accompany my husband to Japan in

1964. That very personal decision cut the momentum with which my work was becoming recognized, and it is true that this momentum never again picked up. Ever since 1969, when I separated from my husband, I have been preoccupied with bringing up my children and have not invested in the art world at large the energy that nourishes a healthy career. Artistic and cultural changes that took place in art during the 1970s and 1980s have also put a distance between my work and the kind of art that is now being acclaimed. André Emmerich's loyalty—rare, usually both dealers and artists play musical chairs—has kept a place for me. But this combination of circumstances has vitiated much that he might otherwise have been able to do to promote my work.

I am home.

At the opening I sadly missed David Smith, who was killed in an automobile accident in 1965. Like Philip Guston, he had a "booming" voice and even when silent his presence boomed: he might have buffeted me on the back, roared in my ear, made a commotion. Artists came—Martin Puryear, Buffie Johnson, Peter Halley—and I was very glad to see them. But I missed the excitement I felt in the 1960s, that intoxication.

The opening was, however, a revelation. I found friendships of many years renewed. With my classmates at Bryn Mawr; with students past and present (one from Madeira School, where I taught from 1967 to 1972, some from the University of Maryland who are making lives in art, a few from my current seminar there); with an architect whom I knew in the late 1960s when I had no studio and worked in a room in a house on Calvert Street in Washington where he was living; with members of Yaddo's board of directors, on which I served for a number of years. Whole cycles of relationships encircled me. The truth is that I have chosen to live

a life more private than professional. In a personal equation combining aim, temperament and responsibilities, I have been more or less reclusive (not seclusive, perhaps exclusive) and it is the benefits of that balance that I reap—richly.

Weighing all these matters on the train home, I felt a solid satisfaction that my work is placed, like a chip in a game of roulette, on the wheel of fortune. That is what I set out to do in 1989 and that is what, with a great deal of generous help, I have done.

Perhaps it was the inevitable drop in spirits after the opening of an exhibition that made me shaky when I drove to Baltimore the week after my return from New York to receive an honorary doctorate from the Maryland Institute of Art and to address the graduating students. I looked at them with particular interest because I am supplementing my reduced income by undertaking a second job and will be teaching at the institute next fall. Art students are at once more and less lively than university students; they certainly feel a wider latitude to express themselves. I liked their imaginative fancy-dress and their vociferation but I felt an unaccustomed gap between their energy and mine—for the first time felt distanced by my age, even by my ideals.

SUMMER

Summer has come. Yesterday I went to the University of Maryland to initiate the process of my legal retirement. I got lost, walked and walked under a hot sun and had to ask for directions over and over again, as the retirement office had recently moved to the very edge of the campus, far away from my customary paths. I felt exiled, almost frightened, as if in being retired I were being put to a kind of death. Heat and disorientation sharply reminded me that I am older than I usually feel.

Arriving at the proper office, I was welcomed with equable kindness. A calm gentleman settled me into a comfortable chair and then patiently led me through a series of legal papers by way of which he delivered me out of the University of Maryland payroll system and into the State of Maryland retirement system, reassuring me at every step. The art of being officially old seems to lie in cooperative submission.

But on the whole this is not a society in which to grow old, or to be without resources. I feel myself a citizen in a heartless country. The United States has just "won" a savage war in the Persian Gulf. Little red-white-and-blue flags flutter all over the nation. Official hypocrisy decrees that we, the populace, rejoice that so few people on "our side" were killed and ignore the thousands we killed ourselves.

The machines with which we killed are being displayed on the Washington Mall, the broad greensward stretching from the Capitol at one end to the Lincoln Memorial at the other; the Vietnam Memorial, deserted neither by day nor by night, lies in between. The grass has been stomped into the ground by a throng of patriotic visitors, baring tan soil embossed by the dried dinosaur-sized tracks left by huge mechanical wheels. The birds usually singing in the trees lining the Mall have gone away.

The sheer competence of the war machines is impressive. A Harrier jet is 46 feet, 4 inches long, 11 feet, 8 inches high and has a wingspan of 30 feet, 4 inches. A handy aircraft, it flies 25mm cannon, Sidewinder and Maverick missiles. The one I looked at closely had barely room for a human occupant. A man's name was printed on the fuselage just below his seat, which was about the size of half a bathtub; next to it, a painting of the ace of spades, and next to that a short phrase in what I take to be Arabic. So the pilot commands from a pit closely covered by a plastic canopy, confronts at knee and hand level a panel of levers and buttons, and flies at 668 miles per hour to deliver as much death as possible as economically as possible. One person, much death. Maximum efficiency.

The people who devise these machines increase the sum total of pain in the world. They increase its potential danger too, confrontation inevitably beckoning confrontation.

Our society is monstrously disjunctive, at once so efficient in war and so inefficient in caring for the welfare of its members. It is frightening to see people rooting in garbage pails on streets, living in cardboard crates under bridges, while their government wages war. Even when there is an emergency in a household, decent parents do not forget to feed the children.

But it is simplistic and sentimental to think of a nation as a family. The culture of a people, like the individual lives of those people, includes all that is evil as well as all that is good. The technology that produced the war machines on the Mall is, ironically, also used in medicine to save lives and to expand human knowledge in a range from personal computers to space exploration.

When I wake up in the middle of the night, I read the works of the Roman orator Cicero. Born in 106 B.C., Cicero lived to see the dissolution of the republic that he had faithfully served. He was a political creature, wily and occasionally unscrupulous, but on balance a genial man. These days, when I wonder if I, too, am watching the dissolution of a political ideal, I think of how interesting it would be to dine with him in his villa at Tusculum in the fertile countryside near Rome.

I have recently been rereading *De Senectute*, his essay on old age.

"Age does not steal upon adults any faster than adulthood steals upon children. . . . I regard nature as the best guide. . . . Since she has planned all the earlier divisions of our life expertly, she is not likely to make a bad playwright's mistake of skimping the last act. And a last act was inevitable. There had to be a time of withering, of readiness to fall, like the ripeness which comes to fruits of the trees and of the earth."

Declaring that old age is inactive is "like saying that the pilot

has nothing to do with sailing a ship because he leaves others to climb the mast and run along the gangways and work the pumps, while he himself sits quietly in the stern holding the rudder. . . . Great deeds are not done by strength or speed or physique: they are the product of thought, and character, and judgment. And far from diminishing, such qualities actually increase with age." Memory weakens in old age only "if you fail to give it exercise, or if you are not particularly intelligent. . . . Besides," Cicero continues, "I never heard of an old man forgetting where he had buried his money!" As for regretting the strength of youth, "I do not miss the powers of youth . . . any more than when I was young, I felt the lack of a bull's strength or an elephant's.

"Age has to be fought against; its faults need vigilant resistance. We must combat them as we should fight a disease—following a fixed regime, taking exercise in moderation, and enough food and drink to strengthen yet not enough to overburden. However, the mind and spirit need even more attention than the body, for old age easily extinguishes them, like lamps when they are not given oil. . . .

"Old people are also complained about as morose, and petulant, and ill tempered, and hard to please. . . . But these are faults of character, not of age."

Cicero's commonsense approach to old age is based on Stoic philosophy: a person is expected to take what the gods give and to make the best of it. Our lives are given to us as responsibilities. It behooves us to be cheerful in order to exert a bracing influence on the general stream of human life.

Having dealt with how to live in old age, Cicero comes to what is perhaps the biggest worry of people who are old: death. "When a man is old there can obviously be no doubt that it is near. Yet if, during his long life, he has failed to grasp that death is of no account,

he is unfortunate indeed. There are two alternatives: either death completely destroys human souls, in which case it is negligible; or it removes the soul to some place of eternal life, in which case its coming is greatly to be desired. There can be no third possibility. If, then, after death I shall either lack happiness or even be positively happy, I have nothing whatever to fear...." Furthermore, an old man "is better off than his juniors, since what they are hoping for he has actually achieved: they want long lives, and he has had one.

"As long as we remain within these bodily frames of ours, we are undergoing a heavy labor imposed on us by fate. For our human selves have come into our bodies from heaven: they have been sent down from their lofty abode and plunged, so to speak, into the earth, which is alien to their divine and eternal nature.... The reason why the immortal gods implanted souls in human beings was to provide the earth with guardians who should reflect their contemplation of the divine order in the orderly discipline of their lives.... What nature gives us is a place to dwell in temporarily, not a place of our own. When I leave life, therefore, I shall feel as if I were leaving a hostel rather than a home.... Even if mistaken in my belief that the soul is immortal, I make the mistake gladly, for the belief makes me happy, and is one which as long as I live I want to maintain."[7]

He lived until 43 B.C. and died by assassination. Active to the very last second, he leaned forward to bare his neck to the sword.

The University of Maryland has appointed me professor emerita, an honor I deeply appreciate. I am grateful to the faculty of the Art Department. I am told that they met "into the evening" to devise a way for me to continue teaching. The result of their deliberation is dual: I return to the university payroll at one-third my former salary (which is generous, considering that professors

emeriti are usually paid by the course at a negligible rate) and I am invited to teach the advanced seminar I have evolved over the years into a discourse as stimulating to me as it seems to be to the students—"for as long as you choose."

I became interested in the art of teaching in 1965, while I was living in Tokyo, when I read Sylvia Ashton-Warner's remarkable book *Spinster*. Her protagonist teaches Maori children in New Zealand to read and write English. She evolves her own method. She starts by asking each child to speak one word, spontaneously; these words are, of course, charged: "mother," "home." She discovers that if she prints this word in bold letters on a card large enough for the child to hold easily, and gives the card to the child to keep, the child begins to connect a specific feeling with the letters and is able to make a natural transition from personal meaning to printed word. She allows the children to pace themselves so their own feelings become their own words. Eventually they develop a more objective vocabulary.

I have found that I too can trust students to find their own ways to process themselves into their work. For my part, I give information as needed, in a form as tailored to the particular person as I can make it. More crucially, I maintain, and manifest, a steadfast faith in each individual's potentiality, provide them with the reinforcement that will give them, I hope, the confidence to translate aspiration into achievement.

My faith in this way of teaching has grown over the years. I find that only honesty serves. I can have no hidden agenda, no inordinate urge to impose my influence. I must be open myself if I am to suggest that students open themselves to themselves. And I must use my highest energies. Teaching can exhaust these energies. I am fortunate to have been fifty-four when I began to work at the university. It worries me to see young artists undertake to

earn their living by teaching; they place themselves in jeopardy of being drained.

And teaching is an anxious business. A teacher has such power to damage, and the damage can be so subtle. It is a moral discipline to keep a watch on invidious motivations. On pride, for example, for just in the nature of the relationship between teacher and pupil, the teacher knows more and can dominate, to the detriment of a student's self-respect. A teacher's cruelty—not too strong a word—can be as unconscious as that inflicted by insensitive parents. I recently read about a mother who gave her daughter, born with congenitally impaired hands, a blouse with many tiny buttons fastening up the back to a high collar.

The finest teaching touches in a student a spring neither teacher nor student could possibly have preconceived. The Latin root of the word "education" is *educere*, to lead forth. Teaching may elicit self-knowledge but unless it also leads students into an ever-broadening view of art and life, self-knowledge results only in self-expression.

It is now the middle of June. The Emmerich exhibition is due to close in two weeks. The likelihood is that every single sculpture will return to me. Despite the university's generousity, I feel devastated. Even the collector who reserved a sculpture before the exhibition opened has reneged: a few days ago he substituted for his commitment a demeaning offer—one-half its price plus $250 per month for the next four or so years; the gallery refused. But it is not the failure to sell that is making me feel so sad. I am used to the way in which sales go by cycles; I have had shows which sold out and those in which nothing was sold. But I have never before had this feeling of rout, of having been driven from the field, outcast.

In some subtle way, I recognize my fate: my claim to fierce independence has resulted in an isolation I acknowledge to be my own responsibility. But every now and then I feel it poignantly. As twilight fell last night, I went out on my front porch to sit in my white wicker chair and watch the fading light.

When I bought my house twenty-two years ago, two trees stood on either side of this porch. To the south, a splendid sugar maple. I could see its branches from my bed and used to lie quietly and absorb with a kind of solid comfort its companionable changes as one season followed another. A thunderous wind tore it asunder one summer afternoon just a few years ago. It fell away from the house into the street, struck dead within seconds, its lovely leaves fluttering in shock. I had it cut up for my fireplace, burned its stump out of the ground in the ancient English way, and planted in the spot thus naturally fertilized a little Norwegian maple. I cherish this slow-growing tree, which I shall never see in its maturity. To the north, a scrawny, awkward, ill-favored, anonymous tree did nothing but lose its leaves and grow them again. Last spring it all of a sudden produced a few random blossoms. This year it bloomed in a blaze of white, and is now making apples.

As the light gradually drained out of the sky, I began to feel a gentle strength within myself, as if nature were compensating for an ebb of light, of hope, by replacing it with quiet fortitude. My eye fell on the young green apples. The astonishing history of their tree ran through my memory and by the time I stood up in the darkness to go into my house, I felt the pull of a slow tide within which all that is personal has a sanctioned, little, place.

But nature can scourge as well as soothe. Emotion is as treacherous as any seas the world can churn, and I have recently been caught in a gyre of my own personality.

The gallery telephoned to say that a collector had made a firm offer for *First*. I have for years intended to give this ancestress of all my sculptures to the Baltimore Museum, where it has been for some time on extended loan, so that it could be added to the nine sculptures that the museum has in its collection. I was born in Baltimore; the centering of my work there is dear to me, and *First* is at its core. But my passionate reluctance to sell it was way out of proportion to any proper evaluation of any object. It was as if all the hopes of my childhood, and of my early maturity as well, were caught and held in the little boards of that sculpture. I was immobilized by my feelings. I remembered how innocently I had made it, how naive I had been. I still had hope for my marriage, my children were young—Samuel was a tiny baby, I still rocked him to sleep. I still believed that all effort was met with commensurate reward.

But reason counsels acquiescence now: my financial situation is uneasy, I should cooperate with the gallery—this would be the only sale from the retrospective. I telephoned New York intending to tell the gallery to go ahead. And then, all my principles wildly fleeing, I heard myself say vehemently that the sculpture meant too much to me to sell unless exchanged for enough money to give me a period of financial surety. I heard myself *bargaining*, and realized with a sick lurch of heart that I could be *bought*.

I have been coming to terms with this bitter fact for some days. I see that just as Shackleton hoped that the white line on the horizon promised a clearing sky, I have been hoping that this exhibition would lift me into security. I see too that I have been entertaining a self-respect invested with pride. And I see that my attachment to my work as a kind of justification for my life is not only inordinate but also the very self-deception that I have sometimes smugly criticized in others.

I am slowly coming to a new, more realistic, equipoise. I have long felt attachment to be burdensome; detachment, liberating. I have tried hard to train myself to a sequence in which I can work all out emotionally, and then see the work "against the sky," in Rilke's words. I have to a degree succeeded, but I now see that an obstinate identification with my work remains intractable to rationalization. Having shot myself all out, I am embedded in my work like a barbed arrow.

The Emmerich exhibition closes today. I feel as if I were folding my wings to land after a long sea flight in crosswinds.

Yesterday I gladly turned my back on Washington and took the highway leading here to Williamsburg, Virginia. I am well and truly landed in the heart of Mary's family, awaiting with them the birth of her baby, due any day.

A subtle, irreducible anxiety seems particularly to haunt artists. I discovered its drag because in 1974 I was surprised to find it assuaged at Yaddo, an estate in Saratoga Springs, New York, to which artists are invited for working visits. There they are provided with comfortable bedrooms, three square meals a day and studios, as well as with the vital companionship of other artists—of sculptors, painters, composers and writers—who form a loose community, undemanding and implicitly sustaining. Virtually all Yaddo's guests feel there a special security that facilitates their work to an astonishing degree. Since my children grew up and moved away, I have not only worked alone but also lived alone. I am accustomed to exercising a more or less conscious ceaseless vigilance and it is an inexpressible comfort to be under a family roof. I am sleeping deeply, and awake refreshed by more than rest.

John is studying law at William and Mary; Mary teaches in the

college, and writes as regularly as she can. They live in a little blueberry-blue clapboard house on a quiet street in this reconstructed Colonial town—a quintessential Baudrillard simulation.

I have the pleasure of occupying half of Rosie's bedroom—eleven-year-old Charlie, Mary's son by her first marriage, has relinquished it for a couch in the children's playroom. No one has made any effort to let Rosie know that she is a female; we have all been surprised by how feminine she is. She stands in her crib and watches me dress with beady eyes; I find myself trying to be what she calls "pretty." She likes soft clothes in soft colors. I am glad to be out of my working jeans and in cotton dresses, covered almost all the time by an apron, as I am helping out. We are sweaty—hot in the fecund July heat under the pine woods which feel haunted, as though the people who lived here before the Colonial settlers arrived from England have never quite departed.

I like the easy mess of family life. Charlie's books and athletic equipment make clutter. Rosie's outgrown turquoise tricycle sprawls overturned in the little fenced-in garden at the back of the house; her new one, violet and white, stands around with its wheels every which way. A collapsed greenish yellow tennis ball, chewed and abandoned by the two dogs, lurks in the underbrush in a clump of golden retriever hair. We adults sit on the lawn in front of the house and talk in the sultry evenings while we idly watch Rosie wheel her doll up and down the pavement.

Yesterday Mary suddenly went into labor while talking on the telephone. Her face lit up, she turned to me, we sprang into action, called John at the law library, and I waved them off to the hospital.

Charlie and I are working on a jigsaw puzzle. We spent the day making sense of it, while Rosie danced around us. Charlie and I

61

are used to waiting for babies to be born; we waited for Rosie together. Neither of us let on that we had any anxiety at all. Charlie may not have had any; his experience of childbirth has been pleasant. Mine has not: I had a ruptured uterus when Alexandra was born—dangerous for both of us; Mary and Samuel were also born by cesarean section, Samuel in a second emergency. Alexandra and Mary have been more fortunate; both have delivered their babies normally, without anesthetic, heroically. For my part, nothing in my experience has equaled the reluctance with which I have had to accept my daughters' pain in childbirth; I shrink from every imagined pang; I cannot spare them a single one. My hands were steady while I fitted the puzzle pieces, and got our lunches and tidied the house, and we all laughed together, but I felt slightly sick all day.

Julia was born in the late afternoon. Charlie tenderly took his new sister close into his arms with the authority of experience, and looked down at her with a thoughtful smile. Rosie clambered up onto her mother's bed, pushing against "*my* baby." All of us chattering with excitement, I drove the two children home from the hospital. We ate some soothing chocolate ice cream and went to sleep, tuckered out all three.

We are getting to know Julia. She is an impressive baby. At nine pounds, five ounces, she entered the world caparisoned in force. She has her father's dark hair and a calm mien, as if her character had fully developed the amplitude of well-assimilated experience. I will not know her at the age of fifty but I can guess what she will look like.

Now that I have five grandchildren, I see a family genetic pattern: Julia "matches" Alastair, Alexandra's younger son; Rosie her older son, Sam.

Charlie is akin to Alastair and Julia, but suffering has marked him. He has a Roman *gravitas*. Illness overtook him during a period of about two years, but in such various disguises that each episode seemed more or less benign until the night before last Thanksgiving when it declared itself as critical. In terrible pain which mystified the doctors at the Williamsburg hospital, he was rushed on their recommendation to a hospital in Richmond. Two weeks later, after many searching tests and consultations, he was diagnosed as having Addison's disease, incurable, life-threatening, but controllable. One of his final intermittent spirals downward toward a mortal Addisonian crisis occurred in my house. I saw on his face the look of mute patience that marks children who are quietly beginning to cast off their moorings, giving way to the slow tide of death. By the time I visited him in the Richmond hospital, this look was fading. But its pentimento remains.

A month later, at Christmas, Mary and I walked arm in arm one evening while a ruddy sunset darkened into twilight. The snowy streets of Williamsburg were lit by festive bonfires surrounded by throngs of celebrating visitors, but we were sober. On Mary's face, rimmed by a lovely fox-fur hat, I saw the unmistakable look of heartbreak. "Nothing will ever be perfectly all right again," she said quietly, factually, seriously, without self-pity. I pressed her arm against my side. All I could do was to keep her company.

Both Mary and Samuel are writers, but it is Mary about whom I worry, as I know very well how children absorb time and energy. If a woman artist has no children, she exempts herself from their demands and has only to underwrite her own goals, so a reasonable variation of the traditional male pattern is available to her. Yet she also deprives herself of what in my experience have been the pungent and proliferating roots that nourish much of the

63

meaning that distills into my work. It seems to me in my maturity that Trismegistus has tested out as being right: we can only wholly develop if experience is as equally inscribed in our bodies as it is grasped by our minds. Terence too: we can understand what it is to be human only to the degree that we are willing to endure all that it is to be human. On balance, I have logically to welcome whatever life brings my children. Samuel will write better in the light of his lonely years, and Mary in the light of her experience as a wife and a mother. Alexandra's widowhood has tempered her character; it is as sweet and sound as a nut.

But yesterday I suddenly began to cry. Everything seemed to be too much: the pain that Mary endured in childbirth but doesn't mention and her steadfast maternal nature; Julia's actuality—it seems incredible that she was inside Mary's body and is now outside, a person; John's affectionate care of his family as he works to support them in every way he can; Charlie's generosity of spirit, his grave acceptance of lifelong illness; finally, Rosie's merry, carefree volatility. I do so wish to make their lives happy, and am so powerless.

I have returned home and for the past week have been methodically moving through my annual medical checkups, deferred this year until I became eligible for Medicare.

The sieve of Medicare has meshes so uneven that only certain conditions are underwritten. Dentistry is not covered at all. No illness is entirely covered. My doctors have worked out individual solutions. Secretaries dispatch my bills—"We do the paperwork for you," they say a little grimly—first to Medicare and then to Maryland Blue Cross–Blue Shield. A charge for the sum neither of these organizations pay will ultimately land on my desk. There is no way to predict what I will finally owe. I am mendicant for the

first time in my life, but so impersonally that I feel no sting. On the contrary, I am touched by the kindness I am shown. The secretaries explain their procedure slowly and patiently, as if age had automatically reduced my competence.

When the forces that shape my life gather themselves together in some mysterious way to generate change, I have the feeling of being borne along toward an implicit, predestined fate. The summer after my graduation from Bryn Mawr was such a period. Part of the pleasure that I took in working in the hospital in Asheville was that I was only a student-aide, had no responsibility beyond what I could do easily. And I remember feeling perfectly certain that I should lie low. In due time, with equal confidence, I made the decision to work in the world rather than in academia, and went on my way. I am in such a quiescent period. But the force of the change that I now feel is taking place is psychological. It is as if the events of the last few months were working in me like yeast in bread that is rising, as if I were becoming a different psychic shape.

The last time I felt the subtle forces of destiny was in the spring of 1989. The influences that would lead me, in January 1990, to change my life by initiating the Emmerich retrospective were building up, but anonymously, in the form of inanition, as if the air I breathed were becoming less and less oxygenated. I became obsessed by a yearning to draw a line in my own person on the earth, due north and then due west across the American continent, ocean to ocean. I panted to run free on that line as I had used to run along the shores of the tidewater rivers near Easton. I longed for limitlessness. I hoped for revelation.

And then fortune presented me with opportunity. I met John

Dolan, a friend of Samuel's, a photographer. When in the course of conversation I mentioned my idea, his eyes lit up. Within seconds, we decided to drive together across Canada. He wanted to photograph. I wanted to see what would happen.

We met only twice before we set out. We took a chance on each other, began as disinterested companions and ended as friends.

We entered Canada at Niagara Falls. The falls did not fulfill the poetic promise of the glorious rainbow-mist cloud that was our first sighting. Perhaps Frederick Church's painting, and countless photographs, robbed it of magic. Nervy—abroad with a stranger after a night of restless sleep in a tacky motel (thin mattress, synthetic nappy blanket)—I resisted its sheer phenomenological magnitude. I tried to cheapen its might to a phrase: an extraordinary amount of water moving extraordinarily fast and dropping extraordinarily far. I heard more than saw, heard a primal roar no throat could have contained, and recognized with a kind of despair a metaphor for life: the promise of beauty overwhelmed by the actuality of brutal force.

By the time we reached the Trans-Canadian Highway, I had realized that although John and I were driving on the same cartographical route, we were really traveling on separate parallel lines of imagination.

We crossed Lake Huron from Tobermory to Manitoulin Island by ferry. Against a gray and stormy sky, I saw a seagull tilting on the wind, riding in place, and in the blade of its white wing, alternating line and plane against the fog, I recognized the precise, alive equivalent of an image I have for years been drawing in my work. I began to take notice of what was happening in a new way. While canoeing on the Michipicoten River, I caught the

scent of a wild rose. John paddled over to the bush overflowing the riverbank. I touched one blossom, delicately, and felt a delicate responsive quiver. On the highway, a rock dislodged from a truck passing us in the opposite direction at seventy-five miles an hour and struck our windshield. Fortunately, it hit my side of the car, leaving a shattered star about eight inches in diameter. I felt the rock's impact in the center of my breast. My first thought was that we had been shot at. I was not even certain for a second that I had not been killed, and started to adapt to death. These three encounters—with the wing of the seagull, the rose and the rock—made me realize that a line of meaning was intermittently intersecting the line of our trajectory. I felt excited: I was being reminded of a reality lying behind and beyond appearance. For in the wing of the seagull I saw an actualization of a vision I had thought my own, in the rose a beauty entirely alive, sufficient to itself, and in the rock the relentless immanence of death.

In Carberry, Manitoba, a few buildings as unadorned as children's blocks straggled along a single railway track stretching into invisibility east and west on the measureless flat land. I understood for the first time that limitlessness might be a threat, that it might induce the reverse of claustrophobia, a desire for enclosure, for protection from the naked eye of sky. The uniformity of that small town might constitute a kind of comfort, rather as the conservative formality with which I was brought up is a comfort to which I can return when independence has led me in harm's way. Psychology may demand that a tendency toward the freedom of limitlessness be pragmatically balanced by defined limits. Even so, Carberry was astonishingly meager. The supper I ate alone at a linoleum-covered table in a tar paper building—by that time John and I separated when we stopped, he to photograph, I to rest—was entirely boiled.

I was glad to move on to the broad empty Saskatchewan prairie, circumscribed by a horizon without circumflex. In great shallow pools, the waters under the land had risen to reflect the cerulean sky in blues so deep and pure that they seemed in themselves to guarantee the union of heaven and earth. Among these pools, patches of mustard-yellow flowers held their ground, islands in a sea of sinuous graceful grasses lifted and tossed, flattened, twisted and smoothed by a rushing wayward unceasing wind.

In Alberta, we turned south off the highway and meandered for a whole day on narrow dirt roads interconnecting the few inhabitants of wheat and grazing land. Their houses and barns were often painted bright red—heartening against the winter snow, and even in the brilliant sunshine of a summer day declaring the intention of indomitability. It would take a store of courage to live on land that so emphatically does not need a human hand. Deserted homesteads, abandoned to sky and wind, were skeletons of failure. Hour after hour, day after day, the men and women who live there must wrestle with the fact that even their best effort can ultimately have only the most fleeting effect on the remorseless roll of these spaces. They may have fallen in love with the prairie, as sailors fall in love with the sea.

We stopped to listen to the wind, a hypnotic sweet sound borne on the sway of the grasses, musical strings infinitely resonant.

"Would we," I asked John as we stood knee-deep, listening, our hair lifting into the cool blue air, "have been moved to art if we had been born on this prairie?"

He tilted his head. "That's a question."

Harold Kalke, a friend of mine with whom we stayed in Vancouver, is native to the prairie. He was born in Success, Saskatchewan, almost due west of Regina, within eighty-five miles of the Alberta bor-

der. His father emigrated from Danzig to Success in 1929, seventeen years after the village was laid out under the auspices of the Canadian Pacific Railway as part of its arrangements to accommodate the extension of the rail line west from Swift Current, Saskatchewan, to Empress, Alberta. His mother also came to Canada in 1929 from the area around Danzig. Married in 1931, his parents had nine children of whom Harold is the sixth. In 1945 the family moved further west, to Millet, Alberta, where they settled on a farm: two quarters of land (three hundred and twenty acres) with a house on it. The Saskatchewan government provided three free Canadian Pacific railway cars for the move: for livestock, machinery and household goods respectively.

Even now Harold's face twists when he speaks of the backbreaking, unremitting drudgery that the Alberta farm demanded of the family. Except in winter, when the children walked a couple of miles to school, the boys worked alongside their father in the fields from the dark before dawn into the dark of night. The prairie sod, almost two feet deep, topped by a thick mat of the grasses John and I listened to, was broken by a single-bladed plow drawn by oxen or by a team of four or more horses. Broken and rebroken, then disced; finally, seeded, tended and harvested.

Inside the house, the work was as unremitting. When his mother had another baby, she put layers of newspaper on the kitchen table, climbed up, delivered the baby herself, climbed down and got the next meal for her husband and children. She is illiterate. Harold offered to teach her to read, but she refused. When she shops she identifies food by recognizing the shapes of containers and colors of labels. Harold and I agree that we like to think of the world she lives in as a world in which words are sounds directly consonated with meaning. And all her meanings are her own, refer to nothing beyond her own experience.

Both Harold's parents are alive. Forced by law to accept the pension that Canada gives its older citizens, they do not use it but give it away. They have a garden, eat their own food.

Harold left the farm when he was about fourteen, educated himself and made his way in the world. He remains in close touch with all his family, who are bound together by the profound loyalty resulting from relentless mutual labor as well as by deep affection. Harold himself, only in his early fifties, constitutes a direct link to the life of the countless pioneers who settled the North American continent. The people to whom we owe the bountiful inheritance they earned for us with their own hands, at their own cost.

The history of the people who lived on this continent before the European settlers is virtually invisible. We encountered it only in anonymous totem-marks on Agawa Rock, on the Canadian shore of Lake Superior—Hiawatha's Gitche Gumee.

In Hiawatha's legendary time, it was to this rock that people came in quest of spiritual transformation. After ritual purification, each one, alone, approached the rock by canoe, and entered it on foot through a narrow fissure in its steep massive wall. In some ancient geological event, a huge granite boulder (still there) had got lodged way up high in this cleft. Here the seekers, tradition tells us, paused to pray to the spirits for permission to enter. Naked save for a wampum belt and a necklace of animal totem-claws, bearing a small ceremonial leather bag, they ascended the fissure and threaded their way to a particular place on the ledge skirting the cliff above the lake. There they sat down, faced west into the waters and remained, motionless, for three days and three nights.

At dawn on the fourth day, they rose and took out of the

leather bag two little pots: in one, animal fat, in the other blood-red powdered rock. Then, slowly and reverently, they drew on the cliff face their personal totems, the animal for whom each had been named at birth, whose spirits they had been summoning to their aid in their ordeal. Through these spirits they had drawn into themselves the power of nature, had replaced their human sorrow and fear with godlike calm and joy.

I had not been ceremonially purified when I came to Agawa Rock but, stumbling down a steep path of immense boulders, I had to humble myself, to accept John's helping hand. And so I reached the ritual place, a ledge just wide enough to sit on securely, when I braced my feet against a narrow parallel rim below which the rock dropped ten or so feet straight down to the great lake. My back was flat-tight against the sheer rock face that rose behind my head way up high against the sky, at a tilt toward the waters as if leaning over them in protection. I sat, listened to sweep of wind and lap of water, and I thought, "I'll just stay *here* for the rest of my life."

Roberta Smith has written a review of the Emmerich exhibition for the *New York Times*.

Her first sentence is "Ann [sic] Truitt's sculpture has always seemed to be an instance of Minimalist Lite." The word "Lite" implies that the work lacks weight, meaning, need not be taken seriously. It also relates the work to diet foods, slyly linking it to the demeaning tradition of women trimming themselves to meet male standards of sexual desirability.

The attribution of motive is the most invidious device of interpretation. Smith states that Truitt "disdains industrial materials." A finicky lady "disdains." She goes on to mark my "preference for the simple wood and paint of American house-builders and furniture-

makers," and calls me "a kind of homespun perfectionist," words that evoke in my imagination a woman in calico toiling at a spinning wheel in a humble country kitchen.

Smith is right that my methods are simple. The sculptures are simple fabrications. They declare neither technical prowess nor the implied heroism of the artists who for their own good reasons have brought the materials and methods of industry into the service of art. Clement Greenberg noted in 1968 that my sculpture edged on "the look of non-art."

I use wood for a number of reasons. A tree grows slowly; my temperament is slow-growing. I feel akin to wood, which absorbs paint as I have found that I absorb experience, in layers that become intrinsic. And wood lends itself to planes. A severe planar armature throws emphasis on color, sets it free into three dimensions so that a whole sculpture refracts the light to which human beings owe their lives.

I appreciate the fact that Roberta Smith gave my work her attention, but I deplore the conventionality with which she subtly and not so subtly stresses that she is appraising the work of a woman.

The achievement of women tends to be judged *in comparison to* the achievement of men. Historically, the majority of art critics have been male, and the majority of artists who have attracted their attention have also been male. These facts flavor the canons of art criticism. This situation is changing, but as matters stand now, the achievement of women in art tends to be undercut. As if women were like Samuel Johnson's dog, who was not astonishing so much because he danced well on his hind legs as because he danced at all. If women protest this context, they implicitly affirm its hegemony.

Women artists incur some psychic damage hard to enunciate.

72

The closest I can come to it myself is that I have a demoralizing feeling that from the world's point of view I am defeated before I start. What I have made has rarely been taken as seriously as I took it when I made it because when I made it I was making it in the context of my own purpose, and the seriousness and range of that purpose has tended to be discounted.

And my womanhood is intrinsic to my work, as a male artist's manhood is intrinsic to his. The difference between men and women is inalienable. It is not a political fact, subject to cultural definition and redefinition, but a physical verity. We do truthfully experience our lives differently because our bodies are different. It is in what we do with our experience that we are the same. We feel, absorb and examine with the same intensity, and intense experience honestly examined informs the art of both sexes equally. Michelangelo's slaves could be writhing in childbirth. Piero della Francesca's Adam and Eve in *The Legend of the True Cross* are both old, Eve's hanging breasts no less expressive of her long, useful life than Adam's stringy, worn-out muscles. True experience is inscribed on female and male body and mind and spirit alike. The power of imagination illuminates all human lives in common.

AUTUMN

The biblical phrase "That which I most feared is come upon me" implies that fate is a form of will: by fearing something, we attract it. I have long wondered about this idea, with a superstitious misgiving in itself fearsome, so that when this thought has occurred to me I have metaphorically crossed my fingers to forfend even its fleeting passage through my mind. Actually, I have been more impressed by how unpredictable my fate has been. But I have also noticed that I have received virtually all that I have really and truly desired. I have learned to be careful about wishing, for fulfilled wishes occasionally have been attended by results I neither foresaw nor welcomed. Logically, if desire tends to attract events, fear may be equally effective.

I feel frightened now: headaches have been plaguing me since last July. My mother died of a brain tumor. Ever since, I have feared that I would too.

The other day I visited a friend of almost fifty years who is recovering from just such a neurological operation as I dread. She lay in her high, narrow hospital bed as innocent as the day she was born, shorn of memory save for shutter flashes of clarity. Her gray hair was shaved as my mother's had been for her brain tumor operation; a scar, skin clamped to skin, curved in a scimitar on her skull as it had on my mother's. My own skin crawled.

Whenever the clouds in her mind parted, we spoke: of our meeting at Bryn Mawr, of her first husband (I am, perhaps, her only friend who vividly remembers him), of our children. Most poignantly of her second husband's recent death, for she had forgotten that he was dead and when I mentioned him she was swept by a wave of grief fresh with shock. She wanted to know what his funeral had been like, had their children been there? I described, she listened, but my words fell like drops of rain into the lake of her forgetfulness.

"I do not know who I am," she said.

"You are you," I said.

"It doesn't seem fair," she went on, in halting phrases. "We got bigger, we grew up, and just when we grew up we began to go down like this," glancing down the length of her inert body.

"We are children," I said and awkwardly began to quote "Suffer little children to come unto me" but stammered over the word "suffer." Too apt.

She yawned wide. "Let's rest here for a while," she said, and smiled sweetly. "You rest too. That will be good."

I leaned back in the chair beside her bed and closed my eyes. Behind them, I saw her as she used to rush about her life, and remembered how incompatible our temperaments had been. The conflict between her practical mind and my abstract mind—the blade between us that made our friendship competitive, ambivalent.

Suddenly awakening, she said, "What do we know?"

"Really—nothing," I said plainly. Instinctively we clasped hands and looked into each other's eyes with what remains to us, deep affection.

I stumbled out of the hospital into fading light. Just here at the entrance, she and I had come to bring our children into the world and had left with them in our arms. When I reached the parking building, I could not find my car. Level two I remembered, but I had confused belowground with aboveground; I blundered up ramps and down ramps until rescued by a woman in a car who offered me a lift and elucidated my mistake. It was as if I did not wish to be different from my friend, unconsciously chose to be as confused as she in order to align myself with her.

And when I got home I saw in one eye the scarlet blotch of a broken blood vessel.

The illness of old companions darkens aging. My lifelong friend, Helena, is laid low by rheumatoid arthritis, her once-lithe lovely body twisted by its cat-and-mouse cruelty.

Our mothers were friends before us. We were both born in Baltimore, in the Hospital for the Women of Maryland, she in December 1918, I in March 1921. Her mother, who I called Juie in a baby version of Julia, picked me to be Helena's special friend. Partly, I have always thought, because my name is Anne. For while Juie was in the hospital bringing Helena into the world, her older daughter, Anne, died. Almost two, she had clambered up to a medicine cabinet, come upon some chocolate-covered pills, and eaten them. Her father had buried her by the time Juie returned home to Easton.

This tragedy shadowed Helena's life, and mine too. We used to look together at Anne's photograph. Transfixed in a small oval sil-

ver frame, she looked back at us: a vivid child, with merry dark eyes and tumbling dark curls—we both had blue eyes and straight yellow hair. Juie had a yearning way of picking up this picture, gazing at it with tears in her eyes, and then gently putting it back on the glass top of her dressing table among other objects in what was for us her mysterious grown-up life. When she did this, we used to push ourselves up against her, crowd her soft, rose-smelling body, surround her with ourselves. There's nothing we can do, Helena's face said to me, and mine agreed. We had never heard the sound of Anne's step at Avonlea, their country house on the Tred Avon River, but she left behind her an echo we never spoke of and never entirely forgot.

Avonlea was a realm. When we turned off the main corduroy road (logs with dirt over them) from Easton, Helena and I used to bounce up and down on the front seat of Juie's handsome dark blue Nash touring car with yellow-spoked wheels. A narrow pine-needled lane wound through woods to the square pillars banked by lilac bushes that guarded the oyster-shelled way curving to the gray-shingled house beside the river. A windmill, alike gray-shingled, stood immediately to the right of this gate. Its great white paddles clack-clacked way up high against the sky, pulling up the water we drank, and telling of the wind we cared about— if it were too windy, Juie would not let us swim. For all that we adored galloping around the wild grounds, swinging straddled on a low limb of the sprawling black walnut tree, and twisting ourselves into pretzels on the trapeze, it was swimming that was our greatest delight. We were allowed to take the canoe out to the raft anchored in the river. Juie stayed on the bank and watched us in case we got into trouble but we knew we wouldn't. Arrived at the raft in our dark blue scratchy woolen Jantzen swimsuits, our first act was to clear the water around it of sea nettles. One

pointed at them, the other dipped them out with a net and dumped them heartlessly on the canvas-covered raft, where their iridescence dried to splotches and evaporated. Then into the cool blue-green water: Helena dived, I jumped. When Juie called that it was time to rest, we sat and dangled our legs in the river and talked. I don't remember what about as much as the susurration of our young voices in the warm air.

There was talk all around us at Avonlea, talk about everything under the sun. In my house "little pitchers" had "big ears"; grown-ups were hierarchical glyphs. Juie made no such distinction. Talking was such a pleasure to her that she not only included us in her conversations with her ever-so-chatty friends and ever-so-emotional cousins (she was born a Goldsborough and the prolific Goldsboroughs blanketed the peninsular Eastern Shore), but also flatteringly asked us our opinions of what was being said. And later discussed with us the people who had said it. Helena's round face would grow serious inside the rim of the perfectly straight "Dutch bobs" in which our yellow hair was cut. Her China-blue (Goldsborough) eyes would focus on the middle distance, and she would make pronouncements that, young as she was, I thought wonderfully wise.

I still think they often in fact were. For Helena was born prudent. I counted on her prudence. On her circumspection too, which in our adventures tempered my native rashness. Above all on her discretion, to which her behavior has always been keyed. Her trustworthiness has been constant in all the long years of our lives, now coming to an end in a mutual fidelity too deep for words.

I have been so scared by my headaches that I have resisted investigation. Yesterday I turned to face what I have been fleeing. I went to see a neurologist to find out whether I have a brain tumor.

A hot bath and a fresh, crisp favorite cotton dress in no way improved my prospects but comforted me and made me feel that I had done my best. The view from the doctor's office, seventeen floors up in the air, lent perspective: I gazed out on an Impressionistic landscape, autumn trees dotted with brilliant colors.

After his examination, the neurologist said that even though I had no clinical symptoms of a brain tumor, he advised three diagnostic tests. Merciful and swift, he ordered them done immediately, that very day. Anxious as I was, I found the tests interesting. In the first, a procedure to check the condition of the carotid arteries on either side of my neck, I heard the surge of my own blood. In the second, an electroencephalogram recording my brain waves, I saw behind my closed eyes kaleidoscopic patterns of hard bright colors that seemed to me surprisingly artificial considering the fact that they originated in my own nervous system. In the third, a magnetic resonance imaging of my head, I lay down on a tray and my whole prone body was pushed into a tight cream-colored plastic tube where I remained for almost an hour, perfectly straight without moving a muscle even in my feet, while bombarded by an intermittent noise like a jackhammer.

All that was demanded of me throughout the long day was that I make myself passive, submit to strangers. By the time I got to the final test I was blessing the fact that I never suffered any physical abuse; instead I felt myself taken back to the safety of babyhood, to all the kind hands I have felt on my body in my lifetime. If I do indeed have a dire illness, this history will cradle me.

I drove home slowly, redelivered into normal life. I thought of my children and wished that there were some honest way I could spare them the hours of anxiety before I heard the results of the tests. I decided that there was no need to worry Samuel, who, far away in San Francisco, did not know my schedule. Home, I sat

down in my familiar white rocking chair and prayed a quiet prayer of thankfulness for having been granted the grace to submit myself to what fate had decreed, and wordlessly tried to place myself in a state of mind for further submission to whatever lies in the future. Then made brief, straightforward, hopeful calls to Alexandra and Mary.

A hot bath and a shampoo were heavenly. I put on a clean and pretty nightgown and ate supper in bed: pea soup and two toasted oat bran muffins with peanut butter on them and a glass of milk. Reread parts of James Herriot's memoirs of his life as a veterinarian in Yorkshire and turned into sleep with as much trusting faith as I could summon.

The neurologist asked me to telephone him at ten o'clock the day after the examinations, today, the day I teach at the university. At five minutes to ten, I stopped my seminar, went to my office, sat up straight in my chair and telephoned. All three tests were negative. "Now that you know there is nothing organically wrong with you," the doctor said confidently, "you will know what to do."

A hot wave of relief flooded my body. Borne on its impetus, I returned to my seminar. But when I began to pick up the threads of our discourse, I found myself trembling. I dismissed the students and drove home very slowly and carefully.

I will just let myself be today, bask in relief. A little ironing, a little sewing—a grateful return to my cave.

The Emmerich exhibition may have attracted more attention than was apparent. The magazine *Art in America* is putting a photograph of *Autumn Dryad* on the cover of its forthcoming October issue, and Brooks Adams, the art critic, is writing an accompanying article.

He telephoned the gallery to ask how many colors I had put on *Avonlea*, a 1991 sculpture. I understand why he asks. The colors on this column are hard to discriminate: three pale yellows varying only slightly in hue and equally slightly in value. I feel hopeful. Brooks Adams must be looking carefully.

Lee Haven is a country house not far from Easton, and while I was over there recently I drove out to look at it. I saw an ordinary Eastern Shore dwelling in a pleasant pine wood. Perhaps that is what my parents saw when they rented it for the summer that I was five, my twin sisters three. But it is personal memory that knits a life together, a dropped stitch skews its pattern.

I took against Lee Haven at first sight: a large very dark umber-brown shingled house set back deep under impending trees, high on a bank above a river cove but so thicketed by woods that it had no view.

Unaccustomed to the country, my sisters and I were eager to explore. A steep path slanted to the water. We scrambled down through tangled milkweed bushes. The shore of the creek was cattailed marsh, bordered under closely overhanging pine branches by a narrow strip of slimy grayish mud on which snakes slithered, sluggishly.

My parents must have decided that it was no place for children to play. We were urged to a vacant tenant house on the property. Small, clapboard painted cream color years ago; eerie tiny empty rooms with loops of peeling wallpaper, splintering windowsills. Obediently, we played in it. We took our dolls there and fed them meals of grass and berries and made up stories for them until one day on our way over we saw a large rough-haired black animal we thought was a wolf lurking in the woods. Linking hands, we dashed back to the main house. Possibly "a mad dog." A policeman

came out from Easton. He killed it with a heavy pistol we saw hanging in his hand as we were herded into the house; we heard the shots; he buried it. We wondered where the grave was but tacitly never went to look for it and stopped going to the tenant house too.

Much was tacit in our childhood. We were rarely asked how we felt, so we kept quiet. Things happened and we just never mentioned them again, even among ourselves—especially among ourselves. "Least said, soonest mended," the grown-ups claimed briskly. When I was bitten by a snake while picking blackberries in some bushes, little was made of it, nothing said the next day. We children made what adjustment we could to fear. We somehow picked up the idea that sadness too was inadmissible. Even now we characteristically try to conceal our fear and sadness: the pattern has persisted, depriving us of some of the dear companionship of sisterhood. Cicero's Stoic point of view is too hard on children; as passed on by our parents, we took in the model without the philosophical context that renders it enlightening. We thought it meant that we should endure whatever happened, silently.

One other image from that summer stays in my mind: my mother rowing all by herself into the place where the creek widened out into the river. She looked so lonely out there.

The Norwegian government has sent out three authentic reproductions of Viking ships, emissaries of their seafaring past. They are anchored in Georgetown, and yesterday I went down to look at them, down to the edge of the Potomac River where Smoot's Sand and Gravel used to provide me with grog for my clay and cement sculptures in the 1950s, and where my 1960s sculptures were fabricated in Galliher's Lumber Yard. These blunt businesses have been obliterated in favor of an elaborate public playground,

Harbor Place; decorative flags on tall poles imitate the motley banners of a country fair.

The Viking ships were imitations too, of course, but I had hoped that they would lift my heart in memory of the sheer daring with which the Vikings took to the sea with nothing between them and death but thin wooden boards and their own skill in wind and wave. Slender curved prows rose gracefully above the still river waters; carved, they gave evidence of the inherent human impulse to make utilitarian objects beautiful. But, like Williamsburg, which, however conscientiously reconstructed, remains bland—Colonial life cleaned up, tidied, disinfected—these reproductions were disappointing. History may best be left to mythic narration, to bardic poetry, and the traces of ancient places have their own tale to tell. After all, the originals of these tame Viking ships bore in their graceful bodies men who were marauders, as ruthless as they were brave.

And I myself, I remembered, was ruthless in my search for materials to put to my own purposes. I too took and used. The gravel at Smoot's was the crushed rock of mountains, the lumber at Galliher's cut from once-leafy trees.

I was overjoyed the other afternoon to see an agitated blur against the light shining through the glass panel on my front door and to recognize my daughters' chattering voices. I ran into their arms, Julia's little person rounding out the circle of our hug. Alexandra was spending the weekend with Mary and John in Annapolis, and the two sisters, bearing Julia, who is nursing, had come over to the National Gallery of Art; they had decided to stop off on the spur of the moment. I made tea and round cucumber sandwiches. The sunny living room rang with happy conversation. Once again a baby napped on the sofa, rump in air.

When they left, they took liveliness with them. I missed them sadly even as I waved them off in their car, but it was a relief, as always, to talk things over with them, to hear what they are doing and to tell what I am doing.

I am making certain changes in my life to relieve the stress that is making my head ache. While I was preparing for the Emmerich retrospective, and while it was going on, strain was inevitable, even healthy: I had to make a number of decisions and make them very carefully to do the best I could to make it successful. Now it is over. I find that hard to realize. It's as if I had just finished running a marathon and my legs were still twitching. But the neurologist who said that I would know what to do was right. I do not need to keep so tight a hold on the course of events. I am delegating more to Misha Ringland, a boyhood friend of Samuel's, an artist himself, who has for some years been helping me in the studio. He is undertaking a computerized inventory of all my work, as well as making the tedious arrangements for its transportation and storage. I often consult with him too, make decisions with him instead of alone.

I am also resting more. I take long walks and dig in my garden during these brilliantly clear fall days, planning ahead for next spring. And I am working with a physical therapist to ease my taut body.

I have long been interested in Wilhelm Reich's theory that psychological traumas imprint themselves on the body in the form of muscular tensions that if unrelieved harden into what he calls "armor," habitual patterns which then operate more or less autonomously to bind the whole person. Reich devised a kinesthetic methodology by way of which these constrictions might be released, with the result that the original traumas could be consciously examined. His therapeutic ideas were excoriated, partly because his claims to cure were extravagantly expressed in

87

terms that tended to be nonscientific, partly because he attached these claims to the apparatus of an elaborate theory of sexuality—roughly the idea that psychological health depends on orgasm—and partly because his therapeutic emphasis was on the body instead of on the psyche, a turnabout that was unfashionable at mid-twentieth century. The medical profession declared him a crank. He died in prison, legally condemned for malpractice.

Reich's idea that a body is a historical record is validated for me by my experience in life drawing. The lives of the models are inscribed in the lines and folds of their flesh. These histories are individual, but the models also evoke the universal: as soon as they are naked, they acquire the dignity of humanness incarnate.

A life ingrains a body by way of habit as well as trauma. Years of climbing ladders and holding brushes just lightly, just firmly enough to overlay delicate layers of paint have made in me kinesthetic patterns now as natural as breathing. This is surely one of the pleasures of work in general. Familiarity with certain stances, movements and gestures yields finally such perfect ease that, paradoxically, the body is forgotten: knowledge and experience become autonomous.

The October issue of *Art in America* has been published. Even though I have known that it was coming, and have looked forward with pleasure to this substantive symbol of success, I feel startled to see *Autumn Dryad* on the cover, juxtaposed with my name. There it is, visible in the world at large. Misha Ringland, who has just returned from Europe, tells me that he saw a number of issues, four deep, at the Louisiana Museum in Denmark—*Autumn Dryad* after *Autumn Dryad* in a long line. I feel the warmth of fortune's smile in my very bones.

Brooks Adams has written a graceful and appreciative article. I

feel pleased by its personalness—he makes connections between my life and my work in quotations from my second book, *Turn*—even though I generally feel uncomfortable with any personalizing of art criticism, and doubly uncomfortable because it is particularly common, and subtly condescending, in criticism addressed to the art of women.

Adams examines the work with gratifying care. Perhaps he sticks to his eye a bit too closely—I miss the critical attention to historical context that I am used to—but it is a relief to be tagged neither as a Minimalist nor a member of the Washington Color School. And his eye is penetrating: in discussing *Nicea*, he notes that the "delicate 'neck' of tiny red brush strokes suggests a bloody incision. . . . This painted line raises the emotional tenor of the piece to a hairsplittingly fragile and, one is tempted to say, almost hysterical pitch. . . ." I wish that he had not given in to temptation. The word "hysterical" evokes the hysteria to which women are supposedly prone, honest passion disallowed.

Apropos my books, Adams remarks that "Truitt can write her own history." This is true only in the personal sense, and my motivation is not as personal as it may appear. Life is a lonely business. My impulse is to hold out my hand to readers. By recording my life as clearly as I can (while retaining my reticences) I offer them my companionship, a kind of friendship.

On balance, my feeling is that Adams has taken me on my own terms, allowed me and my work our own context.

I was recently asked to join members of the Art History Department at the University of Maryland for a Ph.D. comprehensive oral examination. The candidate's field is wide and includes "20th century painting and sculpture . . . 19th century French painting and sculpture. . . ."

Art historians trace the development of art in an orderly fashion linked sequentially in the context of time. Artists tend to pick up what catches their attention with antennae comparable to radar. The whole field of art is their native heath, and I tackled the matter of examination questions with real zest.

I picked out six slides, and asked the candidate to compare three paired works of art:

- The nineteenth-century French painter Théodore Géricault's *The Raft of the Medusa,* a tragic, grand depiction of the survivors of a harrowing shipwreck; and the twentieth-century American painter Roy Lichtenstein's canvas of a comic-strip woman sinking into stripy waves who thinks in a balloon over her head, "I'd rather drown than ask Brad for help."

- Two twentieth-century sculptures: Marcel Duchamp's *With Hidden Noise,* an ordinary ball of hemp twine elegantly encased in a bronze open-sided box and containing a secret object that clinks when the piece is shaken; and Joseph Beuys's *Bathtub,* the actual tub—iron, with spider legs and a spigot to let the water out—in which the artist had been bathed as a baby.

- Two works of art dealing with landscape: a nineteenth-century poetic painting by the Frenchman Camille Corot; and an equally poetic "earth work," stones deployed on the ground, by the contemporary English artist Richard Long.

Although we sat, five professors and the candidate, under fluorescent lights in a bleak seminar room, our discussion was con-

ducted with medieval courtesy—we could have been at the University of Paris in the time of François Villon. Jokes about academic life are rife, but knowledge is its heart and it was a pleasure to catch its beat.

It is now the middle of October. The Emmerich exhibition is emerging as the incentive in my career that I had hoped it would be. Four new shows are in the planning stage. I look back on the evening last summer when I sat on my front porch in the twilight, and feel akin to the little apple tree, now fertile with round red fruit.

One of these exhibitions is a small retrospective scheduled to coincide with the fiftieth reunion of my class at Bryn Mawr next spring. I have just returned from a visit to make arrangements. I looked up in *Turn* what I wrote the last time I was there, in November 1983.

> It is a brilliant autumn day. I walk around the campus accompanied by the ghost of myself as I was when a student here. But it is I who feel ghost-like in contrast with this young self who has risen out of my memory intact, as sturdy as a peat-bog pony, glossy of pelt and sure of hoof. Her sentences are declarative. Her hopes are her expectations. She walks beside me politely, as if in tacit, slightly deferential acknowledgment that it is I who have met her demands with effort.[8]

In the eight years intervening between that visit and this, my view of the "peat-bog pony" has changed. It is as if a sketch had developed into a painting, intuition into understanding, affection into love. I no longer exclude the part of the glossy pony that hurt. For it was while I was studying in college that I struggled

with pain and fear that I dared not admit, especially to myself, in my determination to replace the insecurity that colored much that my family had afforded me with a security soundly based on my own efforts.

It was there, too, that during my junior year I absorbed my mother's death, in October 1941.

My father met my train in Asheville the previous June. I returned home in a daze of pleasure. I had spent my spring vacation with Aunt Nancy, Mother's sister, who had married a Virginian and settled in Albemarle County, near Charlottesville, on a little mountain overlooking the Blue Ridge. There, within the ring of daffodils lining the boxwood that widely encircled her lovely pale gray house, I met at dinner one moonlit night a man so fascinating that I felt for the first time the strange pull of romantic energy. Peter had just returned from Europe where he had fought with the French army, had been decorated for valor by both France and Poland. He spoke with authority, he drove a low-slung foreign car, he was writing a book; he was as handsome as he was experienced. Spring in Virginia is dulcet. Seated beside him (dinner had been formal, I wore a beautiful long silk skirt, narrow stripes of Gypsy colors, brilliant), I was borne in his splendid chariot through winding country roads to the house that he had rented. He lit candles, opened champagne, showed me his manuscript, made gentle love. I fell instantly under his spell and might have succumbed to him forever had it not been that he was writing his book on foolscap in a sloping wide-looped hand; some cool voice in me told me that he could not be serious if he worked with as much elegance as he lived. On this same foolscap, he wrote me long impassioned letters. One awaited me in Asheville: he asked me to marry him, he enclosed a little trinket ring—token of glories to come.

But by the time I read his letter, my world had changed. As I descended from the train and caught Father's eye, I saw that something was badly wrong. Mother was in the hospital. The doctors thought that she had a brain tumor. I was to accompany him immediately to their conference—she might have to be driven to Duke Hospital in Durham that very night for an emergency operation. Father was stricken. It was decided at the conference that he would stay with my sisters, I would drive with one of the doctors, following the ambulance. I never even changed my clothes. The doctor had a convertible; we drove, fast, through the night, we even sang against the tide of anxiety, the wind poured through my hair. When we arrived in Durham, I was given Mother's wedding ring to hold and she was immediately wheeled into the operating room as dawn lightened the eastern sky. I waited, alone, her ring in my pocket. The neurologist explained to me that he had taken out all the cancer that he could, that she would live for another three or four months, that the tumor would continue to grow but would do so without causing her to suffer because he had cut a hole in her skull through which it could protrude. I put her ring back on her unconscious finger.

And I returned Peter's symbolic ring to him. We never met again. His book was published, hailed as distinguished; it had not mattered what he wrote it on—my first lesson in respect for the ways of artists. His intuition that he must be urgent about life was correct: he was killed in 1945 while fighting in IndoChina. His father, whose house in Georgetown James and I bought many years later, memorialized him in a tablet carved into the stone wall of the Bethlehem Chapel of the National Cathedral, a few blocks from my house. When I walk up there I often go and look at it, and remember.

Mother lived four more months almost to the day. We buried her

in a grassy graveyard in Fletcher, North Carolina, overlooking the Great Smoky Mountains. I returned to Bryn Mawr, found there a true alma mater, comfort in my grief, and began to develop a pattern I have followed ever since: the turn of pain into hard work.

I still sometimes need comfort. I found it the other day in the cloister of the M. Carey Thomas Library, in the architectural heart of Bryn Mawr. I stood in that green enclosure, where I used to go when hard-pressed as a student, and felt the presence of my mother more vividly than I have for years. Tears rose to my eyes, out of a body almost twenty years older than hers when she died, a body well-worn and inscribed, flesh and bone, with my life. I felt myself take a place in a line of continuity, my mother to her great-grandchildren, and recognized the poignant effort by way of which each generation earns the birthright of the next.

My headaches continue. It is lunchtime. Usually I know what I want to eat and feel greedy for it. I poke into the shelves of the refrigerator. Nothing looks tempting. My head seems to be filled with fine wires intertwining in a writhing mass as alive as a swarm of angry bees. I go into the studio, my own cloister, as I always do when I am unhappy and sit on the blue-and-white Japanese yukata-material pillow on my one chair. I hold my eyes open even though the light burns them.

The studio is ready for two art dealers who are due to arrive in a few days. Sculptures stand. Twenty-odd paintings loom in two stacks flanked by framed works on paper and boxes marked unspecifically—"Working Drawings—1963," for example.

The center of the studio is clear. My gaze meanders around the floor among the multicolored spots of paint recording twenty years of work. The center of my head, it occurs to me, is what I have been avoiding. I force my attention as if assaulting the fortifi-

cations of a keep, my eyes fixed on the center of the studio. Quite suddenly and perfectly clearly, I "see" an old woman sitting in the circle of a gray stone turret. A woman old beyond any concept I have had of old, a crone heavy with years. She is not dismayed to be discovered. Her eyes are blue like mine but diamond-pure and lit from within, ageless in her crinkled face. We look at each other. "She must have been waiting for me. She will teach me," I think, and find myself smiling. She is smiling too. I feel her patience. She has been "keeping time" for me.

When I stand up, I am stiff. My neck creaks as I turn my head. I glance around and see the rows and rows of glass jars containing the remainders of the paint that I have used over the years, and the empty shining jars ready for more colors. I think of the peanut butter and the applesauce that these jars originally held, of how the life I live in my house has been factored into the life I live in my studio. And suddenly I see how the two have gotten out of balance: I have been *draining* myself instead of *using* myself.

I step out into the sunny garden. Autumn leaves are crisp under my feet. A breeze lifts and tosses them over late-blooming pink-and-white impatiens and yellow chrysanthemums. I make two decisions: I will resign from my second teaching job at the Maryland Institute of Art in Baltimore (my doctor's suggestion), adjusting my economy to the salary I receive from the University of Maryland; and I will telephone Alexandra and ask her to come for a visit, for the pleasure and reassurance of her company and her bracing presence with the two art dealers.

I walk slowly into the house, more slowly than usually. I feel as if I have a new friend—the old woman I am growing into.

Alexandra arrived in a blaze of color, an orange coat and a billowing gold-and-scarlet scarf.

It turns out that she has been seriously considering the old crone I am just beginning to know. Mary too, it became apparent when she arrived with Rosie and Julia to spend the day. We three women sat in the swirl of Rosie's play, passed Julia from hand to hand, and discussed some sensible changes in the way I live in my seventies, headed now, they pointed out, toward my eighties. When Alexandra suggested a continuation of the railing down the kitchen steps to run all the way to the studio, I felt a little leap of relief: I have been scared moving across that open space in ice and snow. My portable television is "an antique." I have been in general "making do." "Whenever you feel yourself improvising," Alexandra said firmly, "work out a permanent solution."

Together, Alexandra and Misha Ringland and I welcomed the two dealers. I made a hearty vegetable soup with what my father would have called "everything but the kitchen sink" in it, and after our work we lunched in my sunny dining room with happy congeniality, discussing all sorts of matters of mutual interest. Among them, Xenophon's triumphant march to Trebizond, which came up in the course of conversation because one of the dealers, Constantine Grimaldis, was born in Greece. He will have a show in his Baltimore gallery to coincide with my retrospective at the Baltimore Museum of Art next May. James Yohe, the director of the Emmerich gallery, and I chose works for an exhibition at the Weatherspoon Art Gallery in Greensboro, North Carolina, scheduled next April.

A satellite containing a telescope sensitive to the infrared wavelengths outside the visible spectrum at its red end was recently launched into orbit around the earth. These wavelengths have been hitherto invisible, even to the most advanced ocular de-

vices. By processing information broadcast by this satellite scientists can translate the facts of infrared radiation in such a way as to render that part of the spectrum visible for the first time. They have discovered to their surprise that what appears to be empty space actually contains very fine matter.

This discovery is a relief to me. For some years I have understood intuitively that all and everything is a whole beyond imaginable scale. I *feel* it to be whole, and even occasionally seem to *know* it to be whole. Because this intuition contradicts the evidence of my senses, which distinguish objects from space, I have decreasingly trusted my senses. So the fact that invisible wavelengths have been rendered visible heartens me. And the corollary fact that these wavelengths are revealed to be matter validates my intuition of a seamless whole within which we each must logically have proportionate being. The wavelengths within this whole perhaps vary so widely in density and in speed that our limited senses perceive their operation as space and matter.

If the differentiation between space, which scientists are now calling "dark matter," and substance is mistaken, perhaps that of body and soul is equally so. A human being may be simply a cluster of particular forces temporarily magnetized at conception, and demagnetized at death.

I have also long wondered about the mechanism by way of which an individual fate, or karma, might be stitched into the physical fabric of an individual body. It occurs to me that the alignment of specific genes, DNA clustered in a unique configuration, may initiate the script of a lifetime in a mysterious ignition.

I resist the concept of predestination as a dogma but I am impressed by the pattern of my life in retrospect. What I have experienced as decisions have been the results of more or less

conscious causes that have sequentially clicked into place, rather as tumblers fall precisely in turn to open a lock. In this sense, I see my life as a narrative. Sometimes I even have an intuitive insight into how my life will be lived out to an appropriate end.

In any case, I am glad to be old enough to have to some degree outlived the drama I used to enjoy writing for myself, one in which I was protagonist, stage designer, director and audience. I used to think that at a certain point I would reach some climactic maturity. Until in 1981, at the age of sixty, while I was flying to Australia, forty-seven thousand feet above the Pacific Ocean, it occurred to me that I wasn't going to get any more "grown-up" than I was!

In this sense, old age is something of a disappointment. There seems to me nothing dramatic about it. In fact, I feel no age whatsoever in my spirit, which my body bears intact. Nothing in my life seems to have affected it at all. I am come to the working hypothesis that when I die the cells of my body, in accordance with the law of the preservation of matter, will transubstantiate in myriad ways matching the myriad substances of my person. Accompanied by the spirit that animates it, my mind, in accordance with the same law, will continue into another life of some sort in which I will continue to learn.

Like the brilliant colors that I saw from the window of the neurologist's office, my headaches have faded, leaving me healthy but depleted. A tincture of anxiety lingers. I had felt the hand of death on my shoulder. And I had realized, for the first time in my own life, how easy it is to skid into the realm of the sick who are not going to get well.

Even though November has blown the leaves off the trees and dulled the landscape, the roses are still blooming in the Bishop's

Garden at the Washington National Cathedral atop the hill on which my house stands. Their scent glorifies the pungent herbs spreading in low beds all around them: betony, winter savory, rosemary, wormwood, rue, fennel, pennyroyal, feverfew, horehound, ginger, coriander, mint, sage. The summer's healing herbs which, if I were the medieval nun safe in a convent as I occasionally wish I were, I would be thinking of drying to cure the coming ills of winter. But it is another sanctuary that beckons me: I am going to Yaddo.

WINTER

Yesterday I flew from Washington to Albany, headed north to Yaddo. The plane rose into snowflakes which thickened and thinned in the wind, finally giving way to pale blue air through which I watched the ground, white-patterned, tilting. My parents, born in 1877 and 1887, never flew. Not having seen the world from the air, their concept of it must have been only an abstraction of received facts. My experience overlays theirs, as that of future generations will overlay mine, expanding its range in particularity—but I am content. I have flown back and forth across the Pacific Ocean eight times, have seen the curvature of the planet with my own eyes, and have felt surging through my body the lift and heft of the great winds encircling the earth.

My children and I used to discuss at the dinner table what animals we would like to be. My choice was a whale. Tethered as I was—the children were young, I was working in the studio and

teaching as well—I yearned for freedom. Whales travel great distances; I did so want to *move*.

Flying up here on the wild wind, I abandoned the sea for the air. I would choose to be an albatross, a short-tailed albatross with a pale yellow head, a pink-and-blue beak, white plumage and a wingspan of thirteen feet. Albatross sail aloft for many thousands of miles (one was tracked for nine thousand!) without alighting; they snatch fish from the waves, not wetting their wings. Wanderers. But even an albatross has a home on earth, for there is evidence that each returns to the same spot year after year, to meet there the same mate, to bring forth, incubate and mutually nourish one annual egg. I like the fidelity as much as the wandering.

Fidelity is ardent at Yaddo, where administrative changes are absorbed into a continuity dedicated to the support of artists while they work. I returned here for nine months in 1984, when the executive director, Curtis Harnack, asked me if I would act in his stead while he took a leave of absence, so I have come back this time to a circle of friends as well as to a place I know intimately. And I had scarcely set foot on this land again when I spied in a distant snowy field a red fox running, long tail streaming behind in a burnished comet. The confidence of that all-out run, the sure touch of paw on native earth, reminded me that here I too am on my own ground, the ground of my work, as natural to me as field to the fox.

A doe leapt across my path as I headed toward my studio before dawn this morning. I watched her scut until it was absorbed into the dark woods and then turned my face up to seek in the zenith the Pleiades.

For some reason beyond logic, the sight of this glittering group of stars always fills me with a rush of joy: I seem to recognize

home. Two hundred and twenty light years away, the Pleiades fill a space with a diameter about one million, two hundred thousand times the distance between our sun and planet. Each many times as bright as our sun, they shine from within a nebula, a mass of cloudlike matter. When I look directly into their sparkle, my skeleton always straightens and lengthens along my backbone, as if the line of gravity affixing me to the earth were vivified.

In 1943, in the Crimea, the German fighter plane flown by the artist Joseph Beuys was shot down by Russian fire. The aircraft was demolished, Beuys's fellow pilot was "atomized." Because, Beuys writes, "I always preferred free movement to safety belts . . . I must have shot through the window screen as it flew back at the same speed as the plane hit the ground . . . then the tail flipped and I was completely buried in the snow." He was rescued by the Tartars, who "covered my body in fat to help to regenerate warmth and wrapped it in felt as an insulator to keep the warmth in."[9] In this way Beuys learned that the very matter of the earth is curative. It is so that the originality of an artist's iconography, however elaborated by other considerations, is intensely personal.

In 1960, in *Bathtub*, Beuys attached pieces of fat to the inside of his babyhood tub. He writes that he is thus pointing to "A molding or sculpting hand . . . that lies behind everything in the world. By this I mean creativity in the anthropological sense. . . . The relationship is with realities rather than artifacts . . . initial contact with elements like water—moving light—and heat."[10]

Beuys and I were born in the same year, 1921, I in March, he in May. I remember a tub like his. I seem in my memory to smell a moist mixture of vapor and iron and to feel the buoyancy of warm water lifting my whole body all at once into delicious mobility.

Although my mother and father were living on the Eastern Shore of Maryland, I was born, as Helena was, in Baltimore, in the Hospital for the Women of Maryland. There is a photograph of the nursery in the hospital's 1921 annual report. Each white iron crib stands apart, surmounted by a white canopy ruffled onto a rod from which it falls in sheltering folds so that each infant lies within a cocoon of privacy. A small white glass-fronted cabinet; a white table on which there is a wicker basket with a scale under it, along with a few glass jars and some piles of cloth. Two white wooden rockers with heart-shaped backs slant on either side of this table. A clipboard chart hangs on the end of each crib. I feel comfortable looking at this photograph. Babies must have died in that nursery for lack of technology but not for lack of the touch of human hands, innocent, gentle.

Beuys's "molding or sculpting hand . . . that lies behind everything in the world" is real to me in my impression that certain places are nexi in a magnetic filigree underlying and animating the earth. These foci attract and hold a particular kind of energy. I used to feel this strange attraction in Big Sur, on the coast of California; when I was a month or so pregnant with Samuel, I once lay stomach-down on the Partington Ridge land that we owned there, pressing my baby into the fecund earth. I felt it too in the Australian bush, on a tawny field of grasses at a meeting of three branches of the Hawkesbury River; at this conjunction there is a spring so deep that it has never been plumbed. In both these places, the energy was neither "good" nor "bad." Its power was inclusive, induced a particularly intense kind of knowing.

This kind of direct apprehension seems to lie at the reaches of our senses, which stretch eagerly to meet it. In sexuality, for example. In music, when it permeates our senses to such a degree

that they give way to simultaneity, flooded by sound that reverberates to open up a whole new range of experience, to promise infinite psychic enlargement.

Edges also seem to me to promise insight, particularly edges where what we think of as opposites meet. It is interesting that the organs of reproduction are so closely juxtaposed with those of excretion; when the concepts they elicit in my mind meet and when I bring to bear on them my intuition that all that exists is one, I discover the simultaneity of creation and destruction.

Snow fell all last night and is still falling. The roads are covered but I know this land and my boots are surefooted.

Yaddo is one of the foci of the planet's energy. I always feel it as I enter the grounds, between the granite pillars that guard the narrow road winding between two lakes and up a hill toward the mansion. The first time I came here, in 1974, I felt it so strongly that I had to pause, then to force myself to continue until I was enclosed. A few days after I arrived, I got sick; partly because of the fatigue I brought with me, but partly, I think, because I had to adjust to a new, heightened level of energy underlying this land.

Over the years I have walked it in all weathers, have imprinted on it evanescent traces of my passage. We make tracks in our lives, weave on the earth a personal embroidery. For example, when I commuted to Baltimore to teach at the Maryland Institute of Art last fall, I used to pass by the Hospital for the Women of Maryland. It is now an institution for old people—I saw a stooped old man craning out a window high in its bleak brick wall one day—but the "cheerful sunny garden court" that the 1921 annual report heralded as "the road to health" remains. On her own tracks, my mother, large with child, must have passed between its flower beds on her way to my birth.

It is a mistake, however, to sentimentalize birth from the point of view of the born. A natal instinct for survival can be mistaken for the capacity to love, the most challenging of human achievements. Infants are narcissistic of necessity: they *need*. It is only with time that this core of selfhood expands, only with experience that babies come to recognize the existence of what is "other" than themselves. And this healthy objectivity develops only if infantile needs are well met. Unless given affection, infants die of despair; children become depressed. When I was working as a nurse's aide, one of my assignments in the pediatric ward was to give the patients "TLC"—tender loving care—at "10:00, 2:00 and 4:00."

Parents are a given but Stella, who took care of me for the first eighteen months of my life, seems to me to have been a special gift. My most consistent earliest memory is of her, of her gentle, firm, warm, reliable hands. My own touch in art may originate in Stella's touch on me. She had color too: her skin was a glowing salmon overlaid by tan. She was "black." I now understand a little of what it must have meant to be black in 1921 and I wonder if my own latent feeling of being in some subtle way bereft, outcast, might have been picked up from Stella. She brought me along in a natural rhythm. I knew immediately—it seems to me in my memory—the security of being fed when I was hungry. Because need evoked satisfaction, I had the feeling of being born into beneficence. Furthermore, the feeling of being acknowledged as real: actual need met by actual satisfaction. It seems to me in retrospect that because I was respected as a person, I learned self-respect very early.

And I have never quite lost the naive confidence with which Stella's lovely care endowed me in my infancy. Notwithstanding ample evidence that good will is not inevitably reciprocal, I have faith in it as a point of view.

It was here at Yaddo in 1984 that I finally learned how impersonally, objectively, I fit into all that exists around me. I learned partly because this place had been put into my hands to protect, and my ardent heart spread out over its acres as if on wings. And partly because I was for the first time an official administrator. I had to act particularly carefully, and I began to notice more clearly than ever before how minor a part I played in the course of events. I acted "for the good" as I saw it, but changed matters very little. Gradually, I came to see that my wisest course was to act as little as possible, within reason. I began to appreciate a natural flow in all that happened, to understand the Zen idea of "effortless effort." I took to solitary walks. I discovered the delight of neutrality. The less I took part, the more plainly I saw every aspect of all around me as precisely, perfectly placed. And I myself no more and no less relevant to it than a single leaf blowing in the wind.

Aniela Jaffe became Carl Jung's secretary in 1955, the year he turned eighty. One day some papers in his ashtray caught fire. She rushed forward to extinguish the blaze and was astonished when Jung stayed her hand.

"Don't interfere!" was one of his guiding axioms, which he observed as long as a waiting-and-watching attitude could be adopted without danger. Situations in which interference was obviously required were decided exceptions . . . life and events . . . happened and he let them happen, not turning his back on them but following their development with keen attention, waiting expectantly to see what would result. Jung never ruled out the possibility that life knew better than the correcting mind, and his attention was directed not so much to the things themselves as to that unknowable

agent which organizes the event beyond the will and knowledge of man. His aim was to understand the hidden intentions of the organizer, and, to penetrate its secrets, no matter was too trivial and no moment too short-lived.[11]

I share Jung's distrust of "the correcting mind." We know the roots of the corrections we make as little as we know what their results will be.

Though what we know, we verily know. I think of the green ice characteristic of Antarctic bergs. Green ice is pure, without the milky-white bubbles of trapped air characteristic of most berg ice. No one is sure exactly where the green ice in Antarctic bergs comes from but it is thought to have been exposed by the shear of mountain glaciers. Somehow it survives intact within the complex ice fabric and rides within it out into the South Atlantic Ocean—a flash of emerald straight out of the heart of the continent. My self sometimes sends out this kind of imperative message.

Today the earth is poised on the orbital pivot of the winter solstice.

I slept later than I have since I got here—settling now into a less excited rhythm—and by the time I walked over to my studio, dawn was splitting the dark purple sky into horizontal ruby streaks over the just barely visible mountains of Vermont. I caught a repetitive harsh phrase: the bark of a fox, perhaps, or the call of a deep-throated bird.

I am established in my studio in Pigeon Barn—Pigeon East next to Pigeon West, in which I worked for almost the entire year of 1984.

When I first came to Yaddo in 1974, I had no idea that whole parts of myself were about to blossom as if moved from shade into sun. I was astonished to feel secure, sequestered on these

grounds, tended by a subtly attentive staff and protected by the rule of an unvarying daily order. I was invigorated by the company of artists like myself, enlivened by interesting conversation with new friends. A young Korean composer was my first friend here; he long ago returned to Korea but we keep in touch by letter. It was a joy to work as much as I wanted to—I could afford to get tired, no one else was counting on my energy. Instead of fighting my way, it was cleared before me. Soon after my arrival, I asked in the office for the name of a place in Saratoga where I could buy a 4 foot x 8 foot piece of plywood to use as a surface on which to paint canvas and two sawhorses to support it; within fifteen minutes a man appeared at my studio door and set up just such an arrangement exactly where I wanted it. Looking back, it seems to me that I may have come here to learn that I was not alone in my work.

But did I come here "in order to learn" that? Do I deduct logical sequence from what is only empirical sequence? Am I only theorizing in a vacuum when I postulate a course of cause and effect that makes my life an orderly process of learning from experience? Do I experience in order to learn or have I simply decided, as a matter of policy, to learn from what I experience?

The Taoist poet-philosopher Chuan Tsu once so vividly dreamed that he was a butterfly that when he awoke he asked himself whether he were a man dreaming that he was a butterfly or a butterfly dreaming that he was a man. I ask myself: were both man and butterfly dreaming?

My initial encounter with the concept of the unconscious was around the age of twelve, when Juie, Helena's mother, told me about the theories of a Dr. Sigmund Freud in Vienna. He thought, she said, that the dreams that come into our sleeping minds emerge out of material we don't know when we are awake. We

were at Avonlea that day and I happened to be looking out at the river when I took in her meaning. I remember feeling relief. For even at that age I felt curious about my mind. I was glad to hear that there might be a lot there to be curious about, and that a grown-up was trying to make sense of how it worked.

I find that memory "tells" me more than I know that I know, as if it operates as a generative force in itself. It unexpectedly juxtaposes various facets of my experience, to some of which I do not recall having paid particular attention. I trust my memory. I count on its validity as a sound foundation for imagination. When, in college, I learned about Carl Jung's theory that "beneath" Freud's personal unconscious there was a "collective unconscious" deeply rooted in the whole history of human consciousness, my conception of what I could learn from myself opened up—infinitely. In retrospect, it was on the basis of this sequence of apprehensions that I came to the habit of using my self as a tool. As a practical tool, obviously, but also as an unknown resource potentially capable, perhaps, of rendering to me what is universal.

"To live is to feel one's self lost." Ortega y Gasset writes that to accept this fact is ". . . to be on firm ground. Instinctively, as do the shipwrecked, [a man] will look around for something to which to cling, and that tragic, ruthless glance, absolutely sincere, because it is a question of his salvation, will cause him to bring order into the chaos of his life."[12]

If I am to live sincerely I must stick to my own experience, and what works for me pragmatically is to learn what I conceive to be lesson after lesson. Like Rumpelstiltskin, I am intent on spinning straw into gold. On the other hand, I am at pains to examine and reexamine this working hypothesis, for unless a premise is accurate, its elaboration leads to folly, not profundity.

The concept of meliorism, the idea that the world is in the

long run improving and that human beings are helping it to improve, seems to me a case in point: flimsy optimism simply perpetuates itself, resulting in an affirmation of nothing but superficiality, and can be a form of self-indulgence. For many years I had hopes of technology, particularly in medicine. But recently I went to see a friend in the hospital and found this dignified eighty-four-year-old woman trussed like a chicken ready for roasting, bound by tubes leading to bottles exposing her fluids and by wires leading to machines recording the erratic curve of her vitality. I was reduced to touching a small patch of skin on one arm, the only place left for human contact. She might have felt herself more herself had she been dying in a tribal cave.

An Oxford zoologist, Richard Dawkins, has formulated a theory to explain the extraordinary speed with which ideas can spread in a culture. In analogy to the fundamental unit of the gene in biological evolution, he posits the existence of a comparable unit in cultural transmission. He calls this unit the meme, from the Greek "imitation." Memes are ideas that function independently; they mutate and travel, and can replicate themselves. They have lives of their own. They operate like mental viruses—people "catch" them.

I have found that certain concepts do indeed appear to exist on a plane that is sometimes accessible. In 1962 I conceived a black sculpture 6 feet x 6 feet x 6 feet which I decided not to make; Tony Smith made this precise sculpture, *Die*, in the same year. When I saw a photograph of it, I was surprised, and could only think that this idea must have been somehow floating around and we both picked it up.

Memes would account for spontaneous simultaneity: shoals of fish so attuned that when they glide each might be a glitter in chain mail; wild geese strung in a migratory arrow; lemmings pelt-

ing into a mortal sea. Much that is Japanese: the psychological "atmosphere" of their dwellings, so immediate as to be almost visible as hues; the delicate empathy by way of which they weave deftly in and out of one another as if in a kind of osmotic action.

Artists here at Yaddo may benefit from the operation of the meme. Because we live on the same daily schedule—we breakfast and dine together, otherwise work in the studios scattered around the grounds—we might appear to a zoologist observing us under a microscope to be moving in unity like a shoal of fish.

I have been given a tiny bedroom and a private bathroom in Pine Garde. I walk around the four lakes almost every afternoon, reveling in each turn of the familiar road. When I was living here in 1984, Mary and Charlie, then four, used often to visit from New York, and Samuel not only stayed with me for a while but also used to drive over frequently from Binghamton when he began doing graduate work at the University of New York there. So as I walk I hear the echoes of their voices, the sound of the ice chips they used to skim across the frozen lakes, and feel in my memory the contentment of our companionship, enhanced by our mutual delight in the prodigal beauty of Yaddo.

On this visit, I can enjoy the company of the other guests in a way that I felt would be unwise when I was an official here. We are a small group, only twelve, as the mansion is closed for the winter. We have our meals in the library—delicious, wholesome full meals, for Yaddo has found that artists, like soldiers, travel on their stomachs. Like soldiers too, we forge friendships here that have a special flavor: we are under the same kind of pressure and have many of the same problems—making a living, for example—so we have a natural empathy with one another. Hearts break at Yaddo; artists are intense people. But I am finding once again that our community is kindly—we wish one another well.

Even the most earnest self-examination is subject to a subtle interpretation that tends to smooth the surface of a life. And at my age time has obliterated the generation able to cast stark light on the past, to bring to bear on it the undeniable authenticity of another point of view. I sometimes feel this loss, so I was excited when two years ago I had the opportunity to visit my governess. "Miss Frances" taught me to read—I can still see her, slender, brown-haired, standing in front of our class at Miss Call's School on the day when I first realized that I didn't need to say each word in my head, could simply look at the print and grasp its meaning. Miss Call moved away from Easton and my parents asked Miss Frances to take charge of a little dame school that they set up in a room overlooking the garden at the back of our house. Here we—my sisters and I, Helena, and two other little girls—studied until Miss Frances left to be married, whereupon I entered the fifth grade in the Easton Elementary School.

On a sunny summer morning, I drove from Washington to Denton, Maryland, and found Miss Frances's white clapboard house on a quiet shaded street. Except briefly—she played the organ when Helena was married in 1944 in Christ Church—we had not met since she left our schoolroom. She was eighty-six. Only her snapping brown eyes were immediately recognizable; then her peppy voice, her forthright, spicy speech, her scrupulous honesty.

Her first question right after we settled ourselves face-to-face, in a rather sharp voice as if she suspected possible disloyalty in me, was, "Do you still have your mother's portrait?"

"Yes," I said, "hanging in my dining room."

Miss Frances seemed to relax. She was pleased—I felt her pleasure as I used to feel it when a child. We then went on to speak of Mother. I too particularly wanted to do so, for as I had prepared

for this visit I had found myself for the first time in years thinking of my mother as a model, incorporating her mien: I wore a blue-flowered Liberty cotton dress cut exactly like those she used to wear so elegantly, my Japanese pearls and the gold bracelet my children gave me for my sixtieth birthday, altogether formal.

"What was my mother like?" I asked.

Miss Frances paused and looked thoughtful. "Democratic," she said.

"Democratic?"

"What I mean is that she never made distinctions in the way she treated people."

"What else?"

"Caring. She took care of people, watched out for them."

A pause—I remembered Miss Frances's pauses, and waited.

"Brilliant. She was a rare person." Miss Frances's voice deepened. "A *special* person."

Another pause.

"She was beautiful. Not like a magazine cover." And then, shyly, "More that her spirit shined."

And as Miss Frances spoke, my mother rose up in my memory, almost fragrant in her presence.

In the course of our conversation, which was as much about the life Miss Frances had lived during our separation as my own and included all sorts of interesting details about the other pupils she had also taught in our classroom, I asked what I had been like.

"Dependable."

"Dependable?"

"Yes. You did everything expected of you."

"What else?"

"Quiet." A pause. "Sedate."

I did not recognize this picture. "Was I interesting?"

Impulsively, *"No."*

A decided No. It occurred to me that I must have bored Miss Frances. And if I bored Miss Frances, I must have been very uninteresting indeed, as she is so lively, curious and fair-minded. I refocused, and was startled to recognize myself as if in the opposite end of a telescope: a correct little girl delineated by the decisive black-ink lines of conventionality.

She was bug-eyed to learn that I had become an artist. Shaking her head at the mystery, she said, "A gift must have been in there somewhere," and went on to speak of gift as divine, of her own in music. "I knew when I was nine that I wanted to play music in a church."

"For God?" I asked.

"No." Her eyes widened. "For the *music*." She had yearned, she said, to play the organ—"those tall golden pipes."

I remembered how she had one day come to school with the idea that we would make a relief map in our study of geography. She had darted down the back stairs to the kitchen and brought back a mound of flour mixed with water and salt. We had modeled on a large piece of corrugated cardboard the continent of South America: the Amazon incised and painted blue in an expanse of green plain, and the Andes mountains pinched up, steep, with whited peaks. I had been enthralled—it was the first time I had ever seen anything *made*. I remembered too how she had supported herself and her mother by teaching us, by giving music lessons, by playing the organ in Christ Church and the piano as accompaniment to the silent films shown in the local movie house. I felt a new mature respect for her independence, her vigor, her confident vision of the world as an arena in which she would express herself as best she could, for her hardihood of spirit.

I asked Miss Frances about my father. Her face closed. I recognized her reserve—she had always been reluctant to criticize.

"I didn't know him," she said. "I never had a conversation with him."

I changed the subject. "What was our house like?" I asked.

What had apparently struck Miss Frances was the distinct unusualness of our establishment. Her adjective for our house was "palatial." And so it was, I suppose, in the context of the Eastern Shore of Maryland: a large eighteenth-century brick house rearing high and straight up from the quiet street, set in a spacious garden stretching back in lawn and flower beds to a carriage house.

"Your mother was the backbone of the house," Miss Frances said.

My mother had imposed her own order. We dwelt within it, surrounded by her inherited belongings: French furniture all curves and brocade, inlaid and ornate; sculptures: a white marble bust of Caesar Augustus on a mottled marble pedestal in the long narrow front hall, and a white marble and blue enamel and gilt bust of Marie Antoinette on a marble-topped inlaid French chest in the living room; sheer white curtains inside crimson draperies at floor-length windows. Chinese tapestries, silk-embroidered. Prints of ships collected by her seagoing Boston forebears. My mother had made a kind of castle, a place set apart and distinguished by her possessions, owing nothing to the homely provincial values of the Eastern Shore of Maryland—indeed at variance with them, rooted in the European tradition of New England. My sisters and I grew up in this enclave, set apart (until we went to public school) as if within a distinct ethnicity.

Miss Frances and I parted with mutual affection. We have stayed in touch ever since. Helena and I thought of having a reunion, of gathering together the twins and our other classmates,

of giving Miss Frances a festive dinner, but time and tide are too much for us: Helena is immobile and Miss Frances is just plain too old, grown too shy to enjoy being celebrated.

My visit to her was like a fairy tale. She took me by the hand and led me back to the childhood I had known only as a child, had not been able to view in the round.

As I drove home, I turned it all over in my mind and it occurred to me that the pattern Miss Frances refocused is echoed in the way I live now: just as I once studied and lived at home, I now work and live at home. I used to ask to be excused and seek out Mother for a chat as I now excuse myself from work in the studio and put something on to cook for dinner. And the traumatic transition from enclave to public school may partly account for the way I cling to privacy, am reluctant to enter the public arena.

But it was my mother, my relationship with her, that Miss Frances most pointed up. At the time that I made this visit, I was rereading *Beowulf*. Hrothgar, the wise old king whose people Beowulf has delivered from two monsters, Grendel and his dam, warns the hero on his triumphant return that if he is not careful he may come to feel that "the whole world turns to his pleasure."[13] As I drove over to Denton I had been thinking that I was superior to my mother, that I had made more of my life than she had of hers. She had submitted to being what Virginia Woolf calls "the angel in the house." I had not. I had instead defeated her when with every weapon at her command she had tried to force me into her mold. For my mother and I had fought a silent, bitter battle. The suspicion of disloyalty that I detected in Miss Frances's first question may have been something that she intuitively picked up.

And inside the dependable, quiet, sedate—and uninteresting— little girl whom Miss Frances remembered *had* lived a rebel. I

used to get up early, before the household awakened, and run up and down, fast, in the garden with our dog. Miss Frances saw me later, when the family was alert.

Beowulf kills Grendel with his bare hands, but Grendel's mother is more powerful than her son. She stretches Beowulf flat on his back on the bone-littered floor of her cave under the black heaving waters of her flaming lake, and raises her dagger over him. Protected by his cleverly woven mail shirt, Beowulf manages to roll out from under her and as he does he sees, hanging on the wall, "a victory-bright blade made by the giants . . . longer and heavier than any other man could ever have carried . . . ornamented, burnished. . . ." He draws it from its magic scabbard and "savage in battle-lust, despairing of life . . . swung hard on her throat, broke through the spine, halved the doomed body. . . ." The sword melts "in battle-bloody icicles."[14] Beowulf carries off with him all that is left, the hilt.

Just so, in some dark secret cave of myself I struck my mother out of my life so I could live it.

My struggle was neither violent nor mythic. I fought her in petty skirmishes, intermittently ambushed the narrative she seemed to me to have written for me. I resisted her in small ways that now make me sad to remember. When I was fifteen, she decided that we three girls should be photographed. Our hair must be washed, she said. My sisters complied. I did not, and in the photograph, which I still have, my sisters' hair is glossy, mine dull and stringy. I stare out defiantly, I suppose supported by my mean victory. But such small triumphs added up. Mother gave in at some point. I felt her withdrawal. I missed her. She died when I was twenty, before I was experienced enough for us to have come to the comfort of mutual understanding.

It was my mother's calm authority over my life that I resented.

Like Miss Frances, I saw the superiority of her character but unlike Miss Frances I felt in it a crystallization that chilled and terrified me: was her life all that I could reasonably expect? For every now and then she pulled aside the curtain of her reserve to reveal insecurities that caught my heart—her disappointment in her life, and her unremitting, strained efforts to reconcile herself to its limitations. I feared the resignation that she had apparently settled for as adjustment.

It may be primarily the oldest daughter who engages the mother in combat, perhaps particularly when the oldest daughter is also the firstborn child.

Statistically, eldest children tend to succeed. A kind of expulsion from Eden may temper their characters. They are all-in-all to their parents until the birth of a second child, which perhaps appears to an immature mind to be a breach of faith. Parents are "forgiven" but a special feeling of utter safety, the result of being the focus of a love entirely exclusive, may never be regained. My impression is that eldest children tend to be bossy because in the course of this process they somehow incorporate the role of guardianship to compensate for the failure of beloved parents, to take up their slack. As the eldest of three children, I recognize my own pattern in my eldest child, Alexandra: an anxious determination to straighten people up so that everyone she loves will be safe according to some secret standard of her own.

Parents often feel a lurking faithlessness to an eldest child when they have a second, and this may lead to a form of denial. They are harder on their firstborn, consciously because they are so perfectly sure that the initial exclusivity of mutual absorption has endowed that child with special strength but subconsciously because they are defending themselves from an illogical, lurking

guilt. Even when quite young, I remember feeling it incumbent on me to be strong for the sake of my parents, as if called upon in some unmentioned way to justify them, to affirm their performance as parents, to make everything all right by showing that I was all right—no matter what I felt. I was trusted to bear burdens not imposed on my younger sisters. And I in turn tend to think of Alexandra as invincible.

Granted that this trust is more or less subconscious, it can lead to critical mistakes.

Before we moved back to the United States from Japan in 1967, James and I took the precaution of entering Alexandra and Mary in an excellent private school in Washington. They were accepted, but in the unsettling context of our return we decided to buy a house served by a good public school and to send them there. One afternoon in the 1970s, when both girls were in their twenties, I was walking past that private school when, as if a voice spoke in my ear, I knew that we should have separated the sisters, placed Mary, a resilient child, in public school and Alexandra in private school. If I had thought of it at that time, I most certainly would have. Alexandra had needed that protection. Detachment from our prosperous, privileged, safe household in Tokyo had demoralized her, coming as it did just at the onset of puberty and coinciding with her father's descent into a frightening mental illness that made him unpredictable, erratic in his judgment, deranged in his habits, even occasionally violent. I had read the phrase "Tears welled up and ran down her face," but they had never welled up and run down mine until that moment when I so plainly saw that I had failed my daughter, made an irretrievable mistake.

When I told Alexandra how much I wished that I had thought at that time of putting her into private school, I saw tears rise in

turn to her eyes and run shining down her cheeks. "I wish you had," she said.

Alexandra's combat with me was more forthright than mine with my mother. At the age of seventeen, she simply declared her independence, left my roof and set herself up elsewhere. I was confronted with a stark choice: I could lose my daughter or we could agree to disagree. Like so many family crises, this one rose to a climax in the privacy of the bathroom: Alexandra stood, I sat on the edge of the tub, looked into her eyes and recognized my defeat. The anger she felt when I divorced her father persisted to make us both unhappy until she had acquired enough experience to gauge the complexities of being adult. We have now come to the mutual understanding, the comfort, of open discourse because our affection for each other never faltered, and because we both worked to make it so. In contrast, Mary moved smoothly into maturity, avoided conflict in all sorts of adroit ways; and Samuel and I managed somehow to devise between us a Renaissance painting with deep-perspective views into which we could retreat when the foreground grew stormy.

At the still heart of parenthood is the intractable fact that we can protect our children neither from our own failings nor from fate. I felt this commonplace but poignant truth most piercingly when in the spring of 1987 Alexandra was stricken with spinal meningitis. "She will either get well or she won't," her doctor said. I sat beside her hospital bed, perfectly straight, and kept my right hand on her right leg. I watched her closed-eyed face, over which dark clouds swept as over a landscape. There was absolutely nothing I could do. I saw her then as she will look when she is old: gray-skinned, dry, husk of all she once was. As a particularly dark shadow passed over her, the words "Death comes as a friend" rose to the surface of my mind, borne on a wave of revela-

tion. Mourning would have come later, and I have no doubt that it would have been lifelong, but mourning would have been impertinent to what I clearly saw in that irradiated moment: the light of our common, inseparable being. I knew without flourish that I could steadfastly watch her die. And I knew as plainly that if fated to know her from her first flutter in my womb to her final breath, knowing her would have been a high privilege.

Recent events—the Persian Gulf War that was so brutally, shockingly militaristic, my frightening headaches, my efforts to place my work in the world responsibly, the loss of tenure at the university that reduced my financial security, the incipient onset of old age—have changed me in ways I cannot yet assess. Yesterday on my daily walk around the lakes it occurred to me that I might simply stop thinking and rely on the force that Federico García Lorca calls the *duende*—"the spirit of the earth.... Dark and quivering.... Roused in the very cells of the blood.... The roots thrusting into the fertile loam known to all of us" that, he says, "surges up from the soles of the feet."[15] For, as I rounded down a hill beside one of the lakes, walking especially carefully on the frozen land, I felt its swell under mine.

The solstice has decisively changed the light. Snow has here and there receded into tongues of celestial white, exposing between them the soft delicate browns of beech and oak mast, the bared breast of earth. I saw beauty, but the revelation of the *duende* is truth as terrible as it is fair. No human hope can prevail against its relentless, millennial power. We emerge out of it when we are born, are reabsorbed when we die. And in between we live lives of stupefying repetitiveness. For all the apparent variety of the narratives we write for ourselves and strive to effect—as I did recently during the course of the Emmerich exhibition—we

are prisoners of time and cause. Lulled by the rhythm of day and night, night and day, we are mechanically carried along until we come upon the brazen face of mortality. But as I walked yesterday I felt the veritable power of the earth coming up under me. I seemed to know that all and everything could be acknowledged, and absorbed, that if I kept on trying to understand I would come to know a human scream and a high wind to be one sound.

The *duende* is a universal resource. Some people seem to yearn more than others to express the individuality they derive from it—but may find that they cannot.

> How wrong the world is in connecting so closely as it does the capacity for feeling and the capacity for expression—in thinking that capacity for one implies capacity for the other; in confusing the technical art of the man who sings with the unselfish tenderness of the man who feels! But the world does so connect them; and, consequently, those who express themselves badly are ashamed of their feelings.[16]

I sadly wonder whether James may have been caught in the predicament that Anthony Trollope thus describes. I feel sure that he "knew" the *duende*, for I felt it strong within him: it was in fact the *duende* in him with which I fell in love. He may have fought this force without ever being able to express it, may have put himself at its mercy instead of aligning himself in its service.

I have been thinking particularly of James because Samuel is now in Mexico, in San Miguel de Allende, where James is buried. He has journeyed to his father's grave. He was last there in 1981. It was during that visit that he turned twenty-one, on November 12. James killed himself six days later. Samuel was under his roof,

recovering from hepatitis, when he did so. Alexandra and Mary flew down immediately. They buried James together.

James and I were both twenty-four when we met. We married two years later. We had in common high hearts, the spontaneity of self-confidence, healthy sensuality, and congenial tastes—after our marriage we gave away the many books we found duplicated in our collections. He had written his honors thesis at the University of Virginia on D. H. Lawrence; I had read all of Lawrence too. In the way of lovers, we thought this a miraculous coincidence. It was only later that I realized that James had not been caught as much by Lawrence's passion as by his place in literary history. But even our differences piqued us: we enjoyed arguing. I loved the way James moved in the world, easily, gracefully, always curious, engaged, discerning. Though I used to wonder that he lived along from day to day, situation to situation, without apparently ever asking himself what it all added up to under the stars.

James had more "native talent" than I, I think. When we were living in Dallas, Texas, in 1950—he was *Life* magazine's Southwest correspondent—he once used my materials and made a painting. It was marvelously expressive: a swirl of painterly marks like those of Jackson Pollock and emerging out of them, just discernible, a face, twisted, wry, wistful, *alive*. But he made only one. He looked at it with a knowing smile, pushed it into a corner, and left it behind when we moved to New York. I would have saved it but he had painted it on the surface of a very small secondhand table with rickety wrought iron legs—he cared for it so little.

A journalist by profession, James cherished until 1958 the idea that he would write a novel. That summer he took a week off from his work as *Time* correspondent in San Francisco to tackle it. On the first morning of this respite he went out on the deck of the house we had built overlooking the lagoon on Belvedere Is-

land, and sat down with a yellow legal pad on his knee and a pencil in his hand. It was a sunny day. The daisies edging the deck blew in a soft wind. Conscious of what he was trying to do, and hopeful, I remember looking out the window and seeing him there, and suddenly, chillingly, knowing without doubt that he was not going to be able to write on his own, in that vacuum out of which art arises as it wills. He had trained himself for too long to respond to a context outside himself, and had not trained himself to initiate and cultivate a context inside himself. I felt his mute anguish. The next time I looked out, he was digging in the border of flowers he had planted along the lagoon. The yellow pad lay on the deck, riffling in the wind. The next thing I knew, he had gone to the garden store. Neither of us ever mentioned the novel again.

I am appalled to look back on my silence. With a diffidence that does not belong in an evolving marriage, I left him alone with his disappointment, which I knew to be bitter. My heart goes out to him now, too late. He must have found himself locked in, doomed. Together we doomed our marriage too. For it was in that part of ourselves that we tacitly locked away from each other that its spring lay.

Suicide is a form of murder. James left my children damaged, bereft: they had not meant enough to him for him to stay alive for their sake. We who were left behind had to struggle with our anger, we were appalled by the brutality of his total rejection; and with feelings of guilt as well, feelings which haunted us all—illogically, as James had decisively moved to Mexico, remarried and made a new life for himself to which I was irrelevant and my children only ancillary. I felt particularly outraged by his cruelty to Samuel, whose bout with hepatitis had been serious, who had just had his twenty-first birthday, and who was especially vulnera-

ble; he had gone down to visit his father with the hope that if he made an effort he might come to know him better. But it was not for nothing that we had all talked things over for so many years. My children and I drew together, as we had once before when James and I were separated. We all acknowledged the terrible force of his mental illness; we wept to think of him overwhelmed. We still weep. Alexandra called one morning just before I left for Yaddo, and spoke of him with tears in her voice.

Sealed by death, the dead are subject to the patronage of the living. They can be interpreted at will, can survive in memory in evolving forms they themselves might not recognize. But the dead also evolve. Each year of the ten that have followed his death, I seem to understand James better.

Until I entered the working world as a breadwinner responsible for the major support of myself and three children, I did not grasp the nuances of the pressures he must have felt and did not sufficiently respect the skill with which, until alcoholism and related maladies overcame his acumen, he forged a successful career. I did not honor enough his energetic approach to the world—it was he who repeatedly took me to Mexico, introduced me to archaeological ruins in remote jungles, and he who brought to our dinner table all sorts of people distinguished by achievement. He had a rare knack for discerning the myriad details that converge and reconverge in the passage of history. He understood a great deal that I did not, and still do not. He served as a naval officer for two years in the Pacific; he knew the seriousness of laying his life on the line. And he had above all that odd quality called style: whatever he did had flavor. He brings that with him when he enters my memory and every time he does so, I seem more to recognize him as he actually was, unencumbered by what I used to think he was, or want him to be.

I do not miss him, save now and then—most poignantly. I do sometimes wonder what our life together would have become had we been able to weather our difficulties. We might in old age have returned to the congeniality we enjoyed when we were young. But on the whole, I think not. For it is what I have learned as a separate person that gives me what understanding of him I now have.

On balance, in the light of all that divided us, of our very different temperaments and of the willfulness that we both indulged, I feel grateful for what we shared more than I regret what we did not share. For James took the hand of the rigid little girl whom Miss Frances knew and led her out into the wide world under his lively and enterprising auspices.

García Lorca tells us that the *duende* faces "on the one hand a fight with death . . . and on the other with geometry" until it reaches "a real and poetical abstraction from this world . . . when this abstraction is reached, its effects can be felt by everyone; by the initiated, who have seen how style can conquer poor matter, and by the ignorant in an indefinable but authentic emotion . . . a profound, human, and tender cry of communion with God through the five senses."

This cry is unmistakable to an attuned ear. Artists keep faith with it. But they have to live while they do so and last evening at dinner the question of how we all make our living came up again. One young painter copyedits legal papers all night most of the nights of the week. A writer ekes out a living in odd jobs and lives in a hole-in-the-wall in New York; I gather that he has a desk and a chair and a bed and not much else. The majority of us teach, some of us with pleasure, some with real distaste, all with the knowledge that we drain ourselves when we do so.

In the long run, usually, genuine originality commands financial reward. But financial reward has recently, in the 1980s, come to some command of art. As William O'Reilly, astute art dealer, remarked, "There are no more green fields. They have been macadamized by mercantilism."

This is the situation projected by Karl Marx and Friedrich Engels in their *Communist Manifesto* of 1848. Engels writes in his introduction to this document that "in every historical epoch, the prevailing mode of economic production and exchange, and the social organization necessarily following from it, form the basis from which is brought out, and from which alone can be explained, the political and intellectual history of that epoch." Based as it is on the economy and economics of money, our society's intellectual history is constrained, Marx and Engels claim, by what they call "bourgeois values." They write that "The bourgeoisie have stripped of its halo every occupation hitherto honored and looked up to with reverent awe. It has converted the physician, the lawyer, the priest, the poet, the man of science, into its paid wage-laborers."[17]

Artists are bluntly confronted by the marketplace. Richard Diebenkorn's wife once told me that when her husband began to get famous she had to get used to the fact that every time he marked a piece of paper, it became worth a lot of money. Even my much more modest position makes the market value of my work way out of line with its intrinsic value as paper, wood or canvas. One of the reasons I enjoy teaching is that I am paid a reasonable salary for what I do reasonably well, an even exchange, perfectly forthright.

The gulf between the value that my work has for me and its value as a commodity feels to me truly unbridgeable. As Clement Greenberg once said, "The price of a work of art bears no relation

to its quality." But some stubborn feeling that things should match somehow persists to taunt me when my work is sold for comparatively little money. Logic aside, I feel cheapened. On the other hand, what price could I myself put on what goes into the work? On balance, I find it best to keep a distance between church and state, to let dealers set prices.

But no matter who sets them, prices are set. Robert Motherwell once compared the exhibiting artist to an Armenian rug merchant squatting on the street with his wares spread at his feet. Like Philip Guston, I shrink and shudder. This reluctance may look like vanity, even like self-importance masquerading as a bid for the reassurance of praise, but it is more honest than that: every exhibition is poignant self-exposure. Yet the alternative is dilettantism, the death knell of art: work made for the pleasure of its maker and never submitted to the checks and balances of public scrutiny. In honor, cowardly.

However these worldly matters may go, Marx and Engels were wrong that all perforce gives way to the subversion of the marketplace. The "spirit of the earth" prevails. I think of an old woman I once heard singing in a remote fastness of the North Carolina mountains: she sat on the splintery wooden porch of her crooked cabin, her sunbonneted head flung back, her voice, cracked, rising in an Elizabethan song, her indecipherable words as profoundly moving as wind over a strange land. And of an Inuit whom Harold Kalke knew in the far reaches of the Canadian north. Harold asked him what he did when he got lost in an Arctic fog. "I close my eyes," he said, "and I go back to where I started from and then I feel my way."

The *duende* may surge down as well as up. It may be its energy that I feel in my body on a line along my spinal cord, a line con-

tinuous and open at both ends that seems to magnetize me to the earth up through my feet and to the sky down through the crown of my head. This energy simply *is*, without regard to the senses that mechanically organize space and time. I feel my personal share of it as an alive nerve on which I strive to stay. In the truest sense of the word, I feel "alive" only when on this nerve.

A nineteenth-century scientist, Robert Brown, postulated the existence of what is called Brownian movement, defined by Webster's as "a random movement of microscopic particles . . . resulting from the impact of molecules on the fluid surrounding the particles." I wonder whether Brownian movement may constitute traces of the *duende* occasionally accessible to the senses, for there is evidence that very young children may *hear* this motion. The sunny nursery in which I spent my babyhood rises in my memory. I used to lie in my white-painted iron crib and listen to a golden hum. I heard it only now and then, in what I would now call waves, and when I heard it I remember having the feeling that I was somehow stretching out of my body toward my head, pulled away from my feet at the bottom of the crib. I can even remember feeling this pull as vaguely threatening, as if it might just keep on and pull me out of my body—and resisting.

1992

Last night I made my way over the snowy land so I could say good-bye to 1991 while gazing at the stars pinpointed by an aisle of pine trees that most dearly holds within its Gothic arch the cardinal verity of Yaddo.

I feel as if I have stepped over a threshold, and I am glad to do so. Nineteen ninety-one was a taxing year. All my castles were breached. The thirty-year-retrospective exhibition highlighted my most intimate self over all those years. Physical and psychological weaknesses that I had not known I had were stripped of the topsoil of my rationalizations. And I turned into the decade of my seventies. No matter how vigorous a life I am living now, I know that my time on earth is running out.

I agree with Cicero that nature does a good job with a life and will in all likelihood see me out of it in orderly fashion. Our planet turns around the sun, the celestial bodies run their impec-

cable courses. All I honestly know about this order is that it *is*, obviously, an order. Cicero remarks that the more intelligent people are, the more they "with their longer and clearer view perceive that they are on their way to a better world." Perhaps.

The idea of death itself, the process, sometimes makes me shudder. How will it come, in what form? Will I be able to behave well? I hope so. I am reasonably convinced that I will do what most dying people do—the best I can. And I feel curious, the same curiosity that has led me along in my life to explore its range and reach.

In the meanwhile, I am concerned to leave my affairs in good fettle. I have made as thoughtful a will as I can devise with the counsel of a classmate of Samuel's at St. Albans, his prep school. The boy I remember, sturdy and somewhat mischievous, has become an estate lawyer; he is the friend of all my children and will join them to take care of any matters I cannot handle before I depart. If all goes as planned, I will be buried in the form of the ashes remaining after fire has reduced the elements of my body. Tidied into a little wooden box, I will go into the earth in Fletcher, North Carolina, alongside my parents. The graveyard lies next to a small stone church that overlooks mountains lying smoky-blue in the western distance.

Age has endowed my body with a substantiality that is something of a comfort. Although I miss the delight of a lithe waist mediating the bone cage of my ribs and the semicircle of my pelvis along the easy sway of a flexible spine, I like having more flesh with which to absorb the sorrows of old age. For I find them exponential, more poignant than those of youth and middle-age because perspective gives me foresight as well as hindsight—and I now know how little I can do about them.

In a willful suspension of logic, I used to hope that my children

would somehow be spared the worst of life. So to some degree they have, but both my daughters have been painfully divorced, one is a widow, the other has a child who will live the rest of his life with a threatening illness. And my son has struggled in the coils of a tempestuous temperament that he is only now, with difficulties he keeps to himself, learning how to place in the service of the poetry he writes. All three are making their way without the financial security that so eased my path when I was their age.

Family life can be heartbreaking, but on the whole I find it sustaining. I look at my grandchildren with wonder. They are so *fresh*. The whites of their eyes are so pure, their arms and legs so warm and round and firm. Most of them are old enough to say what they are thinking. I love listening to them, and they like me to tell tales of what they call "the olden times," as if I were a tribal bard. Relieved of the tending that their parents do, I can enjoy their companionship with freedom, relish their idiosyncrasy without reprimand, and wholeheartedly join them in their present.

Sometimes we have adventures together. When Charlie was about seven, he and I set out one hot sunny summer morning to replace the cracked glass on a drawing I had given him. We drove east into a section of Washington in which I used to have a studio in the 1960s before I built the one in my garden. Twisting and turning between high walls through a narrow dirt alley, we made our way to my framer's workshop, past haphazard flotsam and jetsam, upended boards and splintered crates and rusted pipes and sprawling piles of broken bricks. Here and there, sodden piles of garbage gave off the strong smell of decay; we smelled old urine too.

Suddenly I noticed that Charlie looked pale. I stopped the car.

"Does this bother you?" I asked gently.

"Yes," he said. "It's ugly, and it *smells*."

"Yes," I said. "It smells and it's dirty and it's messy and that's what it *is*." I smoothed his bright hair. "You needn't be afraid. This is the way the backs of buildings are, you don't see it from the front."

Outside the framer's steel door, three men and a woman perched on a cement shelf along the shady side of the building, drinking their morning coffee out of Styrofoam cups and talking in the desultory way of people who have no plans. We exchanged salutations. Now that I work in my garden studio, I miss the casual comradeship of urban alleys, the all-in-the-same-boat unity of common human ilk.

I leave Yaddo tomorrow. I am packing up my studio this morning. I have had with me small sheets of fine paper, my favorite pencils and some white paint but I have not touched them. I have instead put this journal in order, which has been more difficult than I thought it would be because I have had to think through what has been going on in the back of my head since last spring when the Emmerich retrospective began to loom. Technically, I am a dinosaur: I write by hand in notebooks, and in time transfer the words to my typewriter, revising as I go; then an experienced secretary puts the text on her computer. This is a laborious process, but it suits me. I like the slow pace.

I really seem to have come here to get my feet on the ground—literally, for I have felt it under me as a resource. My walks have meant as much to me as the work I have done, glad as I am to have cleared the way behind me, especially as the way ahead looks busy.

I have been reinforced by the reliable repetitiveness of the schedule here, by the freedom from interruption, by the nourishing meals (I sometimes skimp at home) and, as always, by compatible

company. More vividly than ever before, I have felt too the presence of the generations of artists who preceded me here: Wallace Stegner, Flannery O'Connor, Clyfford Still, Milton Avery, Philip Guston, William Carlos Williams, Aaron Copland . . . a noble company.

"How I miss you all at Yaddo!" Langston Hughes wrote after a visit. I will too when I take to the air again tomorrow.

I am home. I circle my territory with the pleasure of renewed vigor, realigning my household and picking up the reins of my own customary routine. There is nothing as satisfactory as normality.

The men from my storage and transportation company are in and out of my studio where I am working along as usual. We are preparing for the retrospective exhibition at the Baltimore Museum of Art, which opens on February 2, and for the Grimaldis Gallery opening, also in Baltimore, two days later. I am having dinner with the friends I have missed. Mary and Julia, now delightfully companionable at six months old, came over from Annapolis for the night. I have been to visit the National Gallery of Art, and to the Hirshhorn Museum for the opening of a friend's exhibition. I am teaching. The red light on my telephone answering machine blinks a lot, announcing calls. I am writing letters, gradually bringing into order the affairs I could ignore while I was away. I have had my teeth cleaned and my hair cut, and have gone over my "good" clothes with an eye toward the coming openings.

January and February are my favorite months. I like the bare branches of trees, structure become visible, and the subtle colors, all sorts of varieties of browns and grays that are seen only at this time of year, brought into focus by the pellucid light that is as close an analogy as I know to the silence out of which my work emerges.

Trismegistus—"As above, so below"—and Terence—"I am hu-

man; nothing human is alien to me"—were joined in my personal pantheon by Heraclitus when I was eighteen, a student in a philosophy class at Bryn Mawr.

I might not have picked up Heraclitus with so much ardor had I not been taught by Désiré Veltman. Dr. Veltman was Dutch, born in the Celebes in the Dutch East Indies. He had the power of utter integrity. Because my name (Dean) began with a D, I was seated right under the podium on which he stood so I looked up at his tall, painfully thin body at a sharp angle. He had wild red hair, glittering very blue eyes, and an accent I had to strain to understand. He taught me to leap from idea to idea without falling into the pit of dogma. I recognized in him the principle that objective intellectual search denies the honest searcher the comfort of "belief."

Heraclitus postulated that two great laws order the universe: the Logos, the law that nothing changes, and the Flux, the law that everything is always changing. He conceived of these laws as at once opposite and identical, as the convex and concave sides of a curving line are at once opposite and identical.

When I had been working in art for some ten years, I began to notice that I felt as if I were doing what was "right" when I felt fractionally distanced from what I was making. I began to experience a kind of alive silence—I cannot say it more clearly—that was new to me. I was surprised. I felt there a subtle balance that had a neutrality dissociated from the passion that I had always thought must necessarily inform art. But by then I had developed respect for my instincts. I kept on thinking about my feeling until one day it occurred to me that Heraclitus's convex-concave curve might be narrowly lined by a space. And that if I practiced remaining in the silence of this space, succumbing neither to Logos nor to Flux, I might align myself with the operation of both forces. I took to this point of view while working.

As time went on, I gradually realized that I felt an unusually acute kind of consciousness in that silence. And that a particular kind of knowing sometimes surprised me there. As, in November 1961, a vision initiating the work that I have been making ever since simply manifested itself.

Except for the years when I was dislocated in Japan, my work has continued to present itself as simply. Just this morning a painting appeared in my mind's eye, whole, as if it already existed. It "came in" with its name—*Fram,* in Norwegian, "Forward," the name of the Arctic explorer Fridtjof Nansen's ship, in which Roald Amundsen made his voyage to Antarctica on his way to the South Pole.

The sculptures for the Baltimore Museum had departed from my storage company by the time I arrived there yesterday to repair some minor damage in *New England Legacy* before it in turn leaves next week for exhibition in the Grimaldis Gallery.

New England Legacy is a large sculpture, 82 inches tall x 72 inches wide x 15 inches deep. It is a stepped tower—two narrow steps at the bottom underlie its sheer walls. Painted a dark green and a deep blue, just discernibly different in hue, identical in value, it is a somber and austere piece. I made it in 1963, before we moved to Japan. Yesterday I repainted one side. It was fascinating to feel, as I last did almost thirty years ago, the particular, repetitive reach of my brush up to its height over my head, to be once again in that intimate rhythm.

I find that I am thinking differently about exhibiting, less grimly, more objectively. The Emmerich exhibition touched tender places in my memory, echoes of my first show in New York in 1963 when I was so innocent that I thought an exhibition would change my whole life. At that time I was surrounded, encircled,

by "art friends"—Kenneth Noland, David Smith, Helen Frankenthaler, William Rubin, Clement Greenberg. For the first time in my life, I found myself the center of attention—the heady attention of people with authority in the art world. The possibilities seemed to me infinite, my hopes were unbounded. I had little idea of how transient such attention is, of how rapidly a person can be picked up and dropped. Picked up, I confidently expected to remain a permanent part of that world. I had the wonderful feeling that my life in the studio would forever after be factored safely into the world at large, placed there so securely that I could count on its support while I kept on working. This naive illusion haunted me until last summer when the Emmerich retrospective seemed so nonreverberative. Finally, at long last, I came to recognize this persuasion as a will-o'-the-wisp.

While working on *New England Legacy* yesterday, my body pressed closely to its looming side, its resonance singing in my bones, I discovered a support that is not illusory. The very fact of the sculpture's existence assured me that my past reinforces my present.

A Baltimore art critic, accompanied by a photographer, came to interview me the other day in connection with the upcoming exhibitions.

I vaguely dread being photographed. Confronted by the gap between what I think I look like and what I do look like, I have the uneasy feeling that the camera has not so much caught me as caught me out, detected me in the act of trying to invent my own appearance. While I am being photographed, I bring myself as close to the surface of myself as I can, partly out of respect for the photographer, partly out of honest curiosity: I have never seen myself, never will, never can, and would like to know what I do

look like. It is unnerving to walk around, as we all do, in a body known only from the inside.

No matter how I feel, I am fascinated by the way different photographers work. On an October afternoon in 1968, Anthony Snowdon arrived on my doorstep to take a photograph for *Vogue,* to accompany an article that Clement Greenberg had written for a forthcoming issue. A man as decisive as he was charming, he rejected the turtle-necked bronze-colored sweater that I had put on—he said it suggested "autumnal chic!"—and insisted that I wear something I worked in. So I added the tattered, torn, paint-splattered quilted jacket that I had been wearing in the studio since 1962. Then he wore me out. For three straight hours he moved me from spot to spot, took roll after roll of film, until finally he backed me up against the trunk of a towering tree. I felt its power in my backbone, and something in me gave way. Then he crouched in front of me and chatted away in so amusing a fashion that I laughed out loud with pleasure. I heard his camera click. He instantly got to his feet, said that we were finished, and we had a stiff drink apiece, both of us done in. That final photograph was, even I could see, a perfect version of someone recognizable as me.

An interview gives scope for self-explanation but even so is never entirely satisfactory. Some automatic "acting" raises my voice a tone or two. I try to be perfectly lucid and to "tell the truth" but seem only to approximate the honesty with which I speak to myself. Sometimes, if the interviewer is skillful and intuitive enough to ask evocative questions, I find myself saying what I have never said before and did not know that I knew. At best, an interview is a kind of intimacy—the kind that two congenial strangers might enjoy during a night of bus travel, knowing that they will part forever in the morning. In this sense, an interviewer and I weave between us a narrative to which we both appear to

be equally loyal. But we are not. We entertain hidden agendas while we chat. Our composite narrator evaporates when we say good-bye. I am left with my thoughts; the interviewer cuts and trims a scenario to fit publication. All this interesting communication goes on in an exciting atmosphere. What is essentially a mutual seduction takes place, a seduction that leaves the person interviewed abandoned and the interviewer pregnant with a tale.

When I write about myself, I "interview" myself. There is a gap between the life I have lived and live, and the life I write. Partly this is the inevitable gap between experience and expression, partly what I make by deliberate choice. I am as honest as I can be about what I write—that is a moral imperative—but I "retain my reticences": I omit, abbreviate, abridge and retrench. The keep of my castle remains private.

I could, of course, be entirely silent. But I feel a certain urge to tell what it is like to be an artist in this culture. By writing about one artist, I hope to draw attention to art itself. For it seems to me that a society can discover in it currents otherwise hidden, unarticulated. Giotto's anguished faces proclaim the cost of personal adjustment to the divine order universally conventional in the European Middle Ages; the dirty feet of Caravaggio's Virgin announce the fact that no matter how elevated a role she played in the evolution of Christianity, the Virgin remained a human woman. This art points to Renaissance enlightenment, its emphasis on the individual. In Cubism, Picasso and Braque point to the breakup of the concept that the world is solid, reveal the unceasing motion of the forces we now acknowledge as composing its transient form.

I enjoyed the two Baltimore openings. Warmed by a February thaw heralding spring, the weather was auspicious. Helen Stern,

whose gift of her collection of 1960s and 1970s sculptures to the museum some years ago forms the heart of the exhibition there, sent me a glorious bouquet of early peach blossoms, jonquils and tulips, and the museum sent flowers to await my arrival at the hotel in Baltimore. My children rallied around me: Alexandra came down from New York, Mary and John drove over from Annapolis where he is working in a law firm, Samuel telephoned loving wishes from San Francisco.

Many friends made the effort to come and our convergence in the place where I was born enhanced my pleasure. I felt a satisfying completion, as if I had been responsible to the baby who had first opened her eyes in that spot on the face of the earth, as if my life had come full circle. I felt too a due proportion between my personal life and my work: tried and true friends combined with artists whom I know well and with people who have been for years concerned with my work.

One of those who came down from New York was André Emmerich. Even before 1962, when he offered me my first solo exhibition, our lives had crossed. In 1953, two pieces of mine were included in the Maryland Biennial at the Baltimore Museum of Art. André was visiting the museum and his eye was caught by one of the sculptures, a small expressionistic head in very dark blue cement laced with silver; he asked a member of the museum staff if he could buy it, she said yes (it was the day before the exhibition was due to close), he tucked it under his arm then and there and that might have been that. But a complication developed: it turned out that a young psychologist had already reserved the sculpture for his fiancée. The museum called me with this news, and gave me to understand that either sale might be considered valid, I could choose. I already knew of André as a distinguished dealer in pre-Columbian art because James collected

145

it; I had been distinctly pleased that he had liked my work enough to buy it so spontaneously. I was tempted, but in the first moral decision I ever made about my work I told the museum that the prior sale should hold.

I had not met André before the day of Morris Louis's funeral in 1962 when he came to my studio. I was impressed by his natural dignity, his grave mien, and by the serious way in which he examined my work, without comment. I liked his silence. I was taken by surprise when he immediately offered me a show. There was something grand about a decisiveness so without flourish.

I cherish loyalty, and André's loyalty to me over years and years of drought—my work has sold neither consistently nor well—touches me. It is particularly moving because I am pretty sure that André has not always liked my work; it seems to me even occasionally to offend him because it is confrontational, apparently nonaesthetic, for he is a man who is, I think, in love with beauty. We maintain a formality that tacitly acknowledges real differences in temperament. But we share something more important: a bedrock adherence to principle. André has kept faith with me, and I with him.

Brenda Richardson, deputy director of the Baltimore Museum, installed the exhibition there. We had agreed that she would install alone so when I walked into the rooms filled with work dating from *First*, 1961, to 1991, I had the delight of seeing it from an entirely fresh point of view. One of the trepidations I feel when my sculptures are exhibited is that they may be harmed: people like to touch their surfaces, they mar them without intending to. Brenda forfended this possibility by isolating groups of sculptures inside a designated pathway: they stood aloof from touch save by imagination. I had the happy feeling that the work was safe. And she so placed them that the sculptures reverberated off one an-

other, as if each were a chord in a symphony of structure and color. From the artist's point of view, the true benefit of exhibiting is the insight proffered by inspired installation: my heart rose to see the work set free to speak for itself.

Brenda and I had discussed the difficulty that some people have in understanding the meaning of abstract art. She suggested that I might tape-record the history of the sculptures that the museum owns, dissect in each one the meaning it has for me, peel off its layers to reveal its essence as deeply as words could go. I see that this might be a useful example of one artist's experience, a possible contribution to an understanding of the process by way of which art is made. It would be relatively easy for me to do because each sculpture does indeed have an emotional and intellectual history.

But beyond that meaning each has a meaning of its very own that I myself do not know, the meaning of its final presence, nameless because it is an echo of the pure intuition out of which it originated. No matter how lucidly I cleared the way, this meaning would remain untouched. I have thought the matter over and have decided to remain silent—as each sculpture is silent, available to the viewer's insight.

Misha Ringland's work is currently being exhibited at the District of Columbia Art Center in a show he calls "Blow." Just as in the 1960s I dropped off (without being conscious, however, of having done so) the traditional sculptural preoccupation with the balancing of structural weights, Ringland has dropped off my own preoccupation with the making of discrete objects. The concurrence of our exhibitions is provocative. Even as I watch myself becoming outdated, I take pleasure in his ideas.

His exhibition consists of an installation that is unique, never to be repeated. No attempt is made to make the whole "readable."

Ringland began by painting the gallery's windows black. This decision not only deprives paint of its traditional role of depiction but also serves to exclude the light that makes such depiction possible, as well as to eliminate the natural world customarily the subject matter of artistic representation. So the exhibition is keyed to artificiality.

Each room is lit by one hanging twenty-five-watt bulb which casts shadows on floor and ceiling, and on the walls Ringland painted flat white, leaving areas of their original gray in the shape of boat hulls viewed from below, "b-low"—blow. Eighty-nine small pictures line these walls. Most are black-and-white photographs of elements of colored photographs. These elements were imperfectly developed by the artist: they obviate the canons of viewfinder framing and of meticulous print development. In a document that he did not exhibit, Ringland says: "The context of the original picture (itself an isolation) becomes irrelevant—it disappears without a trace and a new narrative becomes consistent with the remaining, but wholly new, image. The question is at what point does the small become too small—at what point divorced from the larger picture of the world does meaning break down? The viewer with little to operate upon desires the big picture and compulsively catalogs, defines, and adjusts even with the finished evidence of a recognized thing in front of him. The part is never a part."

Ringland's isolated elements are puns on well-known art. They also include other references. For example, to sexuality ("substitution fetishes such as gloves, purses, shoes stand-in for the feminine"); to cruelty (elements of foxhunting: "cruelty dressed up in civilized yet pastoral ritual"). Ringland notes that "An image is passive no matter what it is because it is related only to the viewer's taste, given the absence of hierarchy . . . in any form but appetite."

Each of the two rooms in the exhibition contains a sculpture,

both assemblages. One refers to passive time (salvaged books, a deflated bicycle inner tube, a battered tin pitcher), the other to energies released in active transformations of matter (electrical wires, beeswax). Each assemblage is mounted on four legs—a chair, a table—symbolizing, Ringland told me, the Aristotelian four causes.

"I made," Ringland writes, "a representation of the represented world where order is determined by arbitrary shreds of standards known only by habit. A sardonic grammar of equivalence in the complete absence of hierarchy, and its replacement with the deified subjective: the malign blossoms of a knowing abjection in the face of images." His exhibition forces viewers to acknowledge a solipsism excluding all illusion.

Such an exhibition edges on being meaningless. But the very Romantic energy it seeks to deny shows through. The rooms seethe with a kind of beauty that has to do with the excitement of having to redefine everything visible in them.

I found Ringland's exhibition hard to look at. The black windows and the apparently haphazard accumulation of "ugly" objects depressed me—as Charlie was depressed by the cluttered debris in the framer's alley. The whole presentation felt like a "blow" in the face. But after an hour of careful examination I realized that I was being forced to consider an idea that I had not before taken so seriously—that meaninglessness might in itself constitute an order of ironic meaning.

Different as our exhibitions are in look and means, Ringland and I hope to tender the same idealistic reward: unpredictable personal revelation.

I have been thinking of how ideals are occasionally self-destructive because I have been reading about Robert Fitzroy, and have

particularly remembered the experience that showed me how my own idealism could lead me astray.

Fitzroy was the captain of HMS *Beagle*, the ship in which Charles Darwin sailed around the world on the voyage during which he made the observations that led him to formulate the theory that the evolving survival of the fittest is a law of nature. He had taken command of the *Beagle* in 1829 at the age of twenty-three, while in South America. A man of deep religious faith, Fitzroy believed in the literal, absolute accuracy of every word in the Bible. A man of action as well, he had while in Tierra del Fuego picked up three Fuegians whom he had brought back to England and educated at his own expense so they could spread Christianity in their native land. Two men, York Minster and Jemmy Button (so named because Fitzroy had bought him for a large pearl button), along with a little girl, Fuegia Basket, had been clothed and schooled, even introduced to King William and Queen Adelaide, by the time the *Beagle* again set sail, with Darwin aboard as naturalist, in 1831.

Accompanied by a young missionary and by a whole lot of goods and chattels provided by the London Missionary Society (including tea trays, wine glasses, soup tureens and chamber pots), the three fastidiously clad natives were set down in Ponsonby Sound on the Beagle Channel in Tierra del Fuego, land of ice and wind at the farthest reach of the South American continent. Ponsonby Sound was Jemmy's tribal home. He was greeted by his family, but barely; to Darwin's sympathetic eye, "the meeting was less interesting than that between a horse, turned out into a field, when he joins an old companion."[18] After laying out a vegetable garden and generally setting up a little civilized community, the *Beagle* departed. It returned ten days later to find the place overrun, the vegetable garden trampled and Fuegia Basket

in hiding with the women. There had been menacing confrontations. York Minster had sided with his own people, Jemmy had been molested. The missionary was unstrung; Fitzroy took him back on board.

When the *Beagle* returned again a year later, the camp was entirely derelict. York Minster and Fuegia Basket had joined forces and departed. Jemmy, in whom Fitzroy had placed most confidence—he had learned to speak English and relished his European clothes and sophistication—was still there but was clad only in a loincloth, and the hair in which he had taken such pride hung around his face in coarse strings. "We did not recognize him till he was close to us," Darwin writes. "We had left him plump, fat, clean, and well-dressed; —I never saw so complete and grievous a change."[19] Amiable as ever, he presented otter skins to Fitzroy and had dinner aboard, but his weeping mate refused to leave the canoe and despite the captain's pleas Jemmy rejoined her. The *Beagle* finally sailed away, leaving him waving from the desolate shore in the light of a campfire.

Darwin felt that Fitzroy had done harm. It was wrong, he concluded, to interrupt the natural development of a culture, slow as it was in Tierra del Fuego. He notes that "Their skill . . . is not improved by experience: the canoe, their most ingenious work . . . has remained the same, as we know from Drake, for the last two hundred and fifty years."[20] It was especially dangerous to interfere with people. He was, as usual, right: at the time of his visit in the 1830s there were thousands of Fuegians, in 1960 scarcely one hundred.

Robert Fitzroy was stricken by the failure of his mission, and seemed never quite to recover. His spirits, always somewhat volatile, were henceforth more obviously depressed. He clung even more rigidly to his theoretical convictions. Because all hu-

man beings were descended from Adam and Eve, he held that there could be no logical differentiation among the peoples of the world; some of Adam and Eve's descendants had deteriorated but only because they had drifted away from the Holy Land; they could be saved if they were simply restored to the knowledge of God enjoyed by their ancestors in the Garden of Eden. He had acted strictly in accordance with these heartfelt principles. It had apparently not crossed his mind that his spiritual ideals would not automatically prevail.

Darwin's admiration for Fitzroy's seamanship, his courage, his energy and his integrity never fails but as the voyage continues the two friends increasingly draw apart. Darwin cannot deny the scientific evidence that he is accumulating and Fitzroy cannot countenance any ideas other than his own.

The *Beagle* returned to England in October 1836. Although Darwin was never entirely healthy again—the seasickness he suffered without surcease for almost five years may have damaged his system or he may have picked up a tropical bug during his adventures on land—his life was henceforward a steady upward progression. He married unusually happily, had ten children, established his genial family in a comfortable house in the country, and with exemplary deliberation published the scientific findings that changed the course of history. Fitzroy's life darkened. His wife died in 1852, his eldest daughter four years later, at the age of sixteen. He was made vice admiral, but sustained a bitter blow when the man who had been his first lieutenant on the *Beagle* was appointed over his head in the naval hierarchy. He took refuge in the science of weather, and originated the method of weather prediction on which, even now, all shipping depends.

The two men last saw each other in a terrible confrontation at a meeting in Oxford in 1860. Darwin was lecturing on his re-

cently published *On the Origin of Species by Means of Natural Selection*, speaking to an audience in an uproar of vociferous disagreement. "Amid the hubbub a slight grey-haired man got to his feet. His thin aristocratic face was clouded with rage, and he waved a Bible aloft like an avenging prophet. Here was the truth, he cried, here and nowhere else. Long ago he had warned Darwin about his dangerous thoughts. Had he but known that he was carrying in his ship such a . . . He was shouted down and the rest of his words were lost."[21] Five years later Fitzroy killed himself.

Fitzroy was twenty-three when he adopted the Fuegians in an attempt to make his ideals come true in the world. I was twenty-four when I made the same sort of idealistic decision: I went to a tiny mining town, Force, Pennsylvania, to live the rest of my life with people I had heard were poor, in need.

I was distraught when I made this rash resolution.

Soon after I began working at Massachusetts General Hospital, in the fall of 1943, I met and fell in love with a doctor interning there. By the time he left for the Pacific as an army medical officer some months later, I thought that we had reached an understanding that we would marry. But I was mistaken. When he returned to Boston at the end of the war in 1945, he told me, all of a sudden, within hours of his arrival, that he planned to marry someone else, immediately, within a week. We had been walking in the summer gloaming, and had stopped to rest by a stone wall. I was so shocked that I ran, fast, around the block. And, without ever quite coming to, resigned my job at Massachusetts General and ran away to Force soon after.

Like Fitzroy, I had my theories. I felt pain to be so universal, so profound, that I could see no solution save to submerge myself in it and assuage it to the furthest limit of my ability. I had read about a doctor who was working with the miners in Force and

decided to offer myself—my training as a nurse and psychologist—to her as an assistant. My thought was that I would live as the miners lived and do for them whatever I could no matter what it was.

I flew from Boston to Williamsport, Pennsylvania, in a storm so severe that the stewardess was strapped in, the passengers vomited to the right and left of me; rapt in my grief, secure as in a trance, I felt the wings of the plane as a bird's triumphantly riding the wind. I spent a night in a boarding house in Williamsport and took a train the next day to a small town, St. Marys, the nearest point of transportation to Force, arriving as night fell.

Both hotels were full, no room, I was told. As I turned away in some despair from the front desk of the second, a man's voice spoke up from behind a palm tree in the lobby. Cecilia Auman was a nice girl, he said, and might take me in for the night; she worked in a drugstore nearby; I could ask her. I trudged through the dark streets and found her behind the counter: a young girl, perhaps sixteen, with an ingenuous face framed by a translucent cloud of pale curling hair. Yes, she said; her brother was to pick her up at ten o'clock. We drove in his truck far out into the country, I was welcomed by her surprised mother, given a bed and the next day breakfast and noonday dinner—but by that time I was so nervous that I couldn't eat even the mashed potatoes. Rattling back to St. Marys in the truck, I decided to telephone my sister Harriet and ask her to join me. Ever loyal, she came. By the time she got there, I had established myself in a hotel and had made an appointment to see the doctor in Force.

I simply presented myself in her office, waited until she had finished with her patients, and asked her if I could work with her. Baffled, she was kind. She invited me to accompany her on her evening rounds and said that she would talk it over with the man-

ager of the mine. The whole settlement (mean-looking, coal-dust-darkened dwellings straggling narrowly along the slopes of steep hills) was owned, I must understand, by the mine. The decision would be his. Two days later, I saw him in his office, a thoughtful man in his forties with thinning hair and patient eyes. I explained. He suggested that I return to Cambridge; he would write me. In due time, he did. In a carefully considered, two-page, tactful letter he told me that both the doctor and he had concurred that I should not come. The doctor did not feel the need of any help; they both felt that I was too young and too inexperienced; my motivation, honest as it was, was too personal. He was delicate, but entirely decisive.

I moved from Cambridge to Boston and rented a $16-a-month railway apartment in the North End of the city. I got a part-time job in a bookstore, I walked and walked day and night, I wrote and wrote—poetry and short stories. I came gradually to understand that I had been delivered by the kindness of strangers and of my faithful sisters (Louise was as solicitous as Harriet, both sympathetic) out of the depths of grief. And one bright summer evening, while riding alone in the rumble seat of a car on the way back to Boston from a concert at Tanglewood, it appeared to me as if in a flash of lightning that I might by way of art, of writing as I thought then, evoke the aspiration that can lift a spirit, relieve it of pain by opening a new way.

I was more fortunate than Fitzroy. Not powerful, not used to command, corrected by the common sense of the doctor and the mine manager, humbled by grief but vitalized by a naturally optimistic temperament, I learned that idealism need never be relinquished but is best tempered by some degree of pragmatism, best served by a mind responsive to change.

I would rather dine with Charles Darwin, but Robert Fitzroy is

of my own ilk. I too feel that all and everything shows forth a mystery so whole that within its context there can be only temporary differentiation. I too have a taste for the absolute. My studio is as intact a little unit as the *Beagle*, as easily overrun by the world encircling it as Fitzroy's Fuegian encampment.

It might appear that of the two men, Darwin survived as the fittest. But they are more like than unlike in essence, as they may unconsciously have perceived when they first met and became friends, for both were gallant, both courageous, persevering, disciplined and tenacious. It is tragic that Fitzroy had so little natural faith that he was driven to a rigid adherence to doctrine.

Now that the two exhibitions are in place in Baltimore, I have returned to routine. I am working on *Fram,* the painting I saw in my mind's eye last month. Four feet by ten feet, it is so large that it engages peripheral vision; that is, it can only be absorbed at a distance, and even so eludes the instant focus of foveal vision. I am fascinated by the way it is coming into view as I apply thin layer after thin layer of three closely attuned grays. I seem actually to feel it moving forward toward me. At some unpredictable moment we will "meet," and then part.

Parting from a work of art is a skill. During the 1950s while I was teaching myself how to be an artist, I used to keep bearing down on the work under my hand until I felt it was finished. For some years I failed to realize that each work had a timing of its own, that in some subtle way it finished itself. Once I had learned to pay more attention to *it* instead of to myself, I began to notice that nothing in art is ever "finished." I could transfer many of my habits to my work but I could not enjoy the satisfaction of having completed a task—as I was accustomed to finishing the dishes or making the beds or completing an academic paper. Instead, I learned to catch

the moment when a work trembled on the threshold of becoming an entity, and to take my hand off it, leave it be. By the time that my work began to appear in my mind in the 1960s, I had fixed this phenomenon as a fact and could accept the corollary fact that every work I made was a failure when looked at in the light of what I had conceived that it was going to be. No matter how faithfully I folded concept into a material form, something evanescent and ineffable remained aloof. Concept resisted facture, and matter resisted the imposition of concept.

When my work began to go out into the world in the 1960s, I found that the things I made sometimes evolved a history all their own. Now I have a mental map of where these works are, so to speak, living. When I go to the National Gallery of Art, the Corcoran Gallery of Art, the National Museum of American Art, all here in Washington, I occasionally see my work unexpectedly. Once I was walking through the Corcoran and glimpsed a flash of orange; I stopped, backed up, and saw in a distant corridor *Flower*, a sculpture I had made some years before. I walked around it with a strange feeling combining the excitement of recognition (I so well remembered making it, the tenderness with which I had pursued the subtle variations of color in an ideal calyx and stamen, the heart of flowering) and of objectivity, as if it had in some authoritative way made itself. Some years later, a curator at the National Gallery called me in to discuss the care of one of the two pieces in their collection; when I saw *Spume,* which is ten feet tall, looming over me once again, I felt stunned—as if confronted by something made by someone else.

A year or so ago I flew over New York on my way to Boston. I looked down on its urban texture spread out in detail in the dry air, and felt a kind of wistfulness as I tried to pick out the location of the Museum of Modern Art, the Whitney Museum of American

Art, the Metropolitan Museum of Art, to pinpoint inside them the sculptures that existed there, so far from my ken.

Other works are scattered around the country, north to Minneapolis and Buffalo, west to St. Louis and Los Angeles, south to Charlotte and New Orleans. I will likely never see them again. A collector bought *Way* out of my studio one summer afternoon and took it to Italy; I am not sure where it stands on that magical land.

I best like my work to be bought by a collector who simply takes it home and keeps it. I imagine how such a work may change, even perhaps in some mysterious way develop, when it becomes a familiar in a particular household; even how it may affect its owners as the seasons roll over it, day and night, year after year.

But for all that my work in art may be at large, it is the distribution of my books that has astounded me. *Daybook* was published in 1982. Pantheon printed an edition of 7,500 copies—7,500, I could scarcely take in the fact that a single work had so proliferated. A year later, it went into Penguin paperback, where it is still in print. *Turn* went out into the world in the same way. I can have no idea of where all these objects are. I only know that, like minute electronic devices, they continue to send me signals in the form of letters from readers. Letters sometimes so eloquent that they touch me to the quick; I answer every single one, gladly.

The fact that publication of a book renders a singular effort not only universally accessible—and at a reasonable price too—but also *safe* is a comfort to me. For I have had to accept the fact that when my work in art leaves me, it goes out under the law of accident and cannot be entirely protected. In 1969, a sculpture that I had made in Japan was caught in a truck collision while en route from Ohio to New York, and smashed; when I heard the news, I felt sick at heart—but when I received the insurance pay-

ment I used it to paint the inside of my house, which I had just bought, all white. I came to understand that the sculptures and I were in a reciprocal relationship by way of which we exchanged a kind of energy.

Some time ago a friend who had flown from his home in Boston down to Richmond wrote me a postcard to say that he had seen in a bank there a sculpture he instantly recognized as mine. Recently, a little girl saw that same sculpture, *Signal.* It is a small column, 59 inches tall x 5½ inches x 4 inches, painted in clear yellow, white and blue horizontal planes. It must have looked like a Maypole to this enthusiastic child: she ran to it, hugged it, swung around it—and scuffed it. I do so like her reaction, which mitigated the automatic spasm of anger I always feel when one of my pieces is damaged. The bank has sent me the sculpture for restoration. I am working on *Signal* now, with the good feeling that I can return it in pristine condition to a place where it apparently encounters appreciation.

Not all damage is that minor. A columnar structure running on a line of gravity from earth to sky is as intrinsically precarious as a human body; no matter how carefully weighted and how strongly constructed, it can be struck down. *Knot,* a column 81 inches x 8 inches x 8 inches, was recently so toppled. This sculpture had survived the Persian Gulf War in the basement of the American embassy in Tel Aviv, but last month a photographer backed into it and knocked it over. A representative of the U.S. State Department Art in Embassies program, under whose aegis *Knot* had been placed in Israel, was present the other day in the studio when I uncrated it. As I raised it to its full height over our heads, we heard loud cracks. The material wedged into a solid cradle at its base, ballast to prevent its tipping, must have been shattered by the force of its fall. To judge from the scars denting its pure yel-

low, white and black encircling colors, it probably dropped at so tipped an angle that it hit the floor twice. The Art in Embassies representative remarked that the Tel Aviv embassy has a marble floor. In any case, the internal damage is, for a variety of structural reasons, irreparable.

I have never been able to detach myself sufficiently to prevent a feeling of having been hurt myself when my work is damaged. I use the money I receive for restoration to make new work, but I never stop rather anxiously holding all my work intact in my mind, hoping for its safety. In *Knot*'s case, this attachment was augmented by the fact that it had traveled in a foam-lined bed inside a wooden crate beautifully made by an old friend. He had for many years packed my work. Last December, he was killed, senselessly gunned down in the street, instantly bereft of both dignity and life in yet another of the wanton murders that now characterize our urban area. His crate is perfect; it stands in my studio reminding me of him, and of *Knot* as it will never be again.

Knot is in chancery. An insurance adjuster came down from New York to examine it. A man so dewy with youth that he could be my grandson, he will make the final decision on its fate. Coincidentally, he will affect my financial position, as by the terms of my contract with the Art in Embassies program his company is bound to pay me *Knot*'s current market price. The stranger who overturned the sculpture halfway around the world may have placed in my hands a sum well over what I now earn in a whole year of teaching.

I have been thinking sadly about my esteemed friend so suddenly snatched out of life while walking down a street. He could have had no time at all to prepare himself for that ultimate change.

I have always had a dumb but persistent faith that when I died, "I" would continue. Leaving my body to be dissolved into its various substances, I would ride in the vehicle of my soul, spirit and mind in close company, into another lifetime. In the course of an unforeseeable number of future lifetimes, I would continue to learn, ever improving, until somehow accepted into eternity. To my dismay, I am beginning to see this linear sequence as a construction similar to the narrative I am accustomed to write for myself in this life, on the paradigm of drama. I have seen myself as a pilgrim, bearing the treasure accumulated in each lifetime into the next. Essentially, a protagonist.

I am only now, unexpectedly, realizing the full force of the words I wrote some months ago: "A human being may be simply a cluster of particular forces temporarily magnetized at conception, and demagnetized at death." I feel backed into a corner by my own logic. I shiver when I think of relinquishing my concept of myself as a pilgrim soul. But honesty is compelling me to recognize that in my "pilgrim soul" I may have devised a final refuge for my egoism.

I feel deprived of climax: eventual absorption into the eternal promised some kind of ecstatic transformation. But if what I define as my soul, "spirit and mind in close company," does not exist in continuity as an entity, I will have no personal consciousness with which to experience anything at all. It is hard for me even to conceive of such a loss. Yet death will come upon me, and I would rather cultivate detachment now than find myself in a tenacious battle to hold on to a nub of self while being overwhelmed by death's omnipotence.

It was when Alexandra was three months old that I felt the full force of maternal attachment, the strongest of all those I have experienced. Her doctor noticed that she had one more roll of fat on one leg than the other; that, she said, might mean my baby had

been born with one leg longer than the other; she might be "crippled." X-rays were taken. While I waited for the results, I ran through the worst scenario: Alexandra's inevitable pain, her having to go through life with a disablement, her bright spirit having to cope with disappointment instead of rising freely into whatever her potentiality might be. I thought it all over carefully while I rocked and nursed her. I searched her eyes to probe her courage. By the time I learned that her legs were perfectly all right, I had decided that I would have to make a little psychological distance between us, and in that space work with her to enable her to accept her fate—to detach myself by that margin so as to reinforce her courage with mine. This decision initiated a pattern: when my children are threatened, I try (I don't always succeed) to find in myself a modicum of detachment in order to bring to bear a perspective that may illuminate the situation.

When my work began to go out into the world, I found that this habit of practicing detachment was useful. But last summer my recognition of an inordinate attachment to *First* sharply reminded me of how tentative my efforts are. Tentative, difficult, but nonetheless worth making: it is subtly degrading to be at the mercy of the ego's narcissistic grip.

But now that I am thinking about how to distance myself from my self, I see plainly that the very struggle is itself egoistic. A solution might be passivity, submission to the momentum that carries a life forward naturally, borne like a leaf on the surface of a river. But my temperament is not passive. I no sooner think of floating like a leaf on a river than I invent a whole scene: a shallow rippling river winding between speckled sycamore trees that arch high over a newly green translucent beech leaf gently moving to the rhythm of water and flickered by noon sun.

* * *

Clement Greenberg died in 1994. I have revised this part of my journal, originally written because he had given me permission to speak with his biographer. I was doing so, off the record by my choice, as the winter of 1992 began to thaw into spring.

Even though I saw him only rarely during the last years of his life, I find that I miss Clem's presence, as pungent as the scent of a wild fox, somewhere on the margin of my life. He appears in my memory in flashes: pointing a sharp forefinger at a painting, his head cocked to one side, his formidable intellect focused like a laser to probe the idiosyncrasy of the artist in a way at once respectful and relentless; walking on the balls of his feet, lightly, from gallery to gallery in a museum, catalog in hand, making notes, indefatigable. I miss his relish of art. I miss his relish in general, his engagement in whatever was immediate, whether a martini, an oyster, Jane Austen, Kant or Marcel Proust. I miss the unpredictable twists and turns of his mind, not always kind, sometimes downright mischievous, sometimes even cruel—though it was my impression that he could regret his wayward tongue: occasionally I heard him revise a verdict in such a way as to soften its impact without in any way compromising its force.

For force Clem had. He had, after all, thought consistently, persistently, deeply about culture and art. I miss his definition of his knowledge as a responsibility. I miss his willingness to judge, matched by a willingness to find himself mistaken, to adjust an opinion to reflect an honest change in what he called his "take" on a work of art. He was in this sense a profoundly moral man.

No artist ever had a more faithful friend to her work. I remember the electricity of Clem's first look at it, early in 1962, the speed with which he took it in and his immediate grasp of its character—above all, the instantaneous, surprising generosity of his response.

And once his fidelity to my work was crucial. "I had an idea that you might have gone back to Tokyo a little upset about your show," he wrote in a letter dated March 12, 1965.

I had just returned from my second exhibition at the André Emmerich Gallery. The previous October a dearly beloved friend, Mary Pinchot Meyer, had been murdered while walking along the Potomac River. I flew from Japan directly to Washington, where every mutual friend relived with me our loss. I was grievously inundated by the time I arrived in New York for the opening of the exhibition. A longshoremen's strike had paralyzed all overseas shipping, preventing the delivery of the sculpture I had made in Japan during 1964 and 1965, so we installed an exhibition of work dated 1963, before I had left the United States. Then, when the Japanese work was released, we replaced our entire exhibition with this new sculpture.

I was appalled when I saw it. It was hard to believe that I had made such lifeless stuff. I knew that I had been miserable in Japan but I had kept on working doggedly, hopefully.

The work failed on two technical counts. The first was that I changed from wood to aluminum—in an attempt to make work that would be easier to ship, I told myself; actually, I had been tempted to make "heroic" sculpture, to go in the direction to which Roberta Smith pointed in her review of the recent Emmerich exhibition, to use the technological range of metal. But my nature is not attuned to metal; this decision distanced me from my own temperament. The second was that Japanese light subtly changes color; in New York, it lost the meaning I had seen in it in Tokyo. I had also used Japanese marine paint, sticky to my hand, and not as easily inflected in hue as the water-based acrylic paint I was used to.

As critically, I had experimented with intellectual formulations

of visual space. Abandoning the sheer weights and plain forms which I truly understood, I had "cut" the sculptures into perspectival shapes that were not without intelligence, but, fatally, without sensibility.

I destroyed all my Japanese sculpture in 1974.

I put on the best face I could and rode out the 1965 exhibition but I returned to Japan in a state of unhappy bewilderment, stirred to my depths by renewed grief for Mary's death escalated by a loss of trust in the validity of my work. Furthermore, the validity of my whole life: I felt an utter rout of confidence.

When Clem's letter arrived, I read it over and over, sitting by the window of our living room, for I had fallen back that sunny morning on being a woman—a wife, a mother—had retreated to the domestic cave to lick my wounds.

It's seldom that a show gels anything for the artist himself, though it's more than human not to keep on hoping, with each new one as every artist I've ever known does, that this one will do it. The issue, really, doesn't lie with a given show, but with the declaration of quality (as you know deep down) and after that the sustaining and developing of it.... General quality is what counts in the long-run, and the long-run itself is all that counts.... It's a matter of keeping at it, show in and show out, or even no shows at all. And if you keep at it recognition will come, inevitably, only it will come without ever giving you full satisfaction and not in the way one dreams it will come. That's the way it was for Pollock and that's the way it's been for David [David Smith] and Ken [Kenneth Noland]—I mean recognition never came to them the way they'd hoped; it always remained a little ambiguous; and I honestly think that's the way it was for Matisse and is for Picasso....

. . . it's quite possible that in the matter of your exile in Japan providence is conspiring with your gift and inspiration: by making things tougher it's also making the art itself better. One never knows here; the chances are that the worse it feels or seems the better it will turn out for the purposes of art.

But it was not in the context of art that I came to know Clem as a friend. In 1966, when I had been living in Japan for two years, he arrived there to visit under the auspices of the Cultural Division of the U.S. State Department. He traveled with a Japanese guide but in between these trips he stayed in Tokyo, and became an adopted member of our family. He enhanced all our lives, especially those of my children, for it was one of Clem's courtesies to treat children attentively. He bought them Beatles records and danced them around the living room!

I had the pleasure of showing him the byways of Tokyo. Undelineated by the sharp edges of his public identity, anonymous in a strange country where he could say only Good Morning, Good Night, Thank You and Good-bye, he was almost childlike in his insatiable curiosity. He meekly purified himself with a bamboo dipper before entering Shinto shrines, and his quick eye picked out the interstitial vistas which are the delight of Tokyo's twisting, ancient lanes. We fell into the habit of an easy silence, content to be absorbed into the commonality of Japanese life.

I particularly remember one afternoon when we took a local boat on a long, slow trip up the Sumida River, winding north through a part of the city that had been hideously flattened by American bombing. Jammed in with a mass of people, we watched day fade into evening. In that twilight, something adamant in Clem seemed to give way: I felt what he may have been like when he was alone.

166

Above all else, I cherished, and will remember all my life with gratitude, Clem's native sensibility, alive, responsive and, finally, wise.

Samuel has returned to San Francisco from San Miguel de Allende. He found his father's grave unmarked, anonymous in the dry soil of Mexico, and marked it.

Oliver Wendell Holmes, chief justice of the Supreme Court, believed "that, at a primitive level of the unconscious mind . . . the son absorbed and became his father."[22] This principle, he thought, underlies the law of inheritance by way of which the child legally becomes the parent, with all attendant rights and responsibilities. In the eyes of the law, children *replace* their parents.

In effect, the Christian injunction to "honor thy father and thy mother" means to honor thy self, to respect in thy own person the natural law of continuity linking one generation to the next. Holmes was childless. He mentions neither the difficulties with which children "absorb" and "become" their parents nor those that parents encounter when they are forced by the passage of time that is bearing them away to accept their own replacement. Nor does he mention the paradoxical relief both feel when development eventually delivers them from the intensity of subjectivity into the light of objectivity. The longer I live, the more tenderly and thoroughly I understand my parents. My children too. As they have matured, I have watched them take from James and me what example they needed, discard what they did not need, add their own temperaments and characteristics into the mix, and move ahead on their own trajectories. If all goes more or less normally, mutual independence results in mutual appreciation.

In his biography of Pablo Picasso, John Richardson speculates that at about the age of thirteen, Picasso "must . . . have realized

167

that, compared with other bourgeois families, his parents were poor and déclassé, and that his beloved father was a pathetically bad teacher and painter. This realization would have dealt Picasso's pride a grievous blow. His response was embodied in a determination to exorcise the stigma of parental failure by a triumphant display of his own gifts."[23]

Success may constitute a subtle patronage of parents. First, by impertinently interpreting their lives as failures to be erased, or recompensed; second, by dispelling parental authority through sheer evidence of superiority. In the arrogance of my childhood, I remember having these feelings myself. My parents seemed to me to have settled for uninteresting lives which failed to make them happy (I wanted them to be happy so I could be happy) and I decided early on that I would work hard and do better, break away from a no-win situation.

A child may also think of success as a trophy to be laid at the parents' feet—an exercise in futility if the aim is to earn the approbation and affection denied in childhood. Igor Stravinsky writes: "I am convinced that it was my misfortune that my father was spiritually very distant from me and that even my mother had no love for me. . . . I was resolved that one day I would show them. Now this day has come and gone. No one remembers this day but me, who am its only remaining witness."[24]

Baudelaire notes that "Genius is childhood recaptured at will." We all relive our childhoods all our lives in one form or another. Mine has often been a source of intense, incommunicable joy, but as often a source of equally intense, incommunicable sorrow. I mourn my parents. I longed for them, yearned after them. But they never seemed to guess, or to want to know, this longing. It was as if my temperature were too high. My feeling was too intense to be appropriate, so it could never become articulate. I had

to learn to keep it within bounds. It is cruel, really, to expect from infants and young children a politeness defining how much, where, when and which emotion can be expressed.

Suppression was the only answer my parents implicitly offered for all that I felt. So I found substitute places to put it. It is for this reason, I think, that "place" is so important to me: place and proportion. I had to develop a construction within which I could be as intense as I was. I took to a bleak independence within the context of which expression was possible, but perforce secret. Alone in the early morning before the grown-ups awoke, I could pelt up and down in the garden—but I had only a dog to keep me company.

One of the rewards of independence was ironic: I took to "mothering" my parents. They liked that. When my father had "flu," a euphemism for the periodic alcoholic depressions that confined him to his room, I used to visit him when I came home from school. I would hug him gently, pat him, and tell him about the little adventures of my day. His sad brown eyes would look up into mine, as if hoping against hope. And when my mother was not feeling well and went to bed early, I would leave the desk in the library where I did my homework to look in on her. I would go down to the dark kitchen, heat up water for her hot water bottle, and then sit with her, my hand on her inert shoulder.

For all his brilliant career as a composer, Stravinsky remains disconsolate. This is the hollow core of success: a "triumphant display" motivated by a resolution to "show them" fails to assuage a primal yearning. Paradoxically, success reveals to a successful person the very maw that it was so hopefully and with so much effort designed to fill. One triumph leads to another, but each is marred by a lurking grief that subtly defuses satisfaction.

Unlike success in other walks of life—the surgical operation

169

enables the patient to survive, the lawsuit is won, the house is built—success in art is always problematical. Countless artists are acclaimed while alive, forgotten when dead. Art critics, art historians, dealers—all who have to do with art once it is made—have of course their own motivations but among them is surely a desire to aid and abet artists whom they admire. As surely, they often encounter ingratitude. The reason may be that they are unconsciously addressing in artists an unconscious longing for which there can be no meet answer, no consolation.

The real reward of art is quintessentially immediate and private: the moment in which a work that has been invisible, conceptual, becomes actual. This always seems to me a miracle, each work *itself*, so fresh and new. This instant has an equivalent in childbirth: I always felt that I had got acquainted with the child in my womb but not quite enough to know who the person was, so at the moment of birth I felt a kind of recognition. The phrase "Oh, it was *you*" used to come into my mind when I first beheld my babies.

On the line of Heraclitus's convex-concave curve, parents yearn for their children even as their children yearn for them. The sad fact is that neither yearning can be entirely expressed. The child's yearning is prime, primitive and overwhelming. The parent's, although equally so, must be controlled if the child is to reach healthy maturity.

Now that I have brought up my own children, I see that my parents may have fostered in me the very independence that I thought I was inventing for myself. One of my early distinct impressions was that they had their minds on me, but that they kept their distance, allowed me leeway. I remember being grateful for that. Other parents, I noticed, hovered closely over their chil-

dren's heads, making them feel anxious—for why would they hover unless there were cause for anxiety? Or some failure on the child's part to follow a hidden agenda, to meet expectation? Such intrusive parents leech invigorating oxygen out of a child's air, subtly smother initiative. Such close attention affects the parents also, binds them to the parenthood that is, when all is said and done, only a part of an adult life. If any life is predicated on that of another person, both lives are somewhat stunted. Like bonsai trees, such relationships are miniaturized: they can look pretty, but at a cost fatal to growth.

One emotional aspect of the discipline of bringing up children is the sexual compatibility/incompatibility of gender.

Having enjoyed the comfort of common gender with Alexandra and Mary, I missed it when Samuel came into puberty. I was not exactly sure how to go about guiding him without impinging on the territory of his developing manhood. We both had to depend on good will. We simply muddled through until his maturity delivered us into the compatibility of mutual interests. Samuel led the way. In the spring of 1982, after his father's death and while he was recovering from the hepatitis he had caught while visiting him in Mexico, we drove together to Charlottesville—he thought to transfer for his final two years of college to James's alma mater, the University of Virginia. He drove. I can still see the field at which I was gazing, meadow and a few tenderly feathering trees bordered by a split-rail fence, when he suddenly began to ask me questions about what it was like to work in art, to engage me in the context of his own poetry. I straightened up and focused, and immediately, as if we had topped a mountain into a savannah, we found ourselves equally involved in intense discussion. We spoke as peers.

SPRING

Late yesterday afternoon, the painting *Fram* declared itself whole: it simply left me behind as irrelevant. I was taken aback, as if the breath had been knocked out of me.

I gave it one look in acknowledgment and walked, dragging my feet, to sit on my front porch in the warm spring twilight. Abruptly idle, weary, I watched a pair of red-breasted robins apparently trying to decide whether to build a nest in the apple tree. I felt lonely, as if deserted by a faithful friend, for *Fram* has been keeping me company for some time, bridging me over the ups and downs of daily life.

And in that one brief look, I saw that the painting itself is a bridge in my work. The broad sweeps of its two subtle grays, one overarching the other, reach toward invisibility in all four directions. The low "horizon line," a third closely attuned gray, runs along very slight changes in angle so that it quivers, appears and

disappears. I have been hovering over this line since 1961. I first began to draw it to delineate a dark—black or deep purple—shape looming on white paper, isolating the shape as if differentiating mass in space. Over the years, the line has become more and more independent. It is this line that I saw in the seagull's wing above Lake Huron, and it is this line that encircles *Nicea*, the horizontal line of tiny scarlet brush strokes cutting across vertical broad panels of pink that Brooks Adams thought "hysterical." I have hitherto kept some control over it, but yesterday it broke under my hand, like a distant wave cresting in an open sea.

I have just returned from Philadelphia, where I worked on a panel selecting artists for grants. We the jury sat day after day in a dark room examining and reexamining slides of the applicants' work until we more or less unanimously reached a consensus of priority.

I enjoy such meetings. The company of other artists is a pleasure and it is a privilege to serve one's peers by helping to support them. I have been looking at art for almost fifty years; every single work I see adds particularity to its context in my memory. And every such survey of contemporary art contributes to my overview of the whole field. Years of service on panels, on advisory boards, boards of directors and for the National Endowment for the Arts, plus working visits to universities and art schools around the country, have revealed to me a responsive network offering opportunities to talented artists. It is common cant that resistance to it is a hallmark of significant new art but I am impressed by the open-minded professional attention, comparable to a radar beam, that seeks out art worthy of reward. Young and unknown artists can count on this radar: they need not unduly worry that their work will be overlooked.

While in Philadelphia, I stayed at the Bellevue-Stratford Hotel. When a student at Bryn Mawr, I used to lunch there with a friend of my mother's who made an annual circuit from Maine to Florida, stopping in Philadelphia to see her brother—who was my mother's first love. A desperate love. "I thought the sun rose and set with him, Annie dear," she once told me, in her voice an unappeasable grief I heard only one other time, when she spoke of her own brother, who was smothered to death while playing in a cave during the summer of his fourteenth year. The man my mother loved married someone else and she fell sick of a wasting fever; "Louisa was never strong again," her sister said. When I lunched with her friend fifty years ago, I used to remember all this and I remember it now, sad for my mother's grief, familiar to me now in my own life, in yet another of the strands of the past that are running like colored threads unfaded by time through the pattern of my present.

I would not have come to this wholly gentle sympathy with my mother had not my own experience caught up with hers, and had I not acknowledged, after my visit to Miss Frances, the silent violence of my struggle to separate myself from her. Even more importantly, had I not been forced to recognize in myself her resignation to limitation that had so threatened me while I was growing up. For in Vancouver, under Harold Kalke's roof, I finally came to know as futile my desire for limitlessness.

The Pacific Ocean lay fair before me. I threw out onto its immensity the imaginary line (akin to that I drew on *Fram* and *Nicea*) on which I had been traveling—still yearning—but even as I did so had wryly to acknowledge that in moving as far as ever I could on that line I inevitably would have to return to the longitude on which I was already placed. A person looking to geography for release is like a snake trying to swallow its own tail.

Instead of limitlessness, I found limits: my own physical limits. A few days before John Dolan and I arrived in Vancouver, I had not been able to make it to the top of Athabasca Glacier in the Canadian Rockies. Obstinately, I managed to reach the meandering ridge along which the glacier came to a stop at a temporary angle of repose. The tremendous frozen mass maintained its integrity until its actual meeting with raw earth. Become brittle, the ice mingled at this edge with friable dirt. An innocent-looking meeting but I was feeling the weight of my years and by analogy to age it seemed a little sinister. The earth was disappearing under the ice creeping over it, overwhelming it, as the sheer weight of years bears down a life.

At Vancouver I began quietly to accept the help that Harold and his wife and John seemed to feel due an older person. When we went on a picnic to the Pacific rocks one night, I would not indeed have been able to make it home on the primeval forest trail without Harold's arm. Their hands reached out to me before I knew I needed them. I took them with an increasingly sweet feeling of acquiescence.

And at some point between Athabasca Glacier and Vancouver, I noticed that while looking out the window of the car I had stopped thinking *I might*—"I might touch that ancient black rock with one hand and that virgin snow with the other"—and started thinking *It is*.

Early daffodils are blowing in the March wind. The grass in my garden, dun and sere all winter, is greening, and short stout shoots are poking up out of the mulched flower beds winding out to the potting shed and lining the gray-shingled walls of the studio. The sky is a deeper blue and against it the soaring trees are misted with apricot-color buds announcing the leaves to come.

178

Today is my seventy-second birthday. I feel more changed by the past year than can be accounted for. Plants sometimes surge into efflorescence toward the end of a seasonal cycle and I am wondering if the decade of the seventies may be one of very rapid transformation. I remember having a similar feeling when I turned into adolescence—the strange swell of breasts and the stirrings of new sensations throughout my body, and psychological unsettlement, a trembling in the balance. Then I was intoxicated by the promise of my life to come.

Now that I have lived that life almost to its end, I look back on it and see a rough-hewn match between what I thought it was going to be and what it has been, and is. I recognize it as my own, characteristic in a way deeper than words can say, as if what I am now has always been inherent in me and has simply manifested itself by way of time and experience, as butter materializes out of churned milk.

Even the roads that I have taken or not taken, the mistakes made in ignorance and willfulness that have led to results I neither took the trouble to foresee nor could have foreseen, seem now to have been challenges eventually factored into some kind of responsive personal consistency. I ask myself whether there are, within the inexorable tide of a lifetime, "mistakes." May we not each of us evolve so entirely within a larger teleology that our lives are woven, warp and woof and willy-nilly, into a weft of cause and effect so immense in scale and complexity as to be forever beyond our apprehension? May we not be analogous to the individual cells of our bodies, which live for varying lengths of time and can be thought of as leading autonomous lives, each contributing to our function? Every human being adding some essential singularity to the pattern of humankind?

There is little room for egoism in this view. But if there is such

a thing as a mistake, it may be egoism itself. The adjustments that I have made with so much effort, hot and heavy with ardor, begin to appear to me utterly ordinary, even mechanical, and the events of my life, however interesting to me while I am living them and however characteristically handled, essentially anecdotal, a personal sampler of the general human lot. This feels like a comedown. I understand why older people can look colorless to younger people, as my mother once looked to me: we may seem to have given up a vital struggle. But that very "giving up" may open a way through and beyond the change of death when we each, like earthworms who spend their lives unearthing earth into minuscule new configurations, leave the constellation of the world minutely but distinctively altered.

Yesterday I drove over to Annapolis for my birthday, thinking to sink into the pillow of family life. But when I walked into her house, Mary said, "Shut your eyes," and led me around a corner. There, in the sunshine, rosy balloons floated over a table festive with a pink cloth and spring flowers, and set all about with chairs: a surprise "ladies' luncheon"!

Nine friends, gathered from miles around, smiled and exclaimed and welcomed me. Every one is uniquely dear to me, in particular ways for particular reasons stretching back for years and years. One I first "met" when her mother, who was also there, was pregnant with her; another I have known as Mary's friend since they were in their teens; with two I am linked by literary ties; with two others, both English, a critic and a painter, by way of art; with two more by various mutual lively interests. United by the mysterious compatibility of gender as well as by affection, we wove among us a lovely embroidery of light voices, initiating Mary's little daughters into the ceremony of congenial company.

The intimacy of tried and true friendship abides forever. Initiated by affinity, nourished by layers of conversation growing ever richer as experience is shared on deeper and deeper levels of trust, it is sure comfort and delight. I honestly do not know how I could live without the friends who know me as well as I know them; those who have died I live with in memory. We guard one another, sometimes like warriors in a fierce battle. We pool our resources, expand our range along our various lines of knowledge and judgment. We pay one another a special kind of wholehearted attention without let or hindrance even as it respects reticence, bows to the tactful reserve that the *I Ching* notes as characterizing all voluntary relationships. We read one another's lives as we might read novels, but with an empathy that reveals novels to be, even at best, secondhand. We watch our lives unfold, we discuss, we think things over together. Our memories stretch back like aisles into a past we remember from our different points of view and can translate for one another so that it illuminates the present. And, above all, we laugh! We laugh because no matter what happens or will happen we breathe the air of mutual fidelity.

In *The Art of the Novel*, E. M. Forster divides fictional characters into "round" and "flat." Round characters develop during the course of the novel; they carry the narrative line forward bearing with them the author's meaning. Flat characters neither develop nor change at all; they exist in the interstices of the plot's action, lightening it here, darkening it there, like Jane Austen's Mr. Collins and Charles Dickens's Smike. We recognize them instantly when they appear, we know them for what they are without having to give them particular thought.

The friends I know and love best are round characters in my life. We are developing together, we learn from one another and

influence one another in profound ways. Without them I would be lonely, but I also relish friends who remain more or less flat: people whom I know slightly but have known for a long time, people whom I may have met only once but have enjoyed meeting—I think of an Englishman I once sat next to at a dinner who had read widely and could swing with pleasure from Virgil to Proust to a miscellany of contemporary writers. Many of the flat characters in my life are professional friends: we meet to get things done and we chat as we do so on a level that is perforce superficial but nonetheless satisfactory. Even the most fleeting encounters can be interesting. My children used to be embarrassed because I have the habit of talking to strangers, a small-town habit. I recognize my father in myself—he too liked to pass the time of day.

And, like all ardent readers, I have friends whom I have never met, friends who keep me grand company.

Ernest Shackleton is my favorite of all the early Antarctic explorers. He was the most *natural* leader. Robert Falcon Scott was disturbed, as well as by temperament a private person with private goals to which he thought of his men as contributing and for the sake of which he heartlessly put them in jeopardy: even on the return journey from the Pole, when his companions were on the edge of starvation, stricken with scurvy, ice blindness and deadly fatigue, he urged them to pause for hours on end in order to collect geological specimens. Roald Amundsen was more steady in character and constitution, but as egoistic. His one goal was to reach the South Pole and to return, safely. To this single end he strained every effort of his formidable will and intelligence.

Shackleton was an experienced polar explorer—he had twice almost reached the South Pole—by 1914 when he set out to

cross the continent of Antarctica. The *Endurance* sailed from Grytviken, on South Georgia Island, on December 5. She carried a party of twenty-seven seamen and scientists, and one artist, with Shackleton in command. Six weeks later, she was beset by pack ice in the Weddell Sea and drifted northward in its terrible grip for ten months. There are photographs of her, slightly canted as if riding a lively sea, first surmounting the ice, then slowly, slowly giving way, her timbers relentlessly crushed, until only her spars are visible, then no trace at all: she disappeared, swallowed by the ice pack on which by that time the party was encamped.

On April 9, 1916, the northern rim of this immense field disintegrated under them and the men launched their three lifeboats. Six days later, against fearful odds, they beached on Elephant Island. It was "a desolate speck in Antarctic waters,"[25] but for the first time since leaving Grytviken they had land under their feet. Winter was approaching. Their supply of food was limited and they could not entirely count on penguins and seals. They had no hope of rescue; any rescue party would look for them in the Weddell Sea and would never be able to guess their location, so far off the planned route. Plainly, a few men had to risk their lives for the preservation of their companions, had to sail in the wild winds of those latitudes almost a thousand miles to the nearest inhabited point, South Georgia Island, from which they had set out over a year ago.

They prepared the largest lifeboat, the *James Caird*, which had been built to the orders of F. A. Worsley, the captain of the *Endurance*, in July 1914. She was 22 feet long. "Her planking was Baltic pine, keel and timbers American elm, stem and stern post English oak." When loaded for the trip, her freeboard (height above the water) was 26 inches. The carpenter bolted one of the other boat's masts inside her keel so that she would be less likely to

break her back in heavy seas. Leaving a space at the afterend for steering and access, they covered her with canvas thawed over a blubber fire and stitched into place. Her seams were caulked with cotton lamp wick; the artist, G. Marston, made them waterproof by coating them with his oil colors, finished off with seal blood. They rigged her with a jib, a standing lug, and a small mizzen.

On April 24, Shackleton, accompanied by Worsley, a superb navigator, and by four carefully selected seamen, set sail. On May 7, they landed at King Haakon Bay, a desolate, uninhabited shore of South Georgia Island. Leaving three men there, Shackleton, Worsley and T. Crean, second officer of the *Endurance*, crossed the formidable ice-rock mountains of the Allardyce Range, traveling by day and moonlit night, and seventy-two hours later stumbled into the whaling station at Stromness Bay. Worsley writes that "Three or four weeks afterwards Sir Ernest and I, comparing notes, found that we each had a strange feeling that there had been a fourth in our party, and Crean afterwards confessed to the same feeling." The Norwegians at Stromness told them that "there was never another day during the rest of the winter that was fine enough for us to have lived through on the top of the mountains."

One hundred days later, on his fourth attempt, Shackleton rescued the party on Elephant Island. He had not lost a single man under his command.

> For scientific discovery, give me Scott; for speed and efficiency of travel, give me Amundsen; but when disaster strikes and all hope is gone, get down on your knees and pray for Shackleton.[26]

His leadership is legendary. To begin with, he had a strong constitution—"he was always wonderful at keeping awake for two or

three days or even more if necessary"—and great physical strength. One night after the *Endurance* had sunk and the party was camping on the ice pack, the floe on which they were sleeping cracked right across under the seamen's tent, which it tore into two halves. "In spite of the darkness, Sir Ernest, by some instinct, knew the right spot to go to. He found Holness—like a full-grown Moses—in his bag in the sea. Sir Ernest leaned over, seized the bag and, with one mighty effort, hove man and bag up on the ice. Next second the halves of the floe swung together in the hollow of the swell with a thousand-ton blow."

When the time came to select the men who would sail in the *James Caird*, Worsley writes: "It was certain that a man of such heroic mind and self-sacrificing nature as Shackleton would undertake this most dangerous and difficult task himself. He was, in fact, unable to do otherwise. . . . He had to lead in the position of most danger, most difficulty and responsibility. I have seen him turn pale, yet force himself into the post of greatest peril." Later, one night on watch while sailing to South Georgia, Shackleton remarks to Worsley that he knows "nothing about boat sailing." Worsley comments: "For me, used to boat work, surf landings in every kind of craft, this passage was an adventure. . . . To him, who had drifted gradually from the sea and become mainly a land explorer, it must have been more menacing, perhaps even appalling."

Above all else, Shackleton was tender.

If a man shivered more than usual, he would plunge his hand into the heart of the spare clothes bag for the least sodden pair of socks for him.

He seemed to keep a mental finger on each man's pulse. If he noted one with signs of the strain telling on him he

would order hot milk and soon all would be swallowing the scalding, life-giving drink to the especial benefit of the man, all unaware, for whom it had been ordered.

At all times he inspired the men with a feeling, often illogical, that, even if things got worse, he would devise some means of easing their hardship.

Shackleton died in January 1922 while on his way to Antarctica for another expedition. He is buried on South Georgia Island. I like to know that he lies there, between the frozen peaks of the Allardyce Range and the rolling waters of the South Atlantic, his grave ceaselessly raked by fierce gales.

It is all very well to live in an imagined geography with my "friends" but such participation, however engaged, lacks the bite of truth. I have recently been feeling the force of this distinction because I am writing a book review of Dore Ashton's *Noguchi East and West*, and every word that she writes about Japan evokes the clear-cut vision of it incised on my memory by over three years of residence there. I "go back," stand underneath the royal cryptomeria trees, clap my hands in ritual at the shrines, thread in the delicate, disembodied Japanese way through the throngs of people, smell the tangy winter smoke of Tokyo and the salt-rich decay of the pulpy black sea weeds heaved ashore by the encircling ocean. I hear the crow's harsh call over the iris-river at the Meiji Shrine and the poetic, repetitive wail of street vendors under the somehow intimate Japanese moon.

Isamu Noguchi's mother was American, his father Japanese. Born in Los Angeles in 1904, he lived in Japan from the age of two until he was thirteen, when his mother decided that he should be educated in the United States. She entered him in a school in In-

diana, and thence he departed alone, back across the Pacific Ocean into the heartland of the North American continent—a journey symbolic of the split in his native blood between East and West, and the second of the global crisscrossings by way of which he all his life bridged this abyss. By the time of his death in 1988, he had flown tens of thousands of miles, alighting here and there to anchor his life in works of art ranging from single sculptures in every sort of material to stage sets to public spaces based on the paradigm of Japanese gardens. I met him once, on a sunny afternoon when he had alighted in Washington: a slight man, lithe and fast on his feet, with canny, alive, very black eyes. A Hermes, wingèd, bearing messages.

He made his first sculpture before he was five: "the form of a sea-wave, in clay with a blue glaze." A literal depiction, from which years later he made the leap into abstraction. This leap looks easy, foreordained, but, I think, actually depends on intuition informed by a kind of divine grace.

At the age of seventeen, Albert Pinkham Ryder vowed to himself that he would paint nature as he saw it or give up painting altogether. He recalled in his maturity: "In my desire to be accurate I became lost in a maze of detail. Try as I would, my colors were not those of nature, my leaves were infinitely below the standard of a leaf, my finest strokes coarse and crude." He struggled with this perplexity for months at his grandfather's place on Cape Cod until one day:

> The old scene presented itself . . . before my eyes framed in
> an opening between two trees. It stood out like a painted
> canvas—the deep blue of a midday sky—a solitary tree, brilliant with the green of early summer, a foundation of brown
> earth and gnarled roots. There was no detail to vex the eye.

Three solid masses of form and color—sky, foliage and earth—the whole bathed in an atmosphere of golden luminosity. I threw my brushes aside; they were too small for the work in hand. I squeezed out big chunks of pure, moist color and taking my palette knife, I laid on blue, green, white and brown in great sweeping strokes. As I worked I saw that it was good and clean and strong. I saw nature springing into life upon my dead canvas. It was better than nature, for it was vibrating with the thrill of a new creation. Exultantly I painted until the sun sank below the horizon, and then I raced around the field like a colt let loose and literally bellowed for joy.[27]

I used to feel like bellowing myself when my own work jumped into exhilarating freedom. Jumped but never quite lost touch with the vision that flooded my inner eye that night in New York in 1961. Artists end in their beginnings. Noguchi's little clay wave grew, transmogrified into a dazzling variety of forms, but all his work derives its vitality, to my eye, from stopped movement, movement caught at its crest; and Ryder's paintings ever partake of the bucolic, of some naïveté of impulse. My own very first sculpture was a woman, made of clay, earth, seated full and solid in her own weight. Like my columnar sculptures, she is fixed at what Noguchi calls "the dead center of gravity." More personally, she is what I am becoming.

Dore Ashton speaks of what the French philosopher Gaston Bachelard calls "lived spaces." These are, Ashton explains, "the spaces of the imagination. . . . Such as the spaces of attics and cellars, of sea shell and tree, cupboards and drawers, cave and sanctuary." Bachelard suggested, she writes, "that childhood spaces are 'inscribed' in us. . . . Archetypes . . . of essential and emotionally in-

vested spatial experiences."[28] Archetypes to which we all have access. Because childhood is experienced in common, the spaces of an artist's imagination can spark comparable secret, sacred memories in a viewer. People who can receive the presence of a work of art may find themselves restored to selves they have half-forgotten. Refreshed by another's imagination, they can delight anew in their own.

And can as well view afresh the world around them. "There is to each stone," Noguchi wrote, "a live and a dead side."[29] In a 1987 interview, he says that for him stone is a "direct link to the heart of matter—a molecular link. When I tap it, I get the echo of that which we are—in the solar plexus—in the center of gravity of matter. Then, the whole universe has a resonance."[30] Rocks were so individual to him that when he found that certain granite boulders high on Tsukuba Mountain in Japan were inaccessible, he insisted that a road be cleared, skidded them down and had them shipped to a plaza he was designing in Fort Worth, Texas.

Just as Noguchi's affinity with stone led him to "the heart of matter," mine with water has led me to consider the continuous transformation of everything. Beset that summer at Lee Haven but allowed to wander at will, I used to walk away from the dark house, through the woods and down to the river on the other side of the peninsula on which it stood. A narrow footpath meandered through milkweed taller than my head, ending nowhere, just stopping when it reached the water. I loved that place, a secret all my own, I thought. I used to squat close to the edge, my sneakered toes wet, and watch how the narrow ledge of earth gave way to mud as pale as the river, and then dissolved into it, lapped up, sucked into the gentle tide. A persimmon tree hung low over this spot, its orange fruit the only vivid color among the grayish green bushes. One day I plucked one of these lovely little

189

globes—and found it so bitter that my mouth puckered and I spat it out. My Eden shattered. And I know now that milkweed is a euphorbia: the pure white milky sap I used to touch to find out what it felt like can be poisonous.

Much later, while studying chemistry, I learned that water seeks its own level and found out what the river had been doing. In the course of time, I came to identify myself with it. I found that if I could imitate its fluidity, its edgelessness, I could trade the solidity of preconceptions that limited me to what I judged acceptable for the freshwater tides of life as I lived it along. New ideas could be examined and factored into an ever-expanding context.

New technologies too. Just as in the early 1840s the manufacture of oil paint in portable tubes enabled artists to work outdoors, to paint directly from nature, impulsively, the invention of artist-quality acrylic paint in the 1950s enabled them to cover large surfaces. Because it is water-based, this paint particularly suits me. It flows easily, lends itself to my hand. The proportion of pigment to medium can be inflected in virtually infinite proportions so I can mix the thin layers by way of which I can make it transparent, and rich. I use ordinary utensils: glass bowls and large nonmetal kitchen spoons, a tea-strainer and house-painting brushes as well as sable-hair brushes. I keep everything very clean, wash and rewash, so whatever touches my work is as fresh and pure as I can make it.

And I paint on wood, with which, like water, I feel affinity. I like to think of slow-growing trees stretching between earth and sky.

I began to feel off-color recently while driving back from a day of teaching at the university and by the time I arrived home was decidedly ill. I have canceled my trip to Greensboro, North Carolina,

where I was scheduled to open my exhibition at the Weatherspoon Gallery, to visit the Art Department of the university there, and to give a public lecture.

I was stricken by a virus that is mowing down the students, but this kind of illness, minor yet peremptory, is familiar. I tend to charge ahead on a demanding timetable, willfully ignoring signals of fatigue, until I have used up reserves of energy. Then, in an unconscious or even more or less conscious decision, I take to illness, provide myself with an excuse to stop, to absorb what has been happening.

Passivity allows nature to take over, and nature has a way of taking care of things well, in various interesting ways. The rhizome, for example, grows by putting forth rhizomorphs, slender tentacles equipped with enzymes that facilitate the digestion of certain elements in the soil—a forest fire provides it with a feast. When a few years ago Mount Saint Helens erupted, a particular kind of frog was apparently annihilated; but the tadpoles produced by the few remaining frogs have thrived in waters enriched by volcanic runoff: even as older frogs died, younger frogs have prospered in larger numbers than before the eruption.

When I am overtaken by a minor illness, I think about what I am doing and how I am doing it. By paying close attention to my experience, I can accumulate it in a form I can use. This is, in a sense, a scientific method. In reminiscing about his father's working habits, Charles Darwin's son remarks that he never "let an exception pass unnoticed." Darwin was "charged with theorizing power ready to flow into any channel on the slightest disturbance, so that no fact, however small, could avoid releasing a stream of theory. . . . He was willing to test what would seem to most people not at all worth testing."[31]

Illness may be a form of adjustment but it is a poor one. Well-

191

balanced people keep a weather eye on the intercourse of action and energy. They ward off situations of undue strain, and when they occur, as they inevitably do, they allow themselves leeway to adjust their behavior adroitly to circumstances. They have a kind of objective compassion for themselves.

This is the second time that I have had to cancel official arrangements involving other people. I was mortified to have been forced by headaches to break my teaching contract with the Maryland Institute of Art last October, and now I have caused inconvenience again. I would have been wiser, and more considerate, to have canceled a couple of classes at the university during the current epidemic.

The matter is more fundamental, however. The energy on which I am accustomed to predicate my arrangements is becoming jerky and is also decreasing. I am living on a less dependable amount of energy. I have always worked hard and then rested. It is the proportions that have changed: I am able to work less and must rest more. But in recompense I am gradually finding that "resting" is a pleasure: I read more than I used to; I dig in my garden; I meet with my family and friends; I take longer walks at a more leisurely pace. To be contented has become a purpose.

Spring is rising out of the ground, up into the leaves and blossoms of trees to join light winds in a brightening sky. Waxing and waning on its lawfully appointed course, the sheer authority of divine bounty stuns me. Now that I feel my own equally lawful diminishment, I rejoice too in its absolute reliability.

My exhibition at the Baltimore Museum is still on and last night at the Maryland Arts Gala—artists in brilliant costumes dancing to music pounding off floors and walls—I took an opportunity to look at it again.

One sculpture in particular, *Ship-Lap*, made early in 1962, struck my eye as pulsating in a way that I had never before noticed. Sixty inches by forty-eight inches by twelve inches, it consists of four vertical bands, each twelve inches wide, two very dark green, two black, divided from one another by grooves like those rabbeting the edges of boards in a wooden ship so that each laps over the edges of those adjacent to make a visible joint. The green and black were "held" within this strict structure, but as I looked they advanced and receded as if breathing. How did I know thirty years ago, I asked myself, that this pulsation was the essence of this sculpture? The answer is that I didn't. And if I didn't know then what I was making, I don't know what I am making now. This realization had always lurked in the back of my mind but last night it stepped into the foreground. Irrelevant really: I shall simply keep on making work even if I am unlikely to live long enough to "see" it.

It seems disingenuous to say that until last night I had never entirely realized that my work *already exists* as an actual whole, but that is the truth. Recognition of its autonomy must have begun in late 1989 when I became conscious of all that I had made in art as a weight bearing down on me, pressing me to action on its behalf. Jung once remarked that his patients were far more willing to admit to their "bad" impulses than their "good"; nobility, he found, was more threatening to them than ignobility. I may have felt this kind of natural modesty. But in the context of the museum last night I came to recognize, with neither modesty nor immodesty, that my work is, in fact, a minute tessera in the dimensionless mosaic of art.

I feel a tentative relaxation, as if I no longer have to hold on so hard to the nerve which has been to me like Ariadne's thread in a labyrinth. I even begin to discern the topography of the labyrinth, as if it had been unearthed, opened to a sky from which

I can look down upon the dark corridors along which I have made my way. I begin to see this labyrinth as self, and I am now wondering how my absorption with its twists and turns has affected other people. Have I been selfish in my obsessive exploration? Has the independence I claimed for myself so early in life, and so defiantly, not only isolated me but also isolated from me, and hurt, people who otherwise might have been able to touch me more closely, deprived them as well as me? For I have maintained a psychological distance, I see, in order to adhere to my line. And the monster of the labyrinth has been fed every single bit of my experience, even the nearest and dearest, even the birth of my children out of love given and taken, out of my very body. This could be a terrible confrontation with a self with whom I have been so identified as to have become myself a kind of monster but, mercifully, I see it all rather objectively.

Even so I am wondering if my work has seduced me into inordinate willfulness. I feel remorseful, as if I had sinned.

Dame Julian of Norwich was a holy woman who lived most of her life as a solitary in a cell attached to the cathedral at Norwich, England. In 1372, when about thirty years old, and at death's door, she experienced in a few hours a series of ecstatic revelations, after which she suddenly recovered and lived until 1413. Her revelations taught her that remorse is useful because, inconsolable, we seek its meaning by turning to the largest context we can know—the divine. There we find mercy, its intimate touch on our minds and hearts. Thus we come to some small intimation of the nature of the universal creative force. In this sense, Dame Julian concluded, our sins are lawful, ordained to bring us to this humble insight. We can be comforted, for, she writes, "all shall be well, and all shall be well, and all manner of thing shall be well."

But "all manner of thing shall be well" only in an infinite con-

text. Personally, I feel what James Joyce calls the "agenbite of in-wit," the fangs of conscience. I have tended to arrange my life selfishly in order to keep on pursuing art as much as I wanted to.

Perhaps such a life, even though selfish, is not after all without its benefices. Mary told me this morning that before she left the museum last night, she walked one final time through my exhibition. She wanted to circle one of the sculptures. When a guard forbade her to leave the carpet designated in the installation as a pathway, she suddenly realized that these familiar sculptures no longer especially belonged to her, my daughter. Then she thought of a future time when she might see them after my death, and, though sad, see that her mother was still there, a presence in the work.

In 1989, scientists launched the satellite Cosmic Background Explorer. COBE's findings have just been announced.

Its differential microwave radiometers have measured temperature variations of one-hundred-thousandths of a degree. The configuration of these variations indicates that the galaxy in which our planet is a tiny body originated about fifteen billion years ago in a cosmic explosion, a "Big Bang." This explosion initiated "ripples" of matter which have ever since continued to expand in a uniform pattern of distribution in all directions. Astronomers speculate that "like rocks at the top of a mountain, this first matter . . . gathered momentum . . . until it amounted to countless avalanches, finally accumulated in large piles at the bottom of the mountain—the present universe."[32] If so, we live in a place at an angle of repose, the angle at which moving matter comes naturally to rest. In this case, perhaps relatively to rest, for the law of entropy, the tendency of matter toward inertia, suggests an inherent trend toward an even more inert state.

Astronomers postulate that a force shapes the universe. They

call this force gravity, and acknowledge that it is a mystery—the mystery of Joseph Beuys's "molding or sculpting hand . . . that lies behind everything in the world."

John Dolan and I found the radiant valley in the Canadian Rockies by chance, but some interceptions between person and place seem preordained. Although our journey ended in Vancouver, this valley proved to be my personal destination.

Fair and wide, it lay north-south between two grand mountain ranges of black rock streaked with snow rising steeply toward pure white peaks that surged into the sky as if to declare terrestrial indomitability. Firs spread over the lower slopes in variegated crisp, dark green verticals articulate as fine-tipped brush marks. A swiftly running creek, gently widening and narrowing, wound through the broad shallow bowl of the valley floor, bisecting an open meadow covered with low, glistening bushes.

One afternoon I walked far north up the valley and turned south onto a grassy logging trail that ran along its western slope, bearing with me the heavy sorrow I had thought to outrun in my swift passage across the continent. This mass, the fruit of betrayals given and taken, of hopes ingrained, cherished as hopes against hope, idealisms long gone down to defeat in the coil of common human circumstance, thickened in my throat as if my very life had become saliva and were choking me. I heard myself make a sound, half-grunt, half-whimper, and then, standing straight, utterly solitary, I began to "tell it to the mountains." As I spoke, my throat warmed and opened. I listened to my voice as it materialized in words I had never before spoken aloud, words accepted and, it seemed, assimilated by the great mountains rising into the air above the earth which would in time receive my body and the bodies of my children and their children and their children's children.

Finally, spent, I lowered myself into the cool grasses on the verge of the trail and there, beside my right foot, saw a patch of stout, strong-yellow dandelions bursting out of their encircling leaves.

I have just returned from a trip to Bryn Mawr, where I went to install the small exhibition scheduled to continue through the fiftieth reunion of my class next month.

The foyer of the Mariam Coffin Canaday Library has floor-to-ceiling windows, so the two sculptures, one painting and some works on paper are flooded by natural light. As is an immense Iranian tapestry which hangs high on one wall; dated about 1890, it is marvelously wrought and I was especially glad to see it because it was given to the college by Mrs. H. Gates Lloyd, a Philadelphia collector of art.

I always remember Lallie Lloyd as a collector—she was a friend as well, she and James having been in the early 1960s among the founders of the Washington Gallery of Modern Art—with particular pleasure because she was both ardent and decisive. She flew to Washington in 1969 to look at my work. I expected her to cancel our appointment when I woke up into a blizzard, but she was undeterred. She arrived at the studio precisely on time, in a glistening mink coat and hat that made a fine contrast to the disreputable surroundings in which I was working—I had not yet built my own studio. She looked around, instantly picked out *Ocean Child*, a six-foot column of misty blues, ate some mock turtle soup and cheese and crackers with me, and flew back home through the driving snow. She bought *Sandcastle*, 1963, as crisply, immediately after seeing it for the first time in the Whitney Museum retrospective in 1974. Eighteen and a half inches high by one hundred nine inches long by eight inches

197

wide, it is a long, low rectangle punctuated by two small towers, the whole structure counterpointed by three colors, two tans and a yellow. It was named by André Emmerich, and is the first of my low-lying sculptures. Lallie never caviled. Her faith in my work was forthright, a perfect example of the generous reinforcement that dedicated collectors can give to artists.

Like the Iranian tapestry, the works in this exhibition resonate for me. I made *Valley Forge*, 60 inches x 60 inches x 12 inches, in 1963. Two strong blood-reds, cantilevered one off the other on its rectangular form, at once pull apart and unite the structure of the sculpture; the piece echoes the raw courage of the Colonial militia face-to-face with disunity and adversity at Valley Forge, near Bryn Mawr. *Damask*, 72 inches x 8 inches x 8 inches, 1980, is delicate; its colors, vertical bands of fresh pink, cream color and spring-green, are as innocent as an Elizabethan lyrical poem, or the damask rose for which it is named. It is a hopeful sculpture, hopeful as my classmates and I were hopeful when we entered college.

We hung *Fram* over a stair landing. From that vantage, its subtle icy grays were sufficiently distanced for me to see as I had not entirely been able to before how the line running its length flickers in and out of perception, as meaning flickers in and out of consciousness.

The works on paper date from 1962 to the present. Working on paper is marvelously freeing—something about the way in which it so generously offers itself to the hand, its absorptive perfect flatness, invites a kind of open play. On some of these I have used paint, have put down the massive shape that has haunted me since 1961. On others, I have tried to catch in one or two widely spaced pencil lines edged with tiny brush marks of white the moments at which movement is on the wing, just perceptible as movement.

198

The librarian took our little party of installers to lunch in Rhoads Hall, where I lived for four years as a student. The dining room is reminiscent of a medieval castle: two spreading chandeliers branch overhead and, at either end, ceiling-high leaded windows composed of small clear panes punctuated by random panes of pale blue, pale violet and pale pink inflect the light.

In my luxurious era, the college had many servants. We students who lived in Rhoads Hall walked three times a day into a pattern of round tables covered with starched white tablecloths. At each place a large white napkin. We used to put these folded napkins on the backs of chairs to reserve them for our friends. Seated, we were served by uniformed waitresses.

The style of this room has entirely changed, reflecting historical changes in the college. A cafeteria has replaced the invisible kitchen and the uniformed maids. The students are no longer all women. Bryn Mawr and a nearby college, Haverford, have joined forces; they share students of both genders, faculty and facilities, including dormitories. The sound was different, had altogether a rougher texture, less melodious than in my day, but, I felt, more invigorating.

In the equity of this challenging variety, contemporary students may escape the insidious feeling of social and intellectual entitlement that I acquired along with my education. By my final year, I had become a little arrogant. I got my comeuppance though. I was an honors student, which meant that I wrote an honors thesis qualifying me to graduate "with distinction" if I passed four final comprehensive examinations at a certain level. I ignored the review classes for these examinations. I remember standing at a window one morning while one of these sessions was in progress without me and gazing out at the early spring leaves while thrusting down in myself the uneasy feeling that I was mak-

ing a mistake. I was bone-tired. My mother had died in my junior year. My father was sick with alcoholism and depression in Asheville, and both my sisters were unhappy and unsettled in Boston. I spent much of my senior year traveling up and down the East Coast, trying to do what my mother had asked me to do, "look after the family." In these circumstances, I had had to convince myself that I was "strong," and went too far: I sat for the examinations without proper review and preparation, and my marks were below the honors level. I fell into public failure for the first time in my life. I would graduate, I was told, *cum laude*, but without distinction. I was devastated. I fled to the cloister, and wept.

I stop writing as I remember. I walk around my garden and sit there in a dawn not as comforting as it usually is. I prowl about my studio, stand beside my latest sculpture, more comforting than the garden this time, so tall and straight and staunch. I remember my children and grandchildren, our lovingness. But the darkness that descended on me that day almost a whole lifetime ago stays with me, nullifying for a while all that has intervened.

Yet it was in that very pain that Bryn Mawr endowed me with its final gift: the knowledge of personal failure that is the invaluable predicate of all honest compassion.

And that final reining was a culminating lesson: that achievement depends on unremitting attention to detail, on acknowledgment of the demands of reality, and on submission to those demands; furthermore, on rising to them with a determination founded on a reasoned balance in which goal is given priority.

Spring is becoming summer. Just as I learned in my thirties that a sculpture could not be brought to a tidy end, that it finished itself in its own way at its own time, I am in my seventies taking in as actual fact that I am not going to be able to "round off" my life. In-

stead, I find myself living along a kind of Celtic line, winding back into my life and then winding forward, the past weaving relentlessly into the present and the present as relentlessly into the future.

The novelist Wallace Stegner writes that "The sound of anything coming at you—say a train, or the future—has a higher pitch than the sound of the same thing going away." So, Stegner says, a life in retrospect has "a sober sound of expectations reduced, desires blunted, hopes deferred or abandoned, chances lost, defeats accepted, griefs borne."[33] I hear my life as it recedes from me into the past at the same time that I hear it trumpeting toward me. The "sober" note of my past reverberates in the back of my mind as I position myself in the present to receive the future. It is this interplay that is making aging the most interesting thing that has ever happened to me.

A major part of this interest is objective. It is fascinating to have watched ice that had been cut in large chunks out of a frozen river delivered by horse and cart to our door in Easton and to have flown over the planet, to have seen its photograph from space, even to have stepped in the person of a fellow human being on the moon. Every time I fly, I notice the disproportion between the immense available expanse of the earth and the patches of human habitation on its surface: we are essentially colonists, and our colonies are few and small. It is only in the last ten thousand years, a mere instant in time, that we have abandoned nomadic life to make these settlements. Surely, given our inherently restless, seeking nature, we are going to move out ever more confidently into the universe that beckons us.

I occasionally nudge my grandchildren toward space exploration but so far none seems excited—my last hope is Julia, still too young to say nay! I like to think of their future, of what their lives will be like when current technologies will yield unimagin-

able changes. In the meanwhile, it is simply a pleasure to enjoy family life and I spent last weekend in Annapolis.

After a chatty lunch together—always such a delight to be alone with one of one's children—Mary and I bought garden tools and a lot of flower and vegetable plants. We spent all Sunday making a garden in the sunshine while John went about his household business and took the dogs for runs at the river, Charlie cut the grass, Rosie wheeled about, and Julia stood holding on to us or to anything at hand, crawled or tottered a few steps, or just sat solid as a small boulder watching everything going on around her.

A family's organization is like a nation's. Parents are government officials. Grandparents are *éminences grises:* I keep a tactful eye on matters from a generational distance. I am getting used to being ancillary to the rush of events, which are anyway often too abrupt for me to adjust to easily. I try to resist the temptation to meddle, or to form invidious conspiratorial alliances. This is not always easy; I sometimes jump in and have to pull back. I have a tendency to misjudge the course of events—I say "Be careful," and then catch John's eye and am brought up short by the recognition that he is encouraging his children's initiative. I too did that while I was bringing up my own children, but the instinctive knowledge of how to raise a child's level of aspiration without running into harm's way is not automatically passed on to grandparents: I tend to be too cautious. And my hard-won experience is sometimes pertinent, sometimes not.

When my first grandchild was born, I was taken aback by the objectivity with which I beheld him, as if his birth had isolated for me the fact of human reproduction in and of itself. The naked force of its continuity had been masked from me when my own children were born by the unprecedented outpouring of sheer

love I felt for them. In Alexandra's son, I was startled to recognize an *example*, a link in a continuity of germ plasma to which the personalities of the family were irrelevant: he was, I saw, independent of all of us, to be honored as himself. And, of course, as minute followed minute, love rose naturally to float him into a fresh pond, deep, leaf-fringed, new-formed for his reception.

With the birth of the grandchildren who followed him, the distance at which I first saw Sam opened out into a landscape within which I have come to see the whole family in new perspective. I observe that its constellation is constantly inflected by the intersection of various personal destinies. The predisposing causes of conflict and confusion seem to me unknowable. Effects are equally incalculable. Neither cause nor effect can be controlled, though they can be contained. But only at a cost. Because in its very nature love creates vulnerability, the suffering of any one member is felt by all. All have to make adjustments. Pain has first to be acknowledged, not denied, belittled or brushed over, and then absorbed from the different points of view involved. This refraction breaks it up, reduces its force, and illuminates it in such multiple ways that the afflicted individual can be comforted by empathy, or if that fails, by loyal sympathy.

I have slowly come to realize that a family is composed of people who are teaching one another. Healthy mutual development in this cave of the winds depends on recognition of a common responsibility. If we bring to bear generosity of spirit along with intelligent effort toward equilibrium, I notice, the air we breathe as a family is refreshed by life-enhancing changes.

Some weeks ago Ramón Osuna and I chose twenty-odd works on paper from the decade of the 1960s for the exhibition he will open here in Washington in a few days.

As if in some just compensation for the loss of the excited expectation I used to feel when I was young, my memory of the past is becoming more precise and vivid. I first met Ramón in 1955, and yesterday while we were installing our show he appeared there as if in an illuminated medieval manuscript, delineated at the age of nineteen in exquisitely clear line and color. That summer James and I visited a friend at his seashore house in Cuba: I am six months pregnant with Alexandra. I am wearing my lavender-and-white checked gingham maternity dress, a comfortable free-falling smock enclosing me with my baby, and am standing on a veranda with my back to the brilliant ocean. It is noon. My host has just said to me, *"Mi casa es su casa,"* and I am feeling happy. I look across into the shaded living room and in the distance I see a newly arrived guest, a very young man with very black eyes and very black hair in white cotton clothes. He is sitting at his ease in a woven-wicker chair, waiting for lunch—we had chicken and rice and black beans, I can taste them now!

Ramón and I did not meet again until 1971. By that time he had opened a gallery in Washington. He invited me to show with him, initiating a relationship that evolved slowly during the ensuing years into true friendship. Loyal, above all resourceful, Ramón has given me both honest counsel and the pleasure of his unfailing support. His quick imagination has over and over devised solutions that I, less cunning about how the world goes, would never have thought of myself.

The earliest of the works we chose to exhibit are flatly geometric. Vertical and horizontal blocks, they depend for their meaning on the counterpoint of proportion to a narrow range of color—black, scarlet, dark green, ocher—stark on a field of white. Undecorative, they are utterly austere. I made them in the little attic room that I rented across the street from our house in George-

town, made them fast—one after another they thundered down on me as if tumbling from a waterfall.

By the mid-1960s, while I was living in Japan, I had taken to working out sculptural ideas in two dimensions, using my mind because my intuition had largely failed me. I was homesick so I often used bright, declarative "American" colors. The sensitive way that Japanese light refracts value (the darkness and lightness of a color) may particularly activate the ocular cells that perceive dark/light. Certainly my acuity changed. I got more and more interested in subtle inflection: I even made "colorless" paintings with Japanese ink, one of which we chose for this exhibition. And it was during my years in Japan, working on paper, that I learned how to layer one color on another in virtually colloidal permeability, a technique I was finally able to transfer effectively to sculpture in 1979.

By the time the 1960s came to a close, I was making paintings on paper in which structure was subsidiary to a wide variety of layered color. Subsidiary but decisive, for color without structure is incoherent.

All these works record the decade of my life from the age of forty to the age of fifty, the decade in which I made the transition from the implicit dependence of marriage to the explicit independence of a woman bringing up her children alone and largely supporting them by herself. I observed with some surprise that I looked at them without the piercing poignancy evoked in me by the sculptures in the Emmerich retrospective. I do not know quite why. Perhaps the easy way one sheet of paper follows another, the speed of execution, makes them touch me less deeply. Or perhaps in the last year I have come to identify less with my work. In any case, as we turned away from the gallery yesterday evening, I glanced back at the installed exhibition with detach-

ment, recognizing a record of my visual thinking. The works look like the paw marks of a hunting animal.

> . . . *in Sherpa-country every track is marked with cairns and prayer-flags, reminding you that Man's real home is not a house, but the Road, and that life itself is a journey to be walked on foot.*
>
> —BRUCE CHATWIN[34]

This morning when I came through the garden to the studio, I saw at a great distance around the setting moon an immense circle of mist, iridescent violet-blues hovering against a still-dark sky. Wonder took my breath away. Lifted out of time and place, I felt myself enfolded by magnificence.

Security is, after all, a gift.

But the human impulse toward its construction results in intelligent order. To locate ourselves accurately on the surface of the planet, we have devised a mathematical grid of longitude and latitude. This grid is measured by way of temporal degrees at regular longitudinal intervals east and west from an imaginary line called the celestial meridian running through Greenwich, England, from the North Pole to the South Pole; and by comparable spatial degrees at regular latitudinal intervals encircling the planet north and south from the celestial equator. We draw other imaginary lines on the earth itself—for example, arbitrary boundaries designating political hegemonies. We wake and sleep within the delineations of this useful schema, the work of the human mind but now so native to our thought that we can mistake it for natural fact.

Transients wending our way on the earth, we press ephemeral marks on its resilient surface. We put up private "prayer-flags"—in my case, sculptures. And had I been born a Sherpa, I would have

gathered stones and built cairns in special places: at Avonlea on the Tred Avon River, at Lee Haven where the black dog died, under a wild eucalyptus tree on the Partington Ridge land we owned in Big Sur, at the source of the iris-river in the Meiji Shrine in Tokyo ...

Even more intimately, we construct a grid of psychological longitude and latitude by way of which we sometimes constrict what we experience to what we are willing to experience. It is tempting to remain within the dimensions of such a personal schema, but I have learned that living with psychological insecurity is critical to psychological growth. For the greater the number of freely entertained different, mutually contradictory ideas, the greater the chance that their collision will strike a spark, ignite insight. And a house that is entirely secured is a prison.

I am, however, taking my daughters' advice about not "making do," and am moving to render my domestic establishment physically safer so I can grow old here and continue to work. Yesterday I consulted a contractor. He will cover with wood the treacherous, and ugly, concrete steps leading from the kitchen door to the garden and run a handy fence from them to the studio, as Alexandra suggested. I intend to plant vines on its posts; it will stay me when I walk to the studio in snowy weather and in darkness, and I can lean on it too—I've always liked to lean on a fence and think. He will also run railings on both sides of the stairways inside the house and I am covering my front stairs—I slipped there the other day—with gray-blue carpet. I am particularly afraid of falling down stairs because James's aunt did, broke her neck, and lay dead and undiscovered for six days.

The strain of the past year is subsiding. I am working steadily, today mixed deeper and deeper purples for a columnar sculpture, adding color in small dollops that alter them as little as possible while allowing them just-visible differences. This is the sort

207

of pursuit in art that I like best: the pursuit of the just-visible, of some mystery that seems to me to lie at thresholds of perception. Between coats of paint, I tend my garden. Right now I am rooting out dandelions, ruthlessly but with regret, as they are my favorite plant, so wholeheartedly yellow and determined.

Last Sunday I saw my fifth cousin, Adeline; with her were her daughter, her granddaughter and grandson. The following day she left to visit a newly born great-granddaughter. Adeline is in her eightieth year. Her heart is weakening. She looks frail as she has never since we first met, when I was in Bryn Mawr, from which she had graduated five years before, and she was pregnant with the daughter who was with us Sunday and now lives in San Francisco where she and Samuel have become friends.

Adeline and I look at each other and see the pentimento of years and years. We hold each other's past in cherishing hands. Our weddings (each of us married men the other did not trust), our pregnancies and the births of our children, the deaths of our parents—all to the accompaniment of a chorus of comment. We have been like the women in James Joyce's *Ulysses*, washing on the banks of the River Anna Livia Plurabelle "the convent napkins twelve."

We laughed and waved our arms playfully in the air as if to clear it of the time that is overtaking us. But it is time that has wrought what we now share, time that has hammered and tempered us, time that has delivered us into a state of mind we never thought to come to, proud and healthy and enterprising as we were for most of our lives. When we were younger, we occasionally, a bit fatuously, spoke of humility as a virtue but we little thought that we might ourselves actually have to become humble. We do not claim the virtue, but we sit back: modesty may lead

to the humility that we both see as the way to honest death. What humility we have takes the form of perspective. We address the present. We watch. We are to some small degree disinterested though our voices rise and fall as lightly as they always have—we make the sounds we are accustomed to hear in each other. But we listen more than we speak. Having been in trouble ourselves, over and over, our empathy is sincere, our sympathy rises spontaneously. We are the family elders now, we are treated as we once treated our parents.

I am scouring my house before departing for the summer. Lost books are heaving up out of the sea of the children's detritus on the third floor, Samuel's "bachelor pad."

One, a collection of poetry, was given to me by my godfather for my thirteenth Christmas. Dirty and dented, its stout green binding flaps loose off its spine. My still-childish round script marks my favorites, among them Alfred Tennyson's "The Lady of Shalott" and Matthew Arnold's "The Forsaken Merman."

These were the first poems that my mother read me, long before I received this collection. Her melodious voice introduced me to the fatality of love. The Lady of Shalott, doomed on pain of death to keep her eyes only on a mirror and to weave what she saw there into a tapestry of life instead of living it herself, deliberately chooses death for the sake of one direct look at her beloved, Sir Lancelot, "riding down to Camelot." The Merman, by nature alien to his human lover, calls and calls to her from the sea bordering the shore over which she has returned to her own kind until, at length despairing, he falls back into the ocean depths to tend their Merchildren. So love between men and women, I took in, led on the one hand to death and on the other to the assumption of lonely responsibility.

Cursed, the Lady of Shalott leaves her "Four gray walls, and four gray towers" on her "island in the river / Flowing down to Camelot." She descends to the river, finds there a shallow boat, writes on its prow "The Lady of Shalott," loosens its chain, lies down in it and floats down to Camelot. She sings "Till her blood was frozen slowly, / And her eyes were darken'd wholly." Her boat drifts ashore.

> *And in the lighted palace near*
> *Died the sound of royal cheer;*
> *And they cross'd themselves in fear,*
> *All the knights of Camelot;*
> *But Lancelot mused a little space;*
> *He said, "She has a lovely face;*
> *God in his Mercy lend her grace,*
> *The Lady of Shalott."*

Not for her the bloody flux of childbirth, the wail of a hungry baby at 3:00 A.M., the clatter of running feet, the topsy-turvy of bringing up children, the heartbreak of love come to maturity in hopes disappointed, piercing confusions, separations more bitter than any death of the body. Intact, narcissistic—she makes sure she is recognized, her name inscribed on her barque—her love is crowned only by acknowledgment of her beauty, the least of all she might have been. Yet, I used to feel when a girl, and still feel, her love was worth her death.

Death is all she pays for love. The Merman and his human mate pay with a lifetime of loneliness. He can comfort neither his children for the loss of their mother, nor their mother for the loss of her children. He falls back from the shore,

Singing, "Here came a mortal,
But faithless was she.
And alone dwell for ever
The kings of the sea."

Across the shore, in the town, the woman rejoices in "the blessed light of the sun" until

She steals to the window, and looks at the sand;
And over the sand at the sea;
And anon there breaks a sigh,
And anon there drops a tear,
From a heart sorrow-laden,
A long, long sigh,
For the cold strange eyes of a little Mermaiden,
And the gleam of her golden hair.

Merman, human woman, their children, are caught in the gap between sea-nature and land-nature, metaphor for that yawning between man and woman. After a lifetime of experience, I wonder whether this space is really bridgeable. I only know that the attempt to bridge it has led me to learn more, more intimately, than any other effort I have ever made. It is perhaps the major struggle of most lives, highlighted by the lure and ease of physical union, an affirmation of ineffable joy but pitifully soon intercepted by time. Time also bears with it changes so relentless, individual, inevitable and intractable that stasis is over and over revealed to be only temporary. The tantalizing difference that initiates attraction itself interferes with communication. Absent painstaking definition and redefinition of feelings, a partner be-

gins to *imagine* what the other partner wants, and to adjust accordingly.

The Swiss mathematician Jakob Bernoulli articulated the principle governing the progress of two ships side by side. When they cruise too close together, the water between them is "squeezed," which makes it flow faster. When fluids gain speed, they lose pressure and this drop in pressure sucks the two hulls together. Collision can be averted if the two ships are steered on slightly divergent courses to left and right of their mutual base course. If ship A is a carrier and ship B a destroyer, the smaller destroyer must diverge at a larger angle than the carrier in order to maintain a safe distance between them; the greater the effective speed over the water, the more the required divergence. Even so, two ships in such relation to each other travel at a rate slightly slower than they would if separated by a greater distance. By analogy, partners do well to plot their courses at slightly different angles but not so different they lose sight of each other.

The silent partner in a successful union is a steadfast purpose held, equitably and equably, in common. Then bringing up children together, nourishing compatible ambitions, rising to challenges, bearing and forbearing in the ruck of daily life—all can be woven into a pattern both people feel worthwhile. It has not been my fate to join with a lifelong partner toward such a mutual goal. This sometimes saddens me. But on balance my life makes sense to me. Samuel once took a telling photograph of me: a dark misty shape looming against a lighter mist of ocean structured by almost invisible lines of boardwalk and jetty. I recognize myself.

The separation between man and woman is, beyond all else, a metaphor of the separation between the individual and the divine. It is this gap that seems to me finally crucial, this union toward which I am come to tend, on Matthew Arnold's "Dover

212

Beach," the third poem my mother used often to read to me, which ends:

> *Ah, love, let us be true*
> *To one another! for the world, which seems*
> *To lie before us like a land of dreams,*
> *So various, so beautiful, so new,*
> *Hath really neither joy, nor love, nor light,*
> *Nor certitude, nor peace, nor help for pain;*
> *And we are here as on a darkling plain*
> *Swept with confused alarms of struggle and flight,*
> *Where ignorant armies clash by night.*

At a dinner the other night someone remarked that the art market, in recent years riding high on the rising tide of a prosperous economy, has "collapsed." This is an example of the French mathematician René Thon's Catastrophe Theory. Thon claims that subtle destructive forces accumulate by continuous indiscernible increments that lead, unpredictably, to discontinuous responses: the grinding of tectonic plates culminates in an earthquake, bridges suddenly fall as a result of metal fatigue, an apparently healthy person "breaks down."

The market for art is artificial. Art is not. The urge to differentiate what is personal from what is universal, and to express it, is a human imperative. The most private of all obsessions, it is the most generic. It takes many, many forms and is to be respected in all of them—I think of the sunbonneted woman singing on her porch in the North Carolina mountains. In this broad sense, it is art that renders individuality visible, first as a personal ever-beckoning mystery, then as an available resource to all who hunger for companionship as they strive toward their own development.

213

Now that I am beginning to venture into the realm of old age, which stretches to the brink of death as childhood stretches to the brink of maturity, I draw strength from the affirmation of art in a way that is newly dear to me. I walk around museums with exhilaration, taking particular pleasure in the art I know so well and have learned so much from, and lively interest in what younger artists are making now. I watch their work for what is incipient in the culture, for what they are revealing to me about society in general. I listen to their voices as they tell me what art is becoming. I feel for them infinite tenderness, infinite respect.

But my judgment remains nonetheless strict. Leonardo da Vinci once remarked that "Nothing can be either loved or hated until it is first known." A point of view is necessarily subjective, but its authenticity depends on objectivity, and objectivity demands an honesty sooner or later painful. I look for the rare artists who have had the resolution, the courage and the pertinacity to observe, examine and reexamine on its own terms the given range of their singularity until the particular yields the universal.

I am in the bedroom assigned to me for our class reunion at Bryn Mawr. I have deployed my belongings, but I feel displaced. This residential hall is new since my day. Shaped like a clover leaf, each of its sections houses students majoring in a different language. My window looks out into an elegant courtyard surrounded by leafy plants. I hear the half-familiar voices of my classmates, exclaiming.

I have read the autobiographies we wrote for this landmark occasion. There were 169 of us; 126 alive. Eight are "lost or do not wish to be contacted." Who are they, I wonder. Where? And why have they chosen to extirpate this part of their lives? Thirty-five of us are dead; of these, I remember eighteen—their mute young

faces rise in my memory as if to the surface of a still lake. Forty-nine of us have earned advanced degrees, six in medicine. Most of us have traveled the face of the earth; many have lived, four still live, in foreign countries. One of us has fifteen children, aged fifty to twenty-eight, and thirty-two grandchildren; on another the emperor of Japan conferred the Order of the Precious Crown. Virtually all speak of the history we have lived through and of how in our private lives we made to this history as much public contribution as we could.

We are threading in and out of one another rather as we did when we were students. The girls who led us then have become the women who lead us now; those of us who were amusing then are still amusing; iconoclasts have remained iconoclasts. It is astonishing how the *flavor* of our personalities is the same. And the structure of each character is still perfectly recognizable, fifty years of experience have been written on bone. We look at one another with eager curiosity, listen with eager tenderness because we remember what we were like when we entered college on the outer edge of adolescence. Most of us have seen our children over that edge into maturity; we can now see one another in that perspective. We have in some subtle sense become the mothers of ourselves as we used to be and can accord one another the sincere affection implicit in the understanding we have garnered over the years.

It is the last day of the reunion. I leave for home in a few hours. How little my own character has changed! A certain obtuseness remains ingrained: I had failed to check the weather forecast; it has rained and rained; I did not bring my hooded raincoat and my one pair of shoes are by now wet rags on my feet.

Just as I used to be when a student, I have been more alone than in company. Dripping, I have quartered the campus, have sought out and stood again in the special places that I used to haunt. I walked up to my old room on the third floor of Rhoads Hall. Spartan—a desk, a lamp, a chair, a bookcase, a chest of drawers, a bed—it is an infinitely compatible economy for a life aligned to a purpose. I thought of myself as I was when I lived in this room, hopeful, confused, sorrowful, determined—*fresh*. And it seemed to me suddenly that my life has been like an arrow feathered to a fate proper to it.

I took a last look at the exhibition of my work in the library. I thought of my classmate who has fifteen children and thirty-two grandchildren—she made a village! I thought of my other classmates, of their beauty, the beauty of lives faithfully tended until the very durance of time revealed itself as meaning incarnate.

Late yesterday afternoon I walked finally into the cloister. There, across the grass, brilliant green brightened by rain, beyond the jet of the circular fountain in the center of the court, I saw a student. Her back was propped against the granite wall. She was writing, utterly intent. Not to disturb her, I departed by a far door, leaving her as if leaving myself in place, linked to her in silent continuity.

Continuity prevails. I have returned home comforted.

When Tiresias—who lives in my imagination forever treading with knobby dusty sandaled feet the ancient soil of Greece, a blind seer who sees—meets Odysseus at the border of Hades, he prophesies the hero's fate. At long length he will return home, where he will not be immediately recognized. Years later, in old age, he will make a last journey. He will take up an oar and walk inland, the sea at his back, until he meets a stranger who will ask

him what that thing is that he is carrying. At this spot, Odysseus will plant his oar in the earth and make ceremonial sacrifice to all the gods in heaven. Only then, having himself rendered his life a story null and void, will he be able to settle down for his remaining years among his own people.

We are all as mythic. When all is said and done, individuality, like Odysseus's oar, is planted—and relinquished. This morning I feel a curious lightness of heart, as if I will in time gladly yield my own.

From this point of view, which is new to me, I think of my life as it has been with wonder. I could be a stranger to it.

Alexandra is in Italy, on the wing. Mary is in Annapolis, balancing her life as writer, wife and mother. Samuel is moving across the continent, driving north from San Francisco to Vancouver, where he will visit Harold Kalke, and then due east, stopping at Agawa Rock, to Brown University, where he will bring his current manuscript of poetry to completion while earning an advanced degree. My five grandchildren, a kaleidoscope of dear images, are already active toward their unknown ends. As well as abiding and profound love, I feel for them all a kind of courtesy. I honor them.

I am come to honor what is. I like to think of what I do not know, and cherish the glimpses I have had of its richness. A few days after we arrived to live in Tokyo, we joined a throng of Japanese who were celebrating the emperor's birthday. I stopped on the high arch of the bridge leading into the grounds of the Imperial Palace. I gazed down and in the still black moat that curved between the slant of steep, lichened, ancient stone walls saw many large strong carp, elaborately patterned clear scarlet, white, pale lemon, salmon. Among them I saw with a leaping heart one that was magnificent. Sinuous, dignified, it moved among the others with slow sure power. Its scales were all pure green-gold, glis-

217

tening. During the years we lived in Japan I returned over and over in the ever-defeated hope that I would see this mysterious creature again. On the final day of our sojourn, late in the afternoon of the night on which we were to fly away forever, I stopped one last time. Treading in my familiar footsteps, I walked deliberately up the arch of the bridge, leaned over its cool stone wall, looked down—and saw my fish, my beautiful mythical golden fish, gliding, gliding, pledge of steadfast faith redeemed.

Notes

1. F.A. Worsley, *Shackleton's Boat Journey* (NY: W.W. Norton, 1977), pp. 117–18.

2. *McGraw-Hill Encyclopedia of Science and Technology*, 6th edition, Vol. 19 (NY: McGraw-Hill, 1960), pp. 18–19.

3. Antonio de Herrera y Tordesillas, sixteenth-century historian, quoted in William MacLeish, *The Gulf Stream* (Boston: Houghton Mifflin, 1989), p. 62.

4. *The Amundsen Photographs*, edited and introduced by Roland Huntsford (NY: Atlantic Monthly Press, 1987), p. 131.

5. *Scott's Last Expedition: Journals of R.F. Scott, R.N., C.V.O., on His Journey to the South Pole* (NY: Dodd Mead, 1923), pp. 463–64.

6. Musa Mayer, *Night Studio: A Memoir of Philip Guston* (NY: Alfred A. Knopf, 1988), pp. 205–208.

7. Marcus Tullius Cicero, "On Old Age," *Selected Works*, translated and edited by Michael Grant (NY: Penguin, 1960), pp. 211–47.

8. Anne Truitt, *Turn: The Journal of an Artist* (NY: Viking, 1986), pp. 84–85.

9. Caroline Tisdall, *Josef Beuys* (NY: Thames and Hudson, 1979), p. 10.

10. Ibid.

11. Aniela Jaffe, *Jung's Last Years*, translated by R.F.C. Hull (Dallas: Spring Publications, 1984), pp. 102–103.

12. José Ortega y Gasset, *The Revolt of the Masses* (NY: W.W. Norton, 1932), p. 157.

13. *Beowulf: A Dual-Language Edition*, translated by Howell D. Chickering, Jr. (NY: Doubleday, 1977), p. 149.

14. Ibid., pp. 139–41.

15. All García Lorca quotations: Federico García Lorca, "Theory and Function of the *Duende*," a lecture delivered in Havana and Buenos Aires, translated by J.A. Gill, Poetics of American Poetry.

16. Anthony Trollope, *Miss Mackenzie* (Oxford: Oxford University Press, 1988), p. 182.

17. Karl Marx and Frederick Engels, *The Communist Manifesto* (NY: International Publishers, 1948), pp. 6, 11.

18. Charles Darwin, *The Voyage of the Beagle* (NY: Mentor, 1988), p. 191.

19. Ibid., p. 197.

20. Ibid., p. 186.

21. Alan Moorehead, *Darwin and the Beagle* (NY: Harper and Row, 1969), p. 266.

22. Sheldon Novick, *Honorable Justice: The Life of Oliver Wendell Holmes* (NY: Dell Publishing, 1989), p. 152.

23. John Richardson, *A Life of Picasso*, Vol. I (NY: Random House, 1991), p. 48.

24. Quoted in Alice Miller, *The Drama of the Gifted Child* (NY: Basic Books, 1981), pp. 43–44.

25. Worsley, *Shackleton's Boat Journey*. All quotations, pp. 117–18.

26. Ibid., quotation on the back of the jacket.

27. William Innes Homer and Lloyd Goodrich, *Albert Pinkham Ryder: Painter of Dreams* (NY: Harry N. Abrams, 1989), p. 20.

28. Dore Ashton, *Noguchi East and West* (NY: Alfred A. Knopf, 1992), p. 231.

29. Isamu Noguchi, *Isamu Noguchi: A Sculptor's World* (NY: Harper and Row, 1968), p. 163.

30. Roger Lipsey, *An Art of Our Own: The Spiritual in Twentieth-Century Art* (Boston: Shambhala Publications, 1988), p. 351.

31. Francis Darwin, "Reminiscences of My Father's Everyday Life," in *Autobiography of Charles Darwin* (NY: Schuman, 1950), pp. 108, 109.

32. Kathy Sawyer, "New Findings Support Theory of Big Bang," *Washington Post*, April 24, 1992, p. 1.

33. Wallace Stegner, *Angle of Repose* (NY: Ballantine, 1971), p. 20.

34. Bruce Chatwin, *What Am I Doing Here?* (NY: Viking, 1989), p. 273.

FOR THE BEST IN PAPERBACKS, LOOK FOR THE

In every corner of the world, on every subject under the sun, Penguin represents quality and variety—the very best in publishing today.

For complete information about books available from Penguin—including Puffins, Penguin Classics, and Arkana—and how to order them, write to us at the appropriate address below. Please note that for copyright reasons the selection of books varies from country to country.

In the United Kingdom: Please write to *Dept. JC, Penguin Books Ltd, FREEPOST, West Drayton, Middlesex UB7 0BR.*

If you have any difficulty in obtaining a title, please send your order with the correct money, plus ten percent for postage and packaging, to *P.O. Box No. 11, West Drayton, Middlesex UB7 0BR*

In the United States: Please write to *Consumer Sales, Penguin USA, P.O. Box 999, Dept. 17109, Bergenfield, New Jersey 07621-0120.* VISA and MasterCard holders call 1-800-253-6476 to order all Penguin titles

In Canada: Please write to *Penguin Books Canada Ltd, 10 Alcorn Avenue, Suite 300, Toronto, Ontario M4V 3B2*

In Australia: Please write to *Penguin Books Australia Ltd, P.O. Box 257, Ringwood, Victoria 3134*

In New Zealand: Please write to *Penguin Books (NZ) Ltd, Private Bag 102902, North Shore Mail Centre, Auckland 10*

In India: Please write to *Penguin Books India Pvt Ltd, 706 Eros Apartments, 56 Nehru Place, New Delhi 110 019*

In the Netherlands: Please write to *Penguin Books Netherlands bv, Postbus 3507, NL-1001 AH Amsterdam*

In Germany: Please write to *Penguin Books Deutschland GmbH, Metzlerstrasse 26, 60594 Frankfurt am Main*

In Spain: Please write to *Penguin Books S. A., Bravo Murillo 19, 1° B, 28015 Madrid*

In Italy: Please write to *Penguin Italia s.r.l., Via Felice Casati 20, I-20124 Milano*

In France: Please write to *Penguin France S. A., 17 rue Lejeune, F-31000 Toulouse*

In Japan: Please write to *Penguin Books Japan, Ishikiribashi Building, 2-5-4, Suido, Bunkyo-ku, Tokyo 112*

In Greece: Please write to *Penguin Hellas Ltd, Dimocritou 3, GR-106 71 Athens*

In South Africa: Please write to *Longman Penguin Southern Africa (Pty) Ltd, Private Bag X08, Bertsham 2013*